THE BRISTOL AVON
FROM SOURCE TO SEA

Steve Wallis

AMBERLEY

First published 2015

Amberley Publishing
The Hill, Stroud, Gloucestershire, GL5 4EP
www.amberley-books.com

Copyright © Steve Wallis, 2015

The right of Steve Wallis to be identified as the
Authors of this work has been asserted in accordance with the
Copyrights, Designs and Patents Act 1988.

ISBN 978 1 4456 4829 3 (print)
ISBN 978 1 4456 4830 9 (ebook)

British Library Cataloguing in Publication Data.
A catalogue record for this book is available from the British Library.

Typesetting by Amberley Publishing.
Printed in Great Britain.

CONTENTS

ACKNOWLEDGEMENTS

I would like to thank Jon Bird, Peter Cox, Emily and Penelope Preston and Ian Rees for their assistance in the writing of this book.

INTRODUCTION

Finding oneself beside a river, curiosity usually leads to us asking 'where is it coming from?' and 'where is it going?' If that river happens to be the Bristol Avon, the answer to both questions is inevitably 'not that far away'.

The streams that form the Avon rise and flow on the south-east side of the Cotswolds, and so cannot take a direct route to the sea which is only a few miles to the west. Leaving the limestone uplands, they join at Malmesbury into a single river to flow southward. They cross the lowland clays of northern Wiltshire that separate the Cotswolds from the high chalklands, which stretch from south-west to north-east across much of England, and which are locally recognised as Salisbury Plain and the Marlborough Downs. In doing so, the river flows through or close to the towns of Chippenham, Melksham and Trowbridge. Around Bradford-on-Avon the river takes a sharp bend, cutting back west and north-west through the limestone. Its course, which includes spectacular gorges and which takes it through the great cities of Bath and Bristol, now separates the Cotswolds from the older limestone of the Mendip Hills to the south.

The river has a length of around 75 or 80 miles. It is not possible to be exact in this because it depends where you start to measure from, as I will explain in the next chapter. Its catchment area (the land which is drained by the river) is 860 square miles. However, the compactness of the area within which the river flows is illustrated by the following. The village of Pucklechurch lies in South Gloucestershire just to the north-east of the Bristol conurbation, in a central location within the looping course of the river. I think that no part of the Bristol Avon is more than 15 miles from Pucklechurch.

Until the local government reorganisation of 1974, this course took the Bristol Avon through the counties of Gloucestershire, Wiltshire, Somerset and Bristol (which had been a county in its own right since the Middle Ages). Nowadays, though, the additional county of South Gloucestershire is involved, and the Somerset element has

been taken over first by Bath and north-east Somerset and then further downriver by north Somerset.

The name 'Avon' is a common one for English rivers – besides our example, there is the Warwickshire Avon, which flows through Shakespeare's birthplace of Stratford-upon-Avon, the Salisbury Avon, which flows south from Wiltshire to the English Channel, and a couple of others. The origin of the name, though, is Welsh, or at least Celtic, meaning simply 'river' – in modern Welsh the spelling is *afon*. As Saxon settlers speaking an early form of English spread across the country in the centuries following the departure of the Romans from Britain, they must have asked native Celts who they encountered what a particular river was called. It is easy to imagine the latter being surprised by the question and saying in their own language 'river', and perhaps wondering if they are going to be asked what a tree is called next. The Saxon presumably went away happy thinking that 'Avon' was the name of this particular river, and the name stuck!

As well as describing the course, form and features of the river itself in more detail, I will look also at the towns and a selection of the villages and historic features of its valley, and also a selection of the river's tributaries. The river is also linked inextricably with a major canal and the harbour at Bristol, so these are also matters to investigate. In following the course of the river, I have attempted to stay within the valley, and to avoid chasing too far up the tributaries – though not always with complete success.

I made a number of visits to the area between January and August 2015 to take the photographs used in this book. It was very enjoyable to appreciate the seasonal changes in the river and its environment in so doing. I hope this book encourages you to explore this lovely part of the world.

1

FROM THE SOURCES TO MALMESBURY

The first matter to deal with before we begin our journey along the river is to decide where exactly the river begins. In common with other volumes in this series, this book's title includes the description 'from source to sea'. So when I began researching this book, I thought it rather important to find out where the source of the Bristol Avon is.

I looked online and found that the source is given there as being near Acton Turville in Gloucestershire. Then I read further and found out about the Sherston and Tetbury Avons.

The Sherston Avon is named after a place on its upper course and initially it looked like a better candidate, but there are at least three candidates for its source, including the Acton Turville one.

The Tetbury Avon, named from the Gloucestershire town beside which it rises, is often considered a tributary, but is a sizeable one if so. If it really is a tributary, it is the only one that bears the 'name' Avon, and, to complicate matters further, there are two candidates for its source.

After much head-scratching and exploring, I have come to the conclusion that whether the river has a true source or is just an amalgam of several watercourses does not really matter. Let's just say that watercourses draining much of the southern Cotswolds come together so that, around Malmesbury, they become a single, recognisable river called the Bristol Avon, and that other bodies of water that flow into it further on are clearly tributaries.

And to emphasise the point I made in the introduction regarding the compactness of the river's course, the crow needs only 20 miles to fly from some of these to the sea, but the river itself covers almost four times that distance.

So now to look at these various 'sources', starting with the Sherston branch.

One of the potential sources rises in Badminton Park, which is just inside Gloucestershire. The park is in the grounds of Badminton House and, like the house, originated in the seventeenth century, though the park has been much altered since. The game of badminton was invented here

in 1863 and the park is internationally renowned today as the venue of the Badminton Horse Trials.

Flowing east out of the park, the stream passes under a road and finds itself in Wiltshire. Right next to it here is the tree-covered mound of Giants Cave long barrow. This is one of the communal burial mounds of some of this country's earliest farmers, dating from around 3500–2500 BC in the middle of the Neolithic period. The burials sometimes only included parts of skeletons and were placed within stone chambers. The earth mound was only added when the barrow went out of use for burials. This one is 135 feet long, 85 feet wide and 10 feet high. It was partly excavated in the early 1960s, when the remains of twenty individuals were found.

When I visited this area in June, this watercourse, like those at Tetbury, had dried up. Streams like this, which dry up naturally in summer, are known 'winterbournes' in some parts of the country as a reference to them usually only flowing in winter when groundwater levels are higher. In these cases I wondered whether the dryness might have been a result of abstraction of water for agriculture uses, though.

Within a couple of miles this stream has been joined by two others which flow in on either side, including the one that originates off to the south-west near Acton Turville mentioned earlier. Again the latter's source is just inside Gloucestershire. Almost immediately the single watercourse flows through the village of Luckington.

Passing through Luckington by road you will notice a big triangular village green. Down a lane from the green and away from the village centre there is an access to the slightly odd-looking parish church, behind which is Luckington Court. This looks like a case of the church being built for the convenience of the occupants of the manor house rather than the villagers, with the latter being reminded visually who was running the place every time they came to church. If so, it is the first of several such instances that we will encounter along the Bristol Avon. The church has features that date back to around 1200 and the tall tower dates from soon afterwards. The house has a frontage built around 1700 in the Queen Anne style, but the rest of the building behind is older; dating from the sixteenth century or even earlier.

Two miles further to the north-east the watercourse reaches the village of Sherston. Just before that, another stream flows in from the north-west. It originates about a mile away at Crow Down Springs, and of course this is one of the claimed sources of the Bristol Avon. You can get a good view of the marshy land just below the springs from a pretty little road bridge close by.

The joining of this stream means that there is now no dispute that we are following the Sherston Avon, so let us have a look at the village that gives it the name.

Sherston is a sizeable village with a large square flanked by old stone cottages. The presence of many similar buildings in the side lanes demonstrates that it has been quite a large place for several centuries. In fact, a place

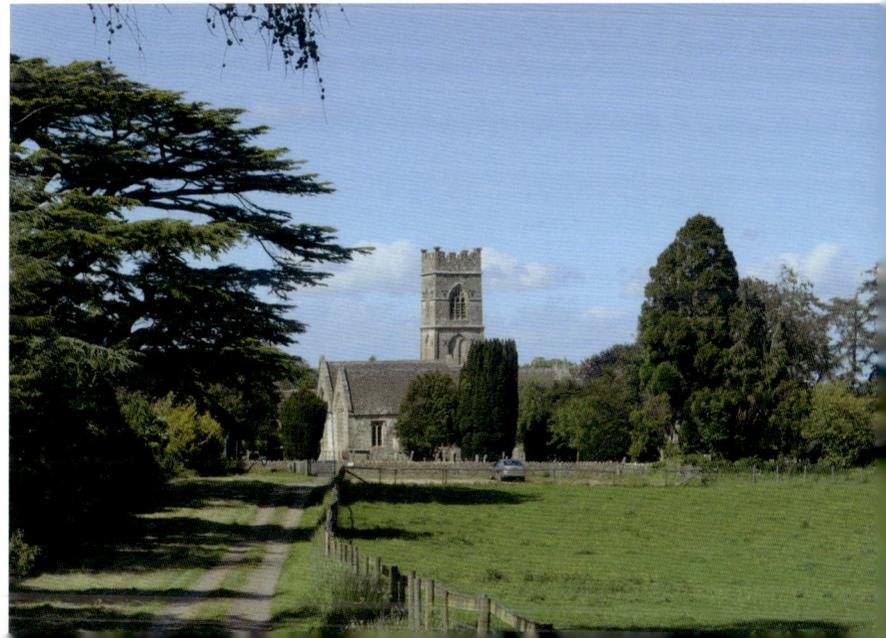

Above left: The tree-covered mound of Giant's Cave long barrow.

Above right: Though dried up, the line of the tributary that runs out from Badminton Park can be seen as a darker line of vegetation as it passes Giant's Cave long barrow.

Below: Luckington parish church.

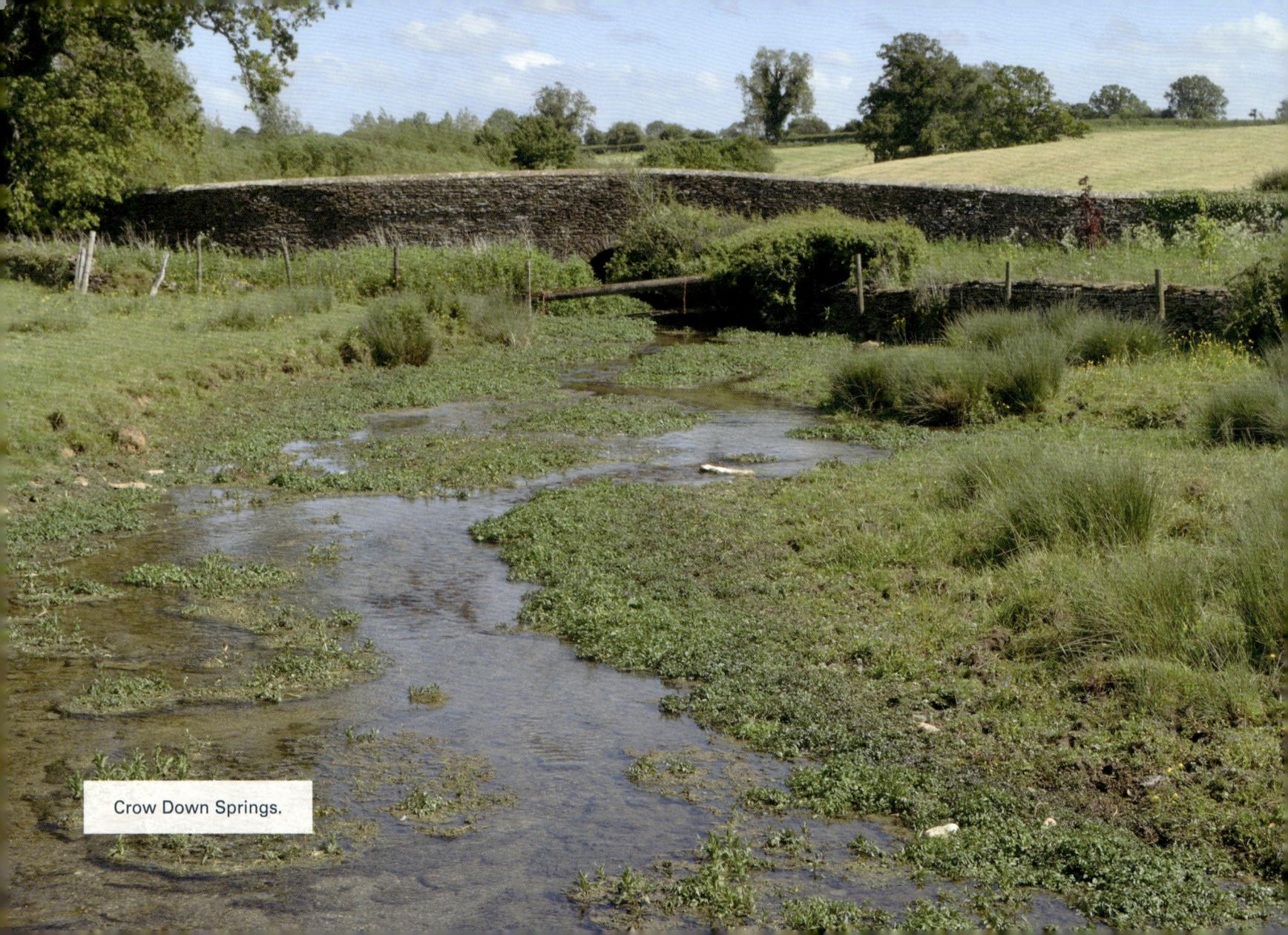
Crow Down Springs.

of this size was probably considered a town until quite recently. To the south of the village the Sherston Avon is now running in a clearly-defined valley that is narrow with quite steep sides.

Easton Grey is a couple of miles downstream from Sherston. Most of the village lies in the bottom of the Sherston Avon's valley, so that if you are travelling along the B4040 between Sherston and Malmesbury you can easily miss it. The parish church is just off that road, not far from Easton Grey House – the latter dating from the late eighteenth century, although presumably there was an earlier manor that the church was located conveniently for, as at Luckington. The church is worth a look, but I strongly recommend that you head down to see the lovely grouping of houses and cottages by the river.

The bridge was probably built in the sixteenth century, and there is a pretty little weir just upstream from it. Next to it is Bridge House, which is of a similar age to the bridge, as well as having a rear wing of 1923 incorporating Arts and Crafts features.

Leaving the Sherston Avon to head east towards Malmesbury, we will head north-east to have a look at the other 'main branch'.

Tetbury is a lovely little Cotswold town that sits on a spur of land above two streams which unite to form the Tetbury Avon. The spire of its parish church, rebuilt in 1780 in the newly fashionable Gothic style, is a prominent landmark. While a couple of the streams that form the Sherston Avon arise just inside Gloucestershire, and quickly cross into Wiltshire, Tetbury is several miles inside the former county. The two streams here originate to the north-west and north-east of the town and flow around the west and east sides of the town respectively to unite and flow south. These are the most northerly of the sources and lie a good 10 miles from the one at Acton Turville.

There seem to be claims for both streams as the single source of the Tetbury Avon, if not the larger river. An information board in the town refers to the western one simply as 'the Avon', while Ordnance Survey maps name Wor Well on the eastern one as the source of the River Avon. In fact, the sections of both streams by the town had dried up when I was there, despite some recent rain. An exception was a pond on the eastern stream, which is known locally as 'The Splash'.

There is a hillfort dating to the Iron Age just south of the town, but Tetbury itself dates from Anglo-Saxon times, with the original centre probably being to the south-east of the present one in an area called 'The Green'. The town grew prosperous on the wool trade, supplying mills further north in the Cotswolds. There is good evidence of this prosperity in the number of fine seventeenth- and eighteenth-century town houses, and especially in Tetbury's central feature – the Market House that was built in 1655 during the rule of Oliver Cromwell. An even earlier market site lies on the north side of town centre. Its name, The Chipping, actually means 'market'.

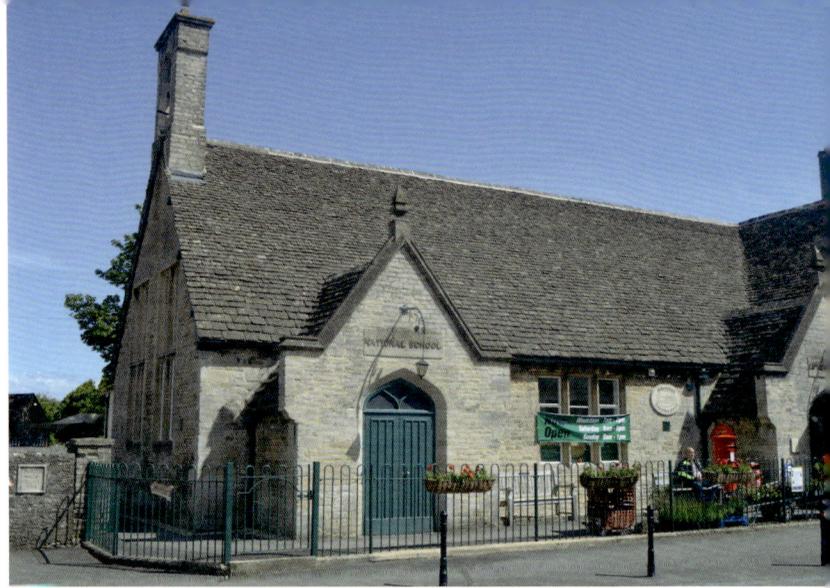

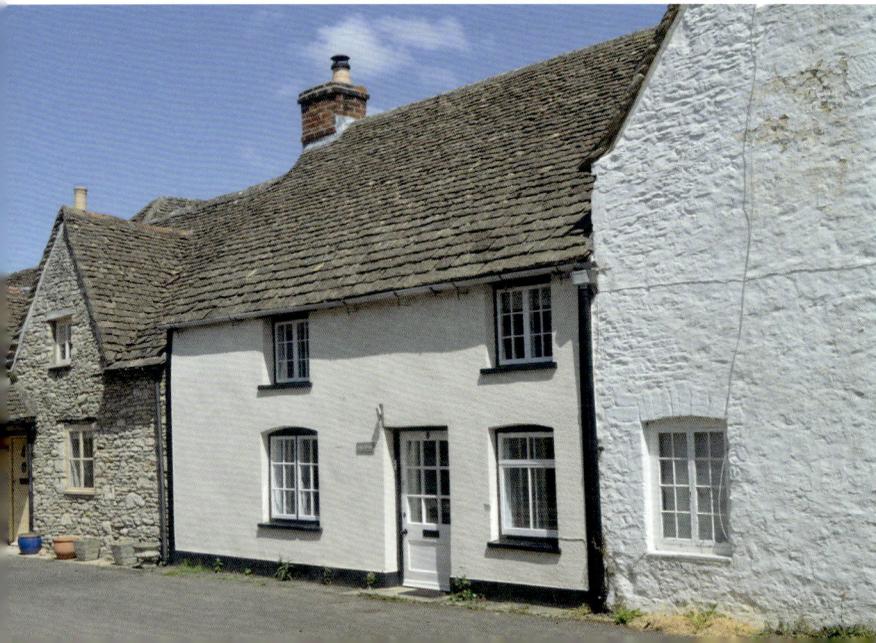

Above left: The central square in Sherston.

Above right: The old National School in Sherston is now the village shop and post office. It dates from 1845, and was part of a movement to bring education to all children in the days before it became compulsory.

Below: Cottages in one of Sherston's side streets.

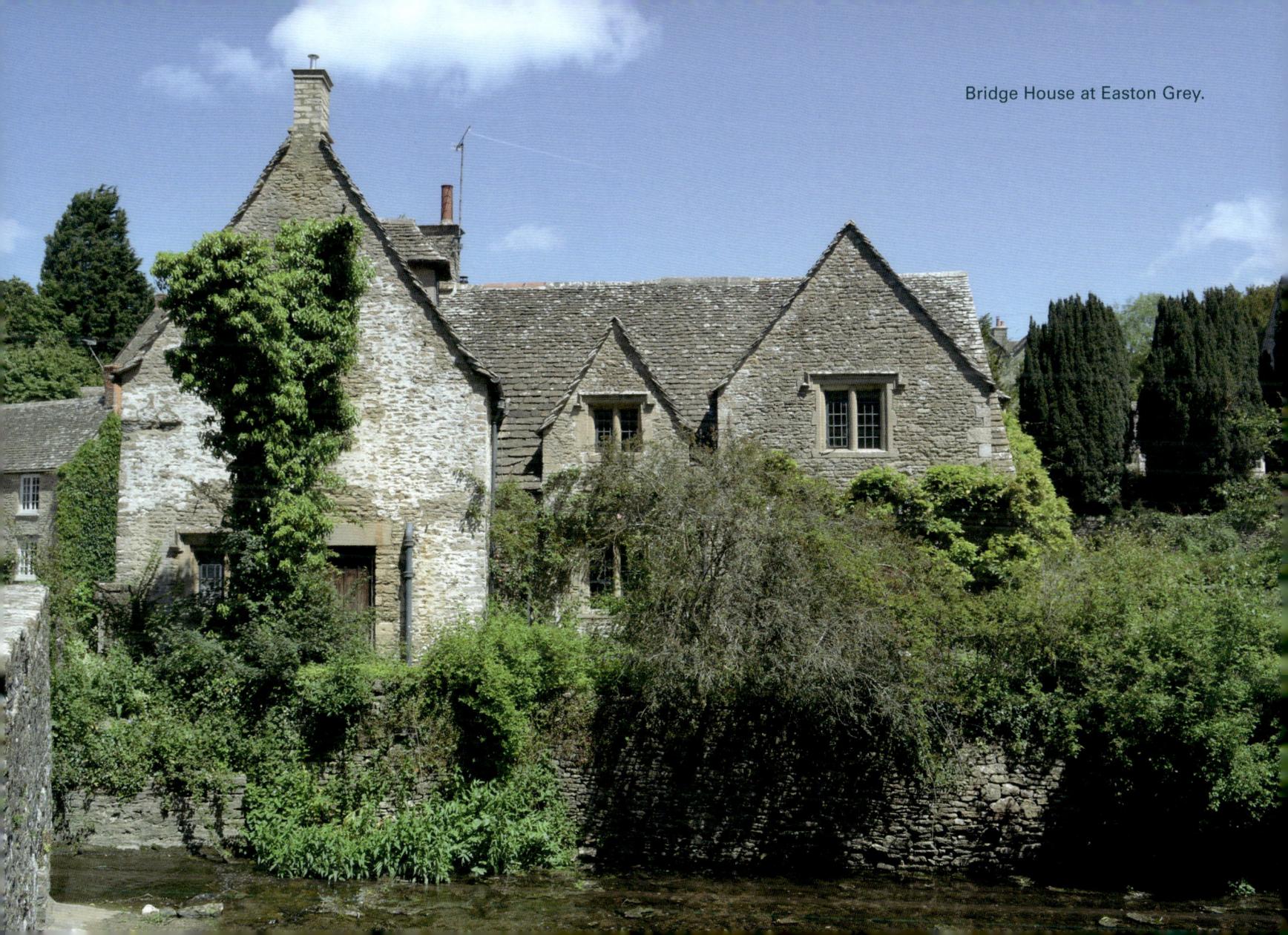

Bridge House at Easton Grey.

Above left: Tetbury's Market House.

Above right: Buildings in Long Street, Tetbury.

Below: More of Tetbury's fine buildings.

The Royal Oak – a 300-year-old building
with a roof of Cotswold stone slates.

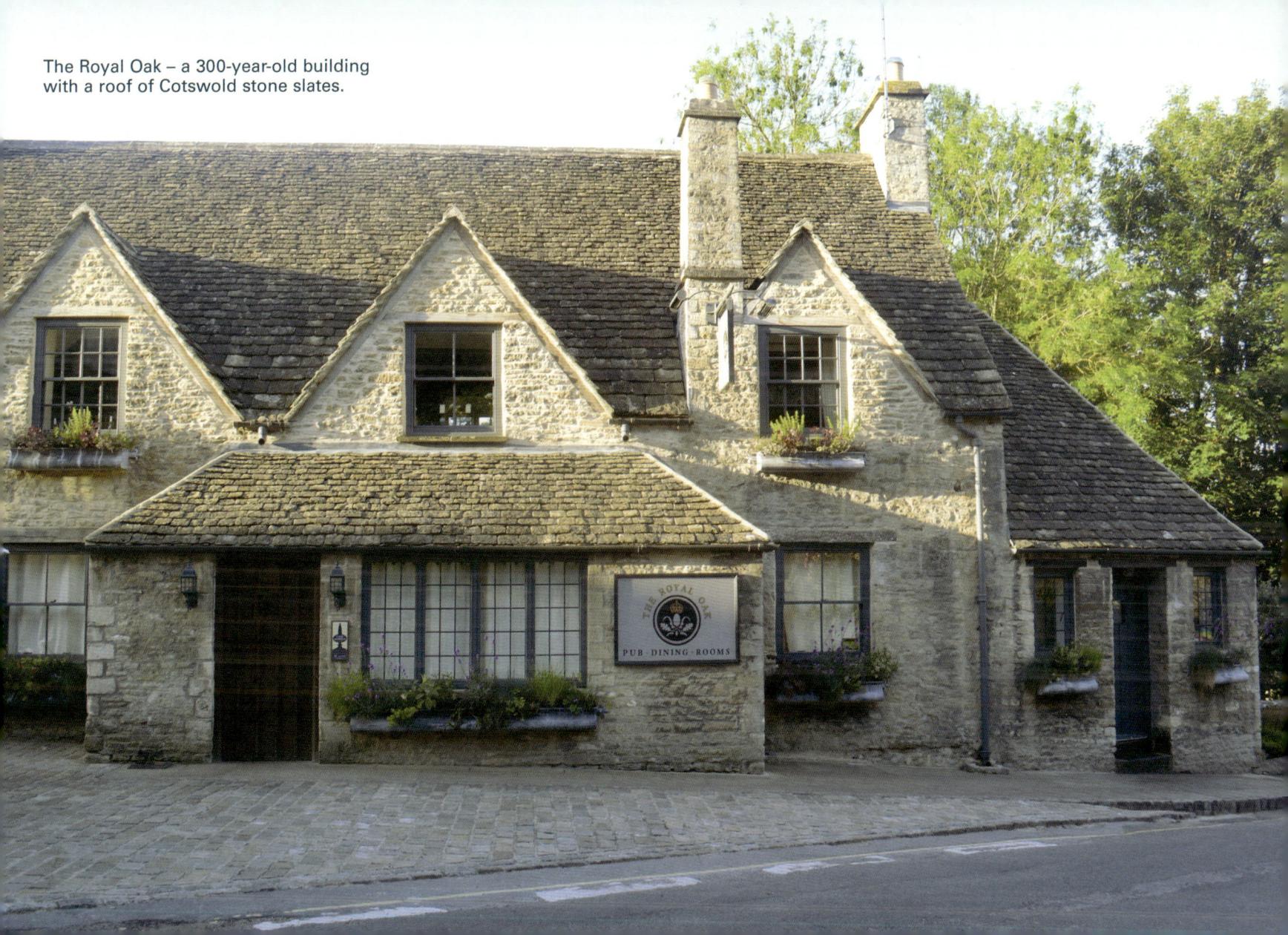

Part of Tetbury's railway station can still be seen near 'The Splash'. There is an engine shed and a part of the platform, and also a section of the rails surviving embedded in the tarmac of a car park. This was at the end of a 7-mile-long branch line that ran from a junction with the Swindon to Gloucester line at Kemble, and which was in use between 1889 and 1964.

Two bridges cross the streams to take main roads out of the town, and their names indicate their destinations. The eastern is crossed by the Wiltshire Bridge, constructed in the seventeenth century, and the western is crossed by Bath Bridge, which continues Church Street and was built in 1774–76 by the architect Thomas Webb. There is a wonderful contrast that demonstrates what an innovation this latter structure was, for next to it, and very much below in the valley, is Waters Bridge. This was Bath Bridge's predecessor, perhaps dating from the early seventeenth century, and intended to carry nothing heavier than a packhorse across the stream.

Around the town I came across references to the 'feoffees', and wondered who on earth these people were. It turns out that this is an old technical term for trustees holding the freehold of land generally for a charitable purpose. In Tetbury's case, in 1633 Lord Berkeley sold the town to four such local men, who were assisted by thirteen elected town wardens. Today there are seven feoffees, who still own a number of sites around the town for the public good.

Leaving Tetbury, this particular Avon winds its way to the south-east, crossing the Fosse Way as it does so. This was the Roman road that ran from Exeter to Lincoln, taking its name from the Latin *fossa*, meaning ditch. When it was built, not long after the Roman invasion of AD 43, it marked the extent of the land then conquered by the Roman army.

Here the Fosse Way is now no more than a track, and there is only a ford and a narrow footbridge across the river. While this section is mainly used by walkers only these days, it has served an additional purpose for over a thousand years, forming the county boundary between Gloucestershire and Wiltshire.

A footpath leads from close to this crossing to the village of Brokenborough. It takes less than a mile to get there, but the river covers twice the distance because of its looping course. Brokenborough is the only village beside the Tetbury Avon and is strung along several lanes on high ground overlooking the river. Although we are in the Cotswolds, the landscape here is not hilly and has the feel of a plateau into which the river has dug itself a narrow channel in a similar fashion to the 'other' Avon at Sherston.

5 miles away from Tetbury, the Avon that bears its name reaches Malmesbury. Another hilltop town, two watercourses run around Malmesbury's western and eastern sides before uniting to continue south. In this case the two rivers are the Sherston and Tetbury Avons.

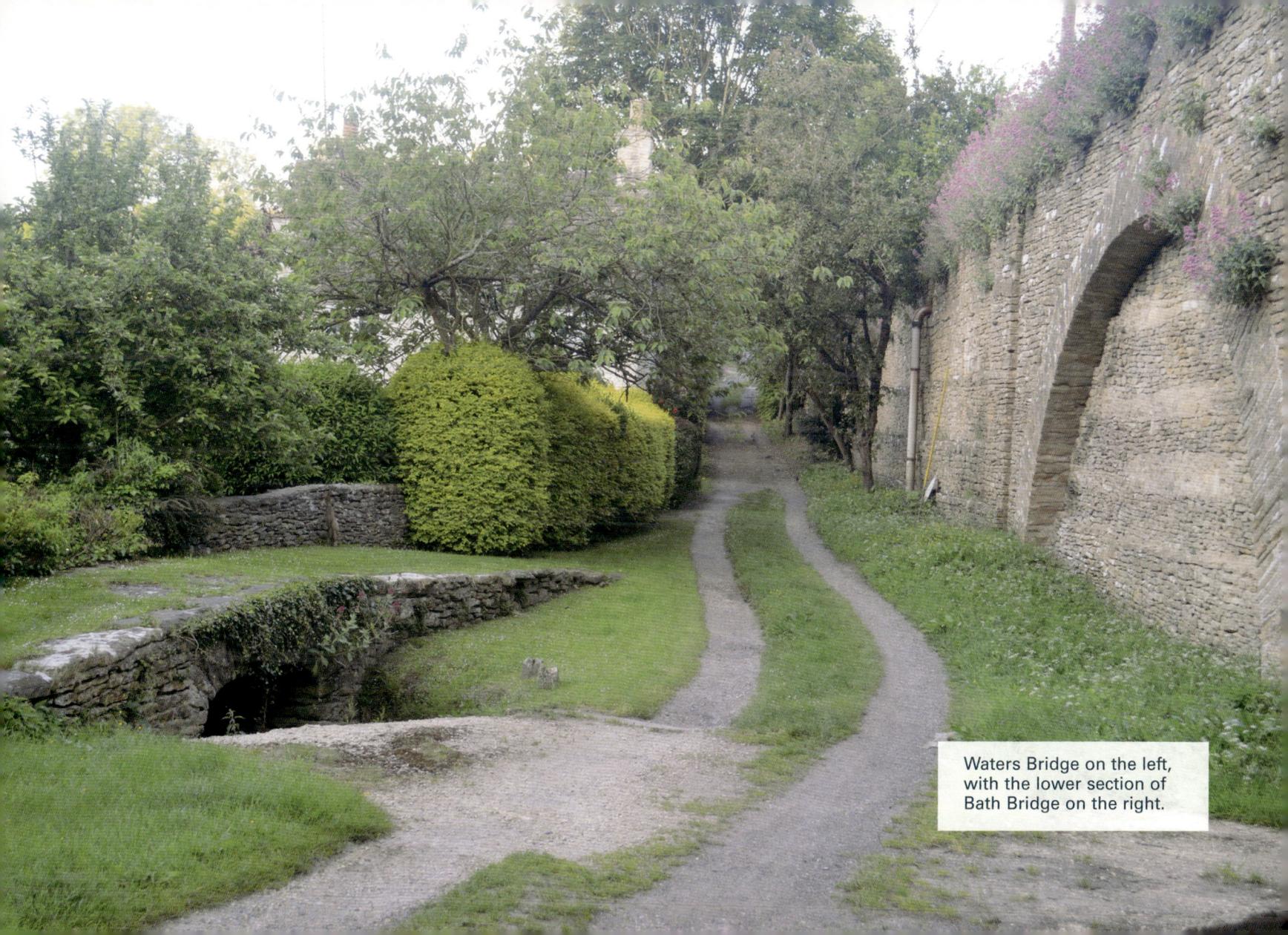

Waters Bridge on the left, with the lower section of Bath Bridge on the right.

Malmesbury's hilltop location looks strategic, and indeed the town was fortified in Saxon and medieval times, but today nothing of these defences survives above ground. Of the town's more spiritual element, fortunately there is still plenty to see.

It is thought that Malmesbury's abbey was founded in the seventh century by an Irishman whose name has various spellings such as 'Maildubh' and 'Maelduf'. Then, in around 700, the Saxon saint Aldhelm, who we will meet again at Bradford-on-Avon, became abbot. The building that we see today, though, is part of a major rebuilding in the twelfth century and, while today the abbey alone makes a visit to Malmesbury worthwhile, what we see today is only a small part of a much larger cross-shaped building. Some of this was demolished after the Reformation, but a central tower had already collapsed around 1500. A few decades later a western tower did the same thing.

There are three particular features inside that deserve special mention. One is the interior of the porch, with carvings dating from the building's construction that are some of the best surviving Romanesque art in this country. Then there is the empty tomb of the Saxon king Athelstan, who died in AD 939 – he was Alfred the Great's grandson and continued the reclamation of land taken by the Danes. My personal favourite is a stone box high up on the south side of the nave. One interpretation is that this was where

The Fosse Way fords the Tetbury Avon.

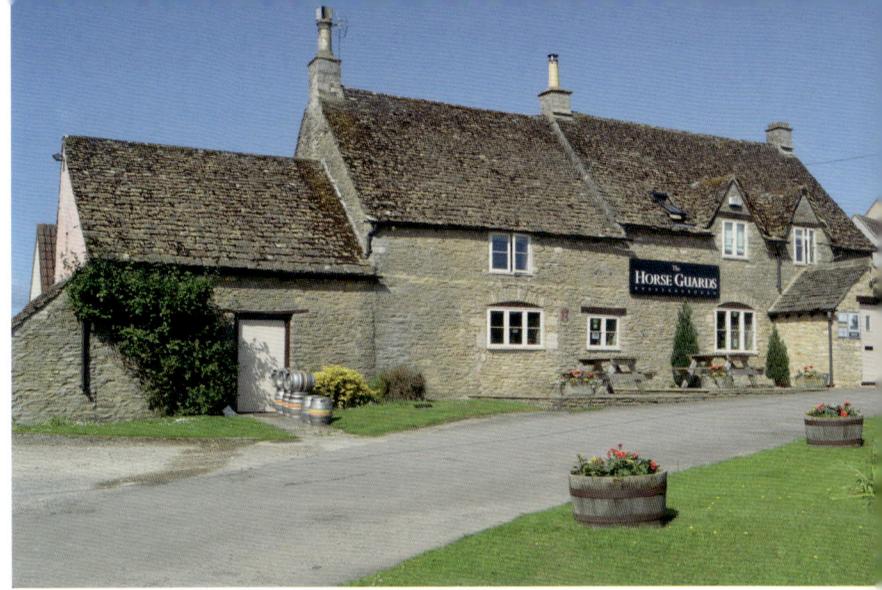

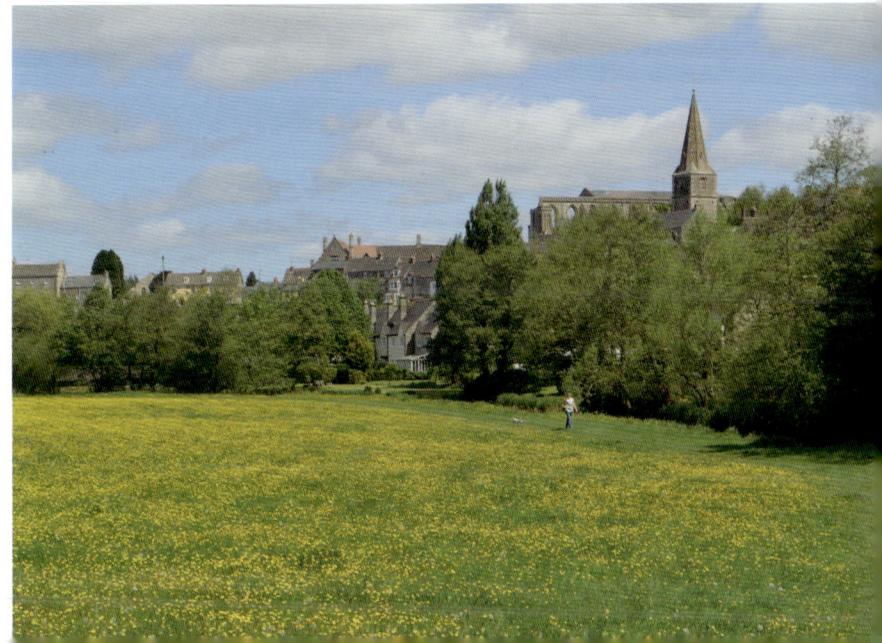

Above left: The 'plateau' landscape near Brokenborough.

Above right: The Horse Guards pub in Brokenborough.

Below: The tower of St Paul's and behind it the Abbey, seen from meads across the Sherston Avon on the west side of Malmesbury.

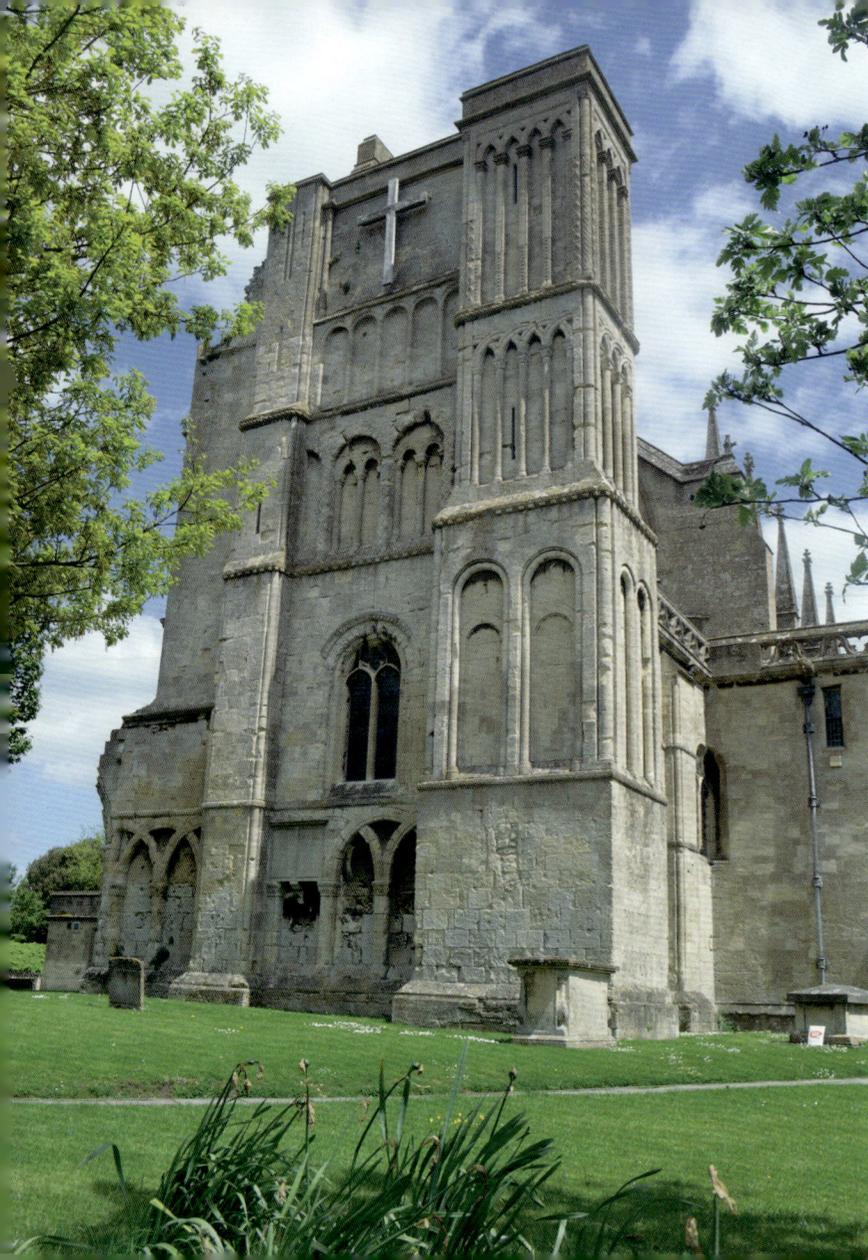

the abbot prayed, but there is another view that it was a lookout, perhaps to catch those nodding off during services!

Having said that the abbey alone justifies the visit, I have to add that Malmesbury has a lot of other historic buildings, including more than its fair share of medieval ones, and other attractions. The following is not an exhaustive list!

Immediately to the west of the abbey, part of the Old Bell Hotel was the abbey's thirteenth-century guest house. Then, round at the south-west corner of the abbey's churchyard, there is an isolated tower – this belonged to a church called St Paul's that was built in the fifteenth century. In the following century a mirror image of what happened to the abbey occurred here – the church collapsed and the tower survived! It might seem odd to have another church so close to the abbey, but it was generally the monks who worshipped in abbeys, and the townspeople had their own churches.

To the east of the abbey there is Abbey House gardens, a paid-for attraction with a variety of floral displays and specialist events.

Round to the south-east in the little square between the abbey's churchyard and the top of the high street there is the Market Cross, built around 1500 in the Perpendicular style to provide shelter for those buying and selling at the market here.

Malmesbury Abbey from the west.

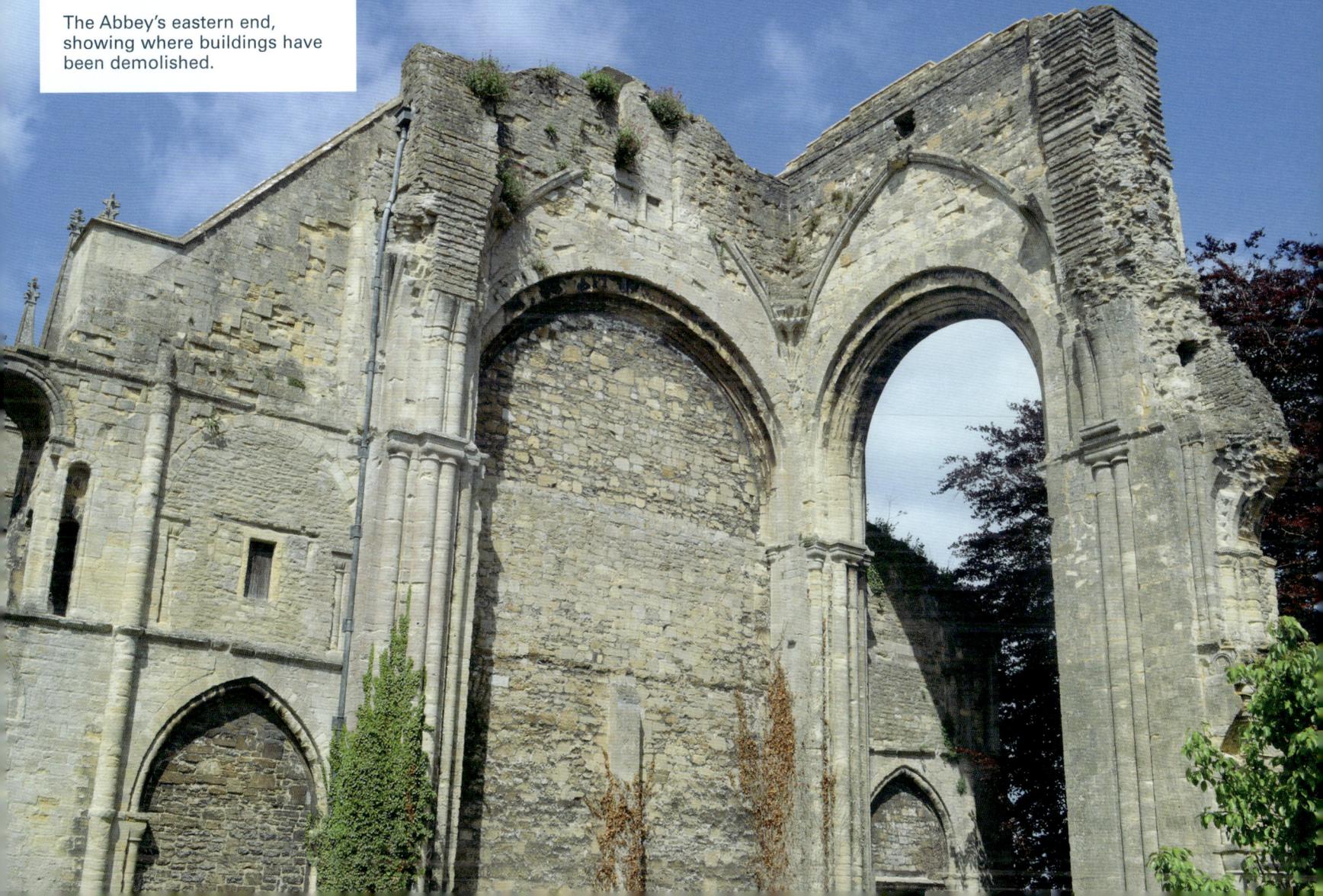

Above: The Old Bell Hotel.

Left: The tower of St Paul's church.

Further to the east there is the Tower House at the junction of Oxford Street, Holloway and Cross Hayes. This is a late fifteenth century hall house, to which a tower was added in 1834. There is a statue of a meditating monk in the trees opposite, which can catch you unawares if you don't know it is there, and round the corner in a square there is the town hall and the local museum – the latter named after Athelstan.

A fascinating array of historic properties can be seen along the high street, and at the bottom of the hill this descends there are St John's Almshouses. These took on this function just before 1600 – the building had previously been the hospital of St John of Jerusalem, of which the late twelfth century entrance survives.

Further out of the town there are some excellent riverside walks, and one interpretation board names all the town's twenty bridges that cross the Sherston and Tetbury Avons and the joined-up version.

On the north side of the town there is the Conygre Mead Nature Reserve beside the Tetbury Avon, and nearby, in another parallel with Tetbury, there is the site of Malmesbury's railway station, which was again at the end of a branch line. This carried passengers between 1877 and 1951, and connected with the main line at Dauntsey, around 7 miles to the south-east.

Malmesbury's Market Cross.

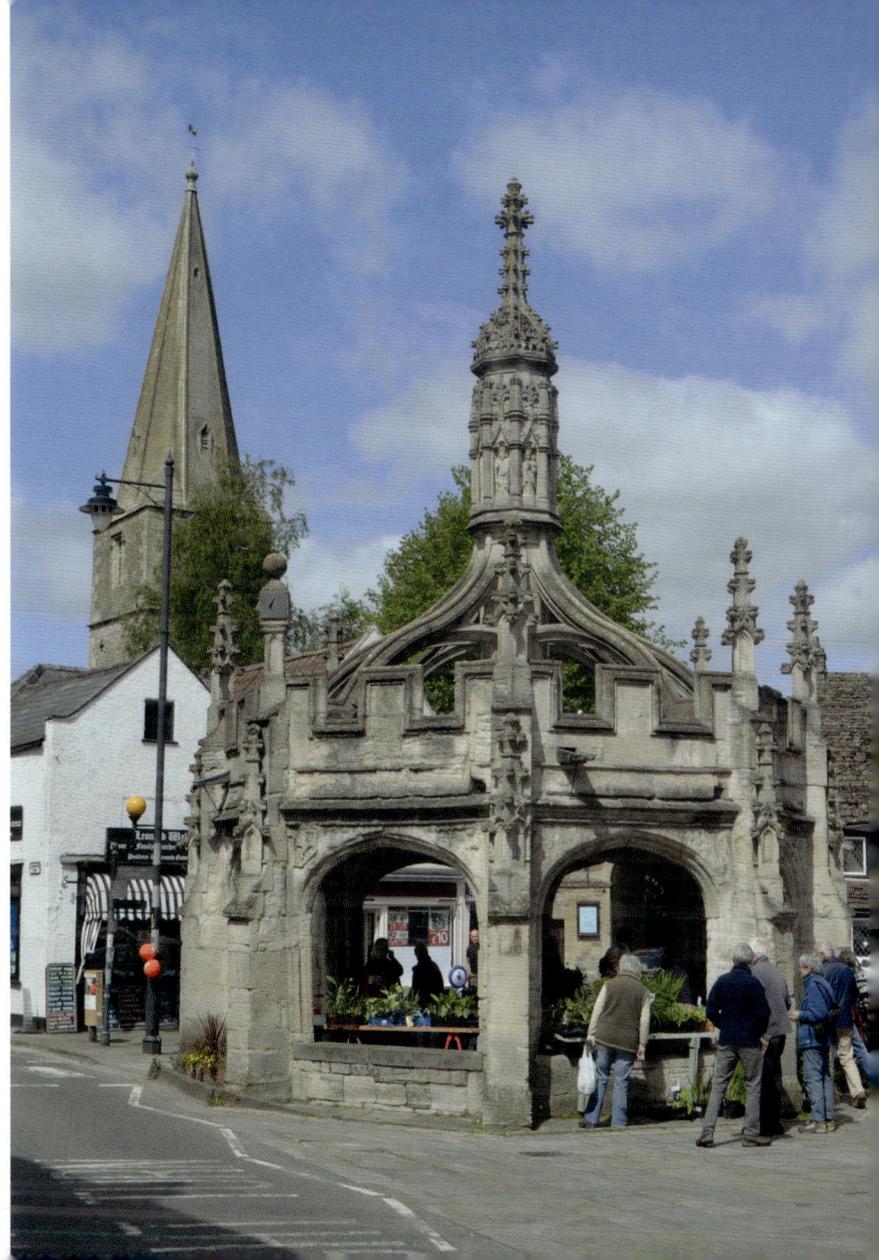

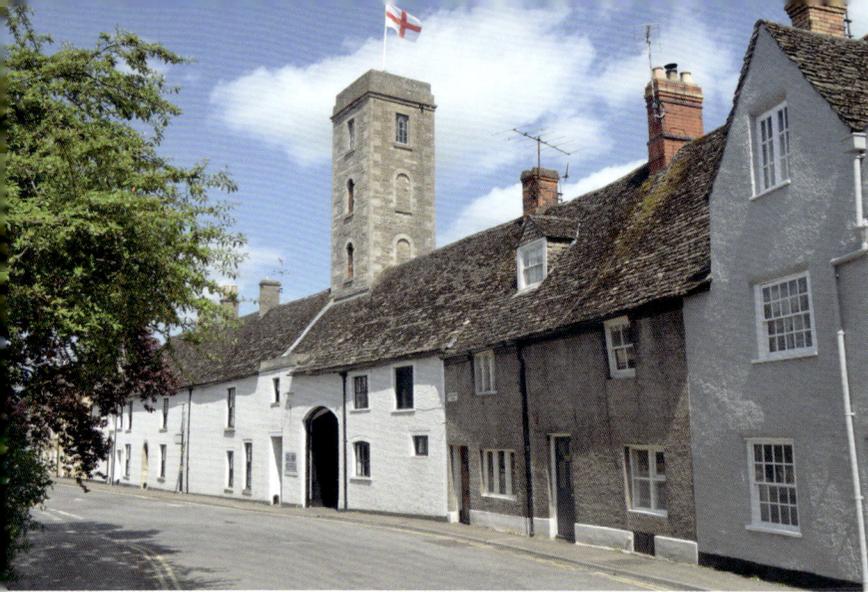

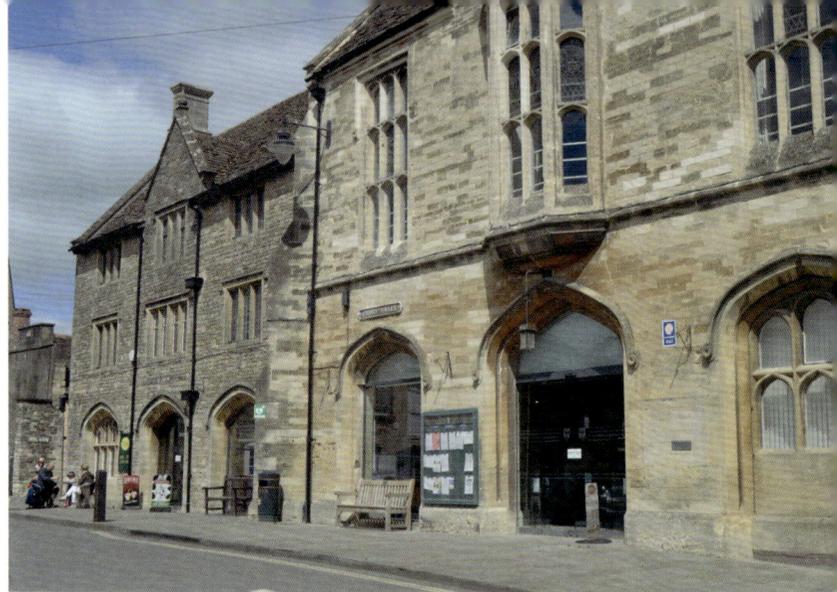

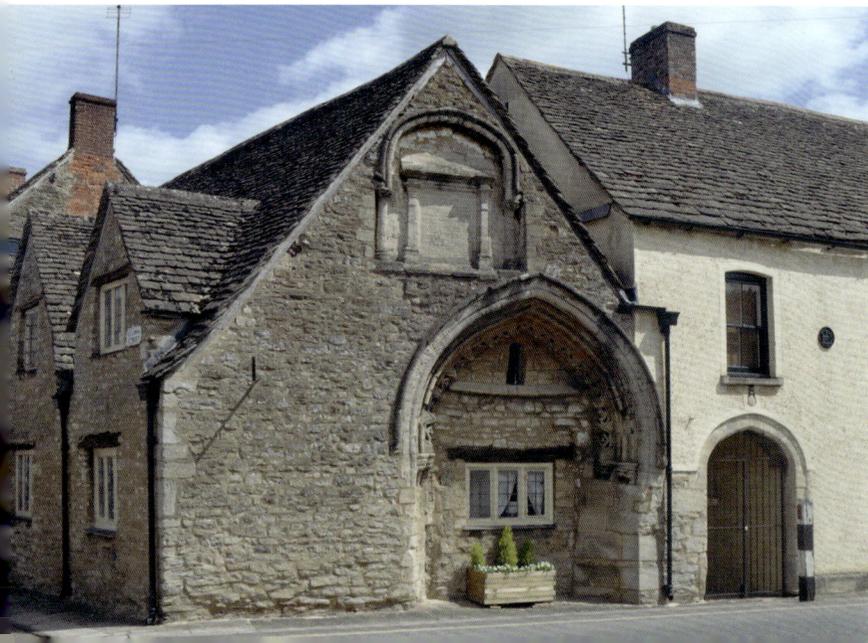

Above left: The Tower House.

Above right: The town hall and Athelstan Museum.

Below: St John's Almshouses.

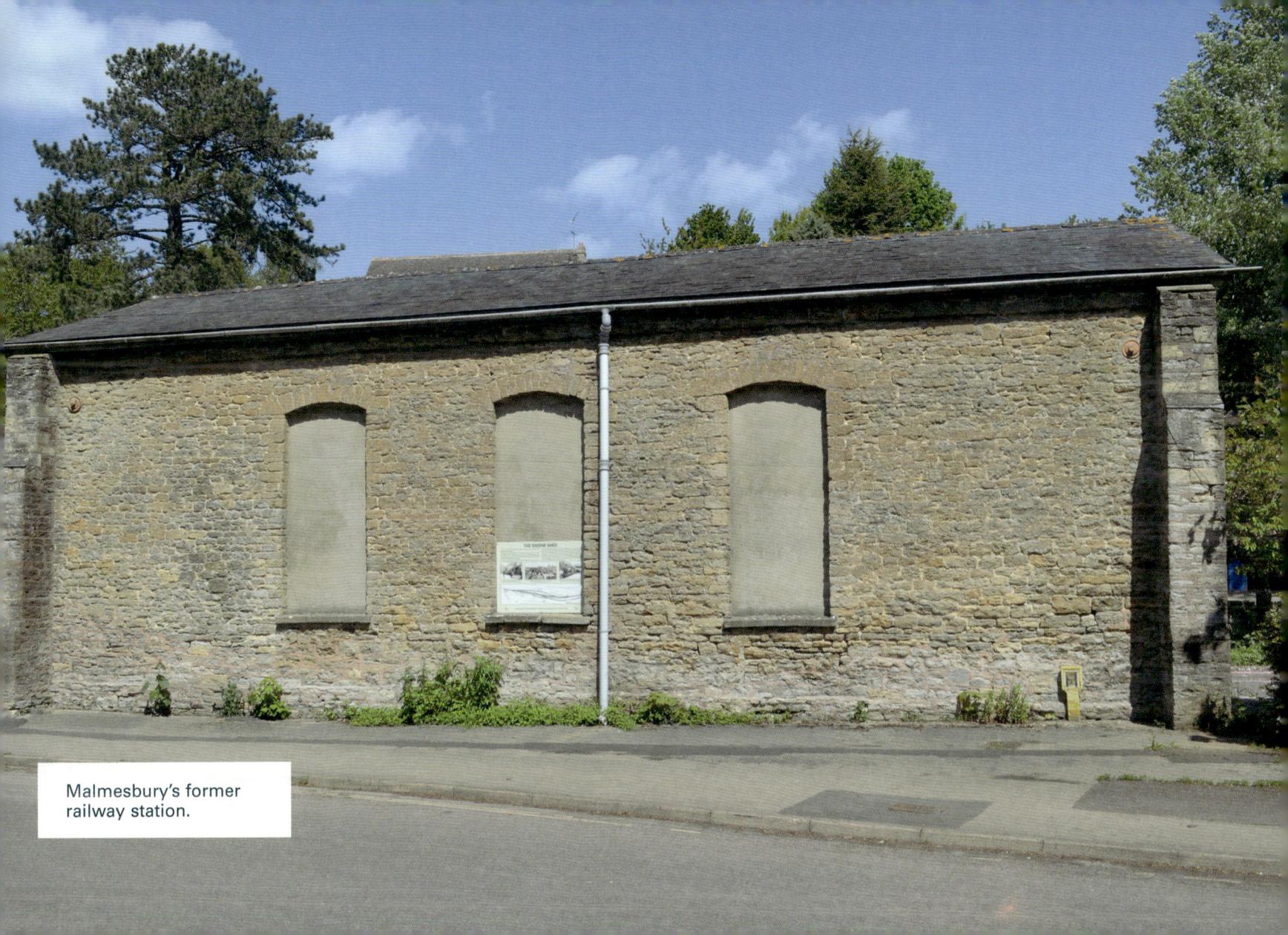

Malmesbury's former
railway station.

THE WIDER VALLEY THROUGH WILTSHIRE

After the hilly Malmesbury, the now-united Avon flows through what soon becomes a broad valley, with the Cotswolds still present to its right (and towards the west), and the Marlborough Downs and their outliers to the left. Despite the proximity of these hills, there are some places in the valley where you feel that you are looking across an unbroken plain.

Now, the underlying geology is clay, and the Avon flows more slowly. Most of the natural wetlands that would form in these circumstances have been removed by modern farming methods, and river levels are often lower than their natural level because water is abstracted for agricultural use.

Other watercourses join the Avon from both sides at intervals through the vale, but by now they are clearly tributaries and we no longer have to worry about which is the real river!

Along the course of the Bristol Avon the towns are generally beside the river. This is particularly noticeable as the river passes through north-west Wiltshire – Chippenham, Melksham and Bradford-on-Avon are all next to the river. Trowbridge might be considered an exception, but it is actually not far away and on a tributary, the Biss.

I think there are three reasons for this:

(i) The towns grew up at bridges or perhaps fords, where tolls could be charged and rest and refreshment offered.

(ii) They took advantage of the relative ease of water transport for trade and travel (in an age when the good roads of the Romans were usually decayed, and where the existing routes were slower and subject to robbers).

(iii) The river was used to power mills.

This is not the case for villages in the area, which were more attuned to agriculture in the fertile lands of the valley

and are generally more spread out. Let us have a look at one of the villages in a little more detail.

Great Somerford lies about 3 miles south-east of Malmesbury. Much of the fabric of its parish church dates from the fourteenth and fifteenth centuries. The building is set some way back from the road, allowing for a lovely ornamental approach (as at Luckington back on the Sherston Avon). Hidden away to the left there is a house called The Mount that dates back to the sixteenth century, and there an outbuilding of the same age that can be seen clearly from the approach to the church. This is constructed of noggin, that is, with a timber framework filled with bricks.

A mound in the garden of The Mount to the west of the church is the motte of a Norman castle, probably built in the twelfth century. In this location it commanded views across the valley and could have controlled any river traffic – although this is hard to envisage today because of intervening trees.

The road north from the village crosses the Bristol Avon, and just beyond the river it was itself crossed by the railway branch line coming from Malmesbury. This had already gone under the main line from London to South Wales and was heading to Dauntsey, where it joined the one from London to Bristol.

Two miles to the south-west of Great Somerford the river goes under the M4, which runs between South Wales and London. This section was opened in 1971, and in the same year all of the English part of the motorway was completed.

A mile or so further on there is a pair of villages about a mile apart – Sutton Benger on the west side of the river and Christian Malford to the east. In the latter there is Malford Meadow, which lies beside the river. An information board at the entrance explains the local geology, fossils and fishing. It also clears up any confusion about the village's name, which sounds rather like that of a person. It comes from a cross at the ford here, hence Cristes-male-ford (Christ's mark ford).

A few miles downriver we are almost at Chippenham, but before going into the town we first encounter a person who left a very singular mark on the landscape and then take a short diversion.

When Maud Heath died in 1474, she left money for the construction and future maintenance of a causeway along the route she used to take from Bremhill up above the east side of the valley to Chippenham, where she sold her eggs in the market. We can perhaps glean two facts from this: firstly, that she must have been an extremely good businesswoman to make the amount necessary, and, secondly, that she had so disliked the damp routes she had been forced to use across the valley that she decided to help those who came after her in this endeavour.

The south-eastern end of the causeway near Bremhill is marked by a monument. It requires a good map to help you find it along a footpath that leaves a road by the outlying

Above left: The view at Little Somerford, a mile north of Great Somerford.

Above right: Great Somerford's parish church and timber-framed building.

Below: A view along the M4, looking eastwards from the bridge taking the road between Great Somerford and Sutton Benger across the motorway. The larger of the blue signs on the left marks the spot where the motorway crosses the Bristol Avon.

Christian Malford parish church.

hamlet of Wick Hill, but the search is worthwhile. It is a sizeable structure, and a seat at the base allows you to rest while enjoying the view westwards across the valley, including the route of the causeway. An inscription on the monument states that it was erected in 1838 at the expense of 'Henry, Marquis of Lansdowne, Lord of the Manor' and William Bowles, the vicar of Bremhill. They are described as 'trustees', presumably of the causeway. I will not inflict upon you the poem added by the Reverend Bowles.

Much of the causeway is marked today by a slightly raised pavement by the side of the road travelling from Bremhill to Chippenham, although modern tarmacking has, in places, brought the road up to the same height as the causeway. The western end is by a bridge across the Avon, with a well-preserved raised section running from a chapel at the hamlet of Kellaways; there, the causeway is its own bridge across low-lying ground. There is another monument near this end, which was erected in 1698 and includes in its inscription the request (or maybe order) 'Injure me not'.

Next we will make a short diversion to look at some of the features of the River Marden, which is a good example of the tributaries crossing the open landscape of the valley in this part of Wiltshire.

The Marden rises near the village of Calstone Wellington, 2 or 3 miles south-east of Calne below the high chalklands of the Marlborough Downs. There are several other streams (tributaries of a tributary, you might say) that flow in generally from the north-east, as well as the overspill from Bowood Lake in the grounds of Bowood House that joins from the south. The river flows slightly north of west, joining the Avon just east of Chippenham. A direct line from source to confluence that is about 6 miles long – the actual length of the river is perhaps closer to 8 miles.

Once more we find a disused railway. This line linked Calne to the Great Western Railway's London–Bristol line at Chippenham and for much of its course ran along the bottom of the Marden valley just south of the river. It was built by a private company and it took a fair amount of argument, and then three years of actual construction work, before it opened in 1863. In the 1870s it was sold to the Great Western Railway, then, in common with the rest of that railway, it was nationalised after the Second World War. The line closed in 1965, and today a cycleway follows much of its route to fulfil the same purpose of linking Chippenham and Calne.

The site of Stanley Abbey lies about halfway along the course of the Marden. This was founded as an offshoot of the Quarr Abbey on the Isle of Wight, and belonged to the Cistercian Order. It began in 1151 at Loxwell – a couple of miles to the south-west on the other side of Derry Hill – before moving to the present site, half a mile from the village of Stanley, in 1154, where it remained until it was closed in 1536 during Henry VIII's Dissolution of the Monasteries. Other than earthworks, no visible remains of the abbey survive.

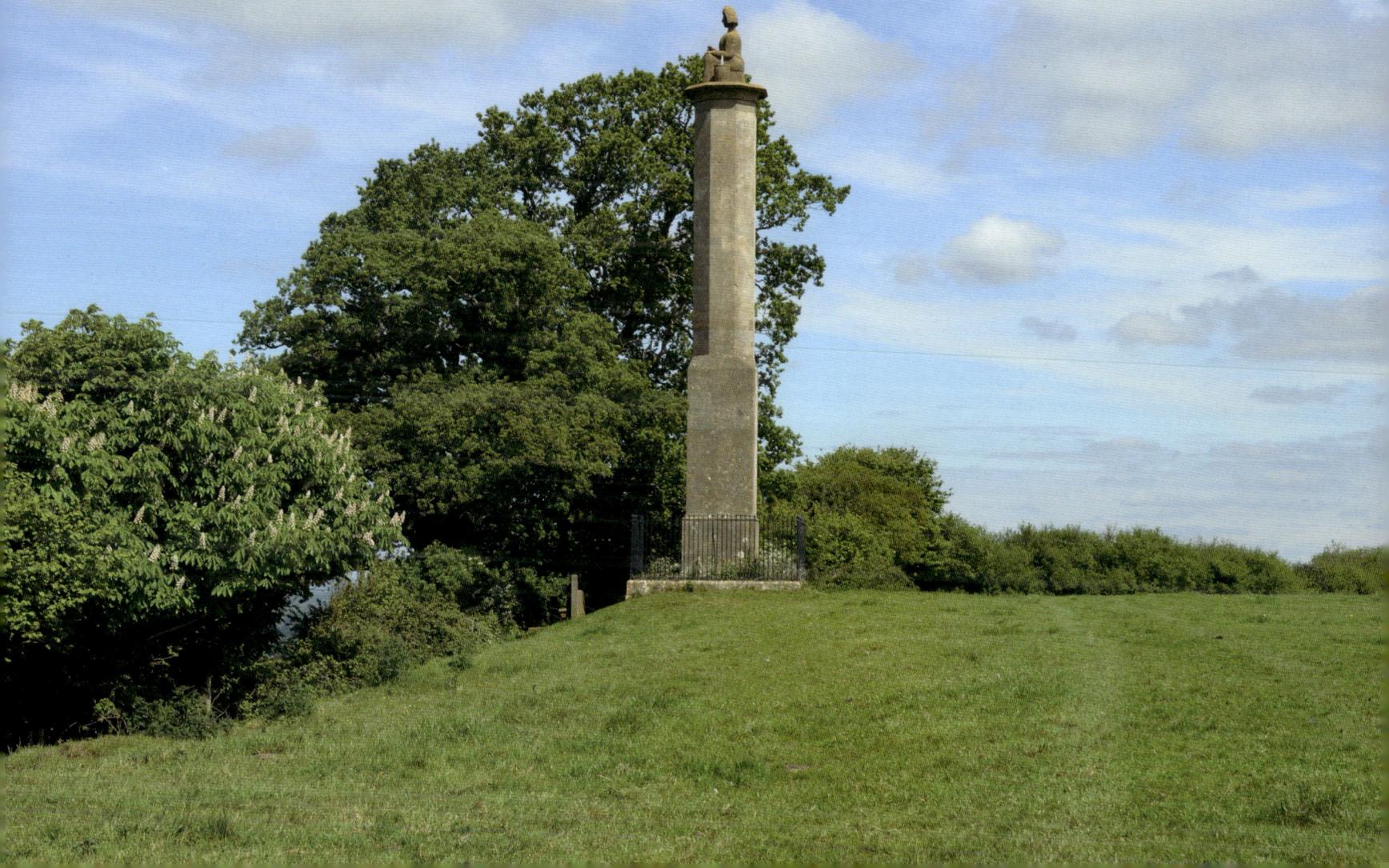

The monument at the Bremhill end of Maud Heath's Causeway.

The view from the base
of the monument.

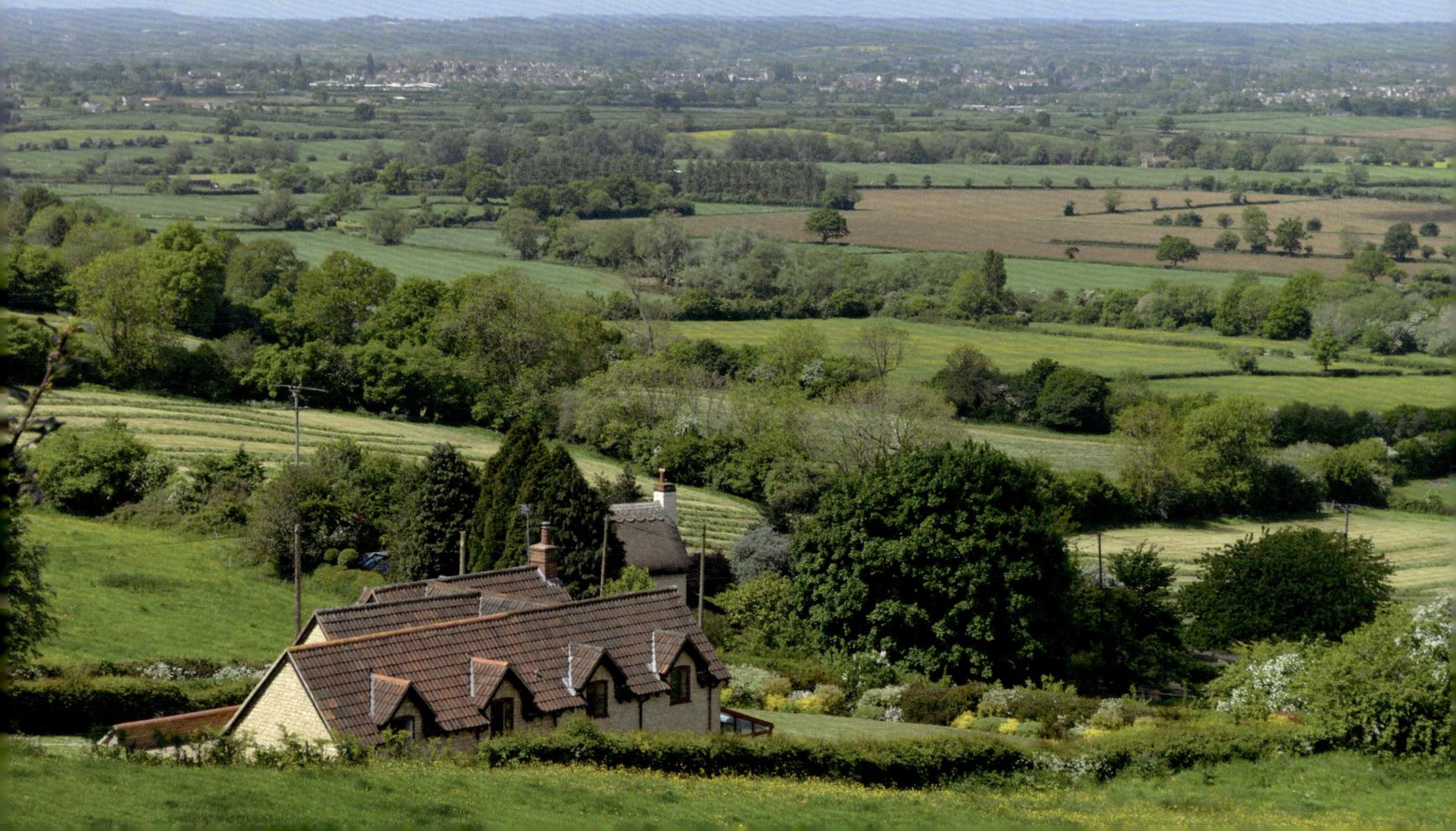

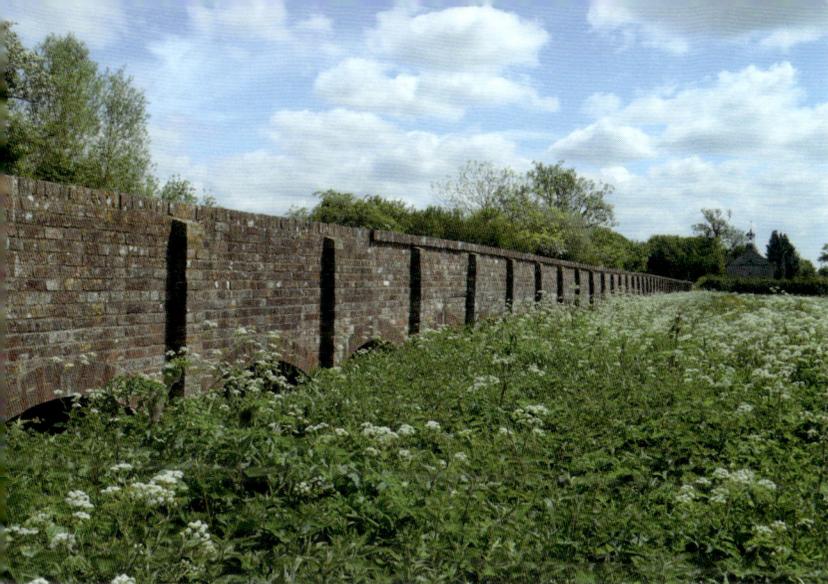

Above: The raised causeway at the western end, near Kellaways.

Right: The monument at the Chippenham end of the Causeway.

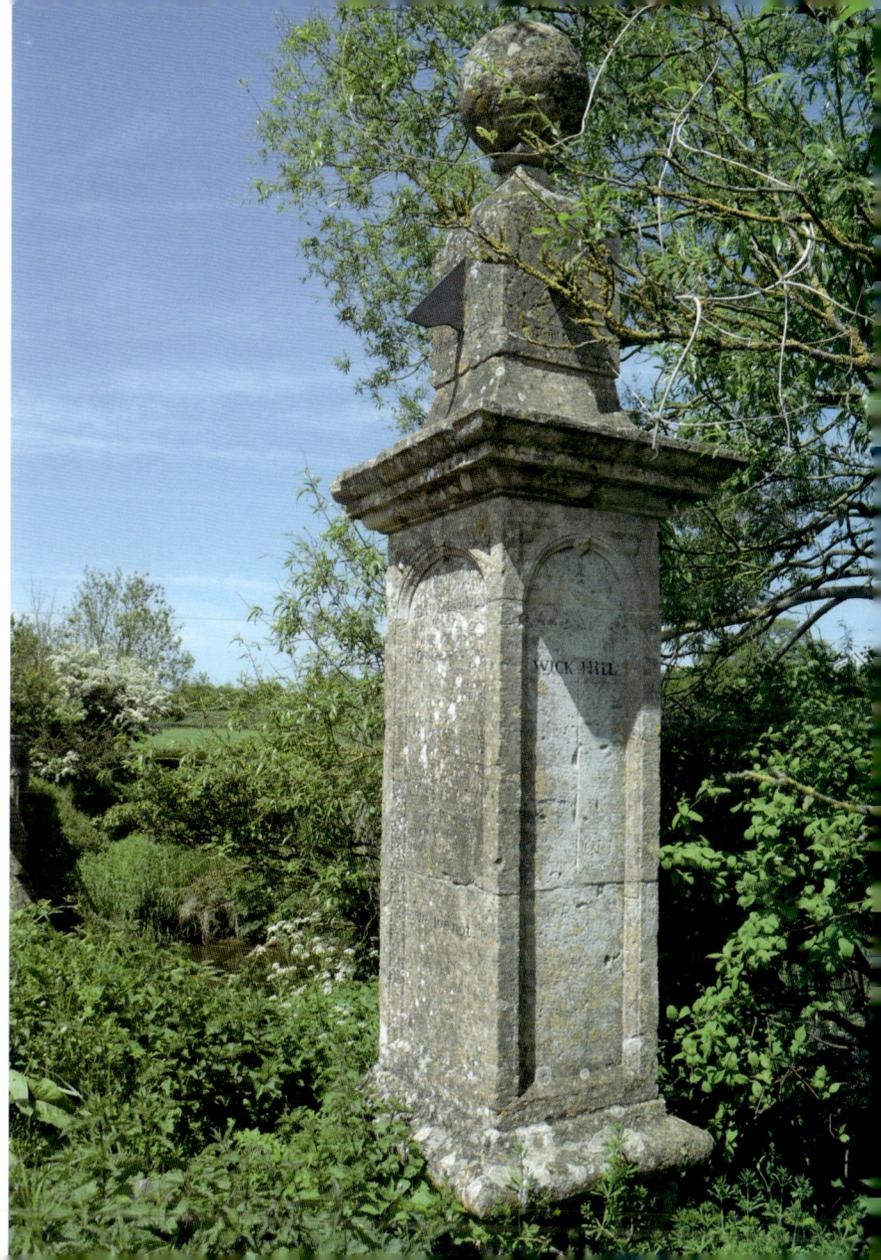

The view from the bridge at the Chippenham end of the Causeway, with the London–Bristol railway line.

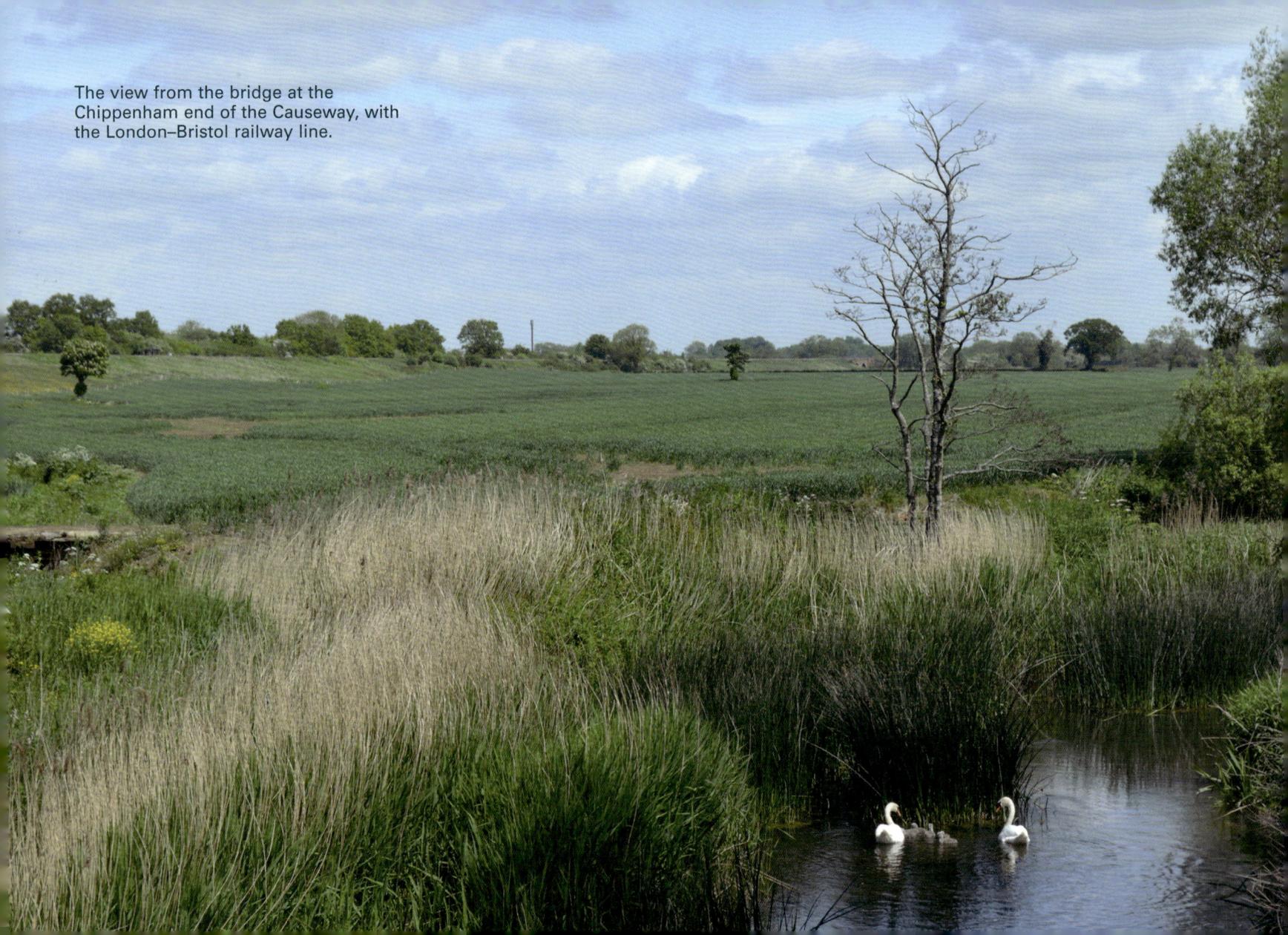

Above: The landscape near Bowood House, with the Bristol Avon's valley in the distance.

Right: The River Marden.

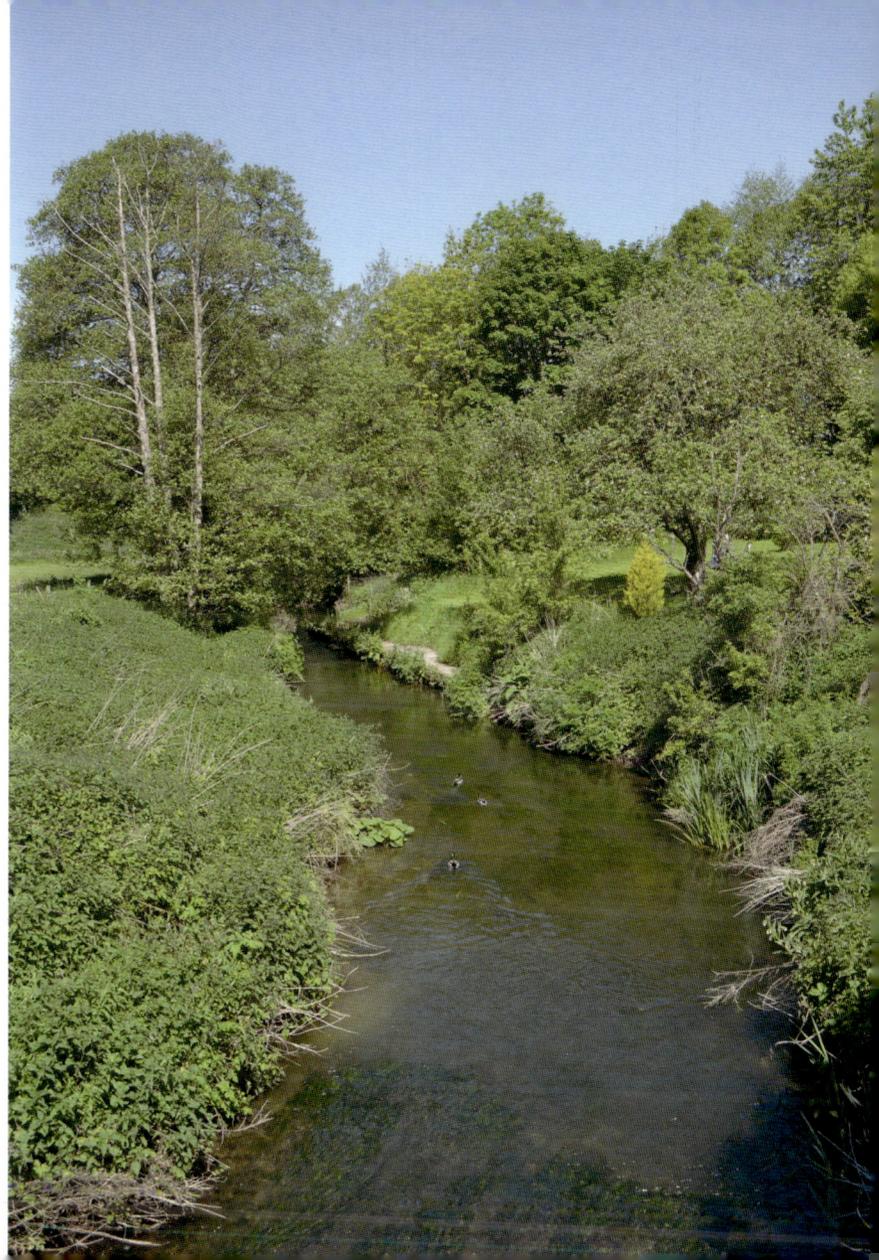

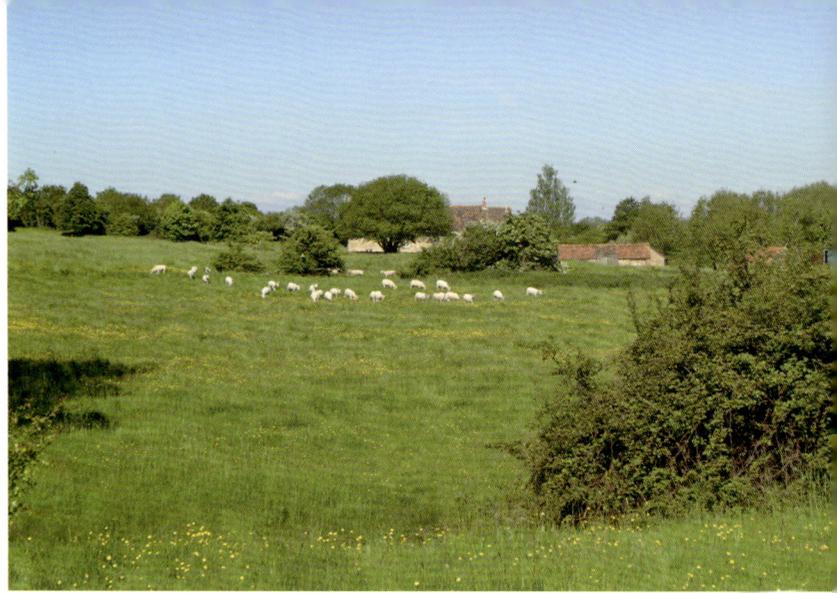

Above: The site of Stanley Abbey.

Left: The cycleway on the former Chippenham–Calne railway line.

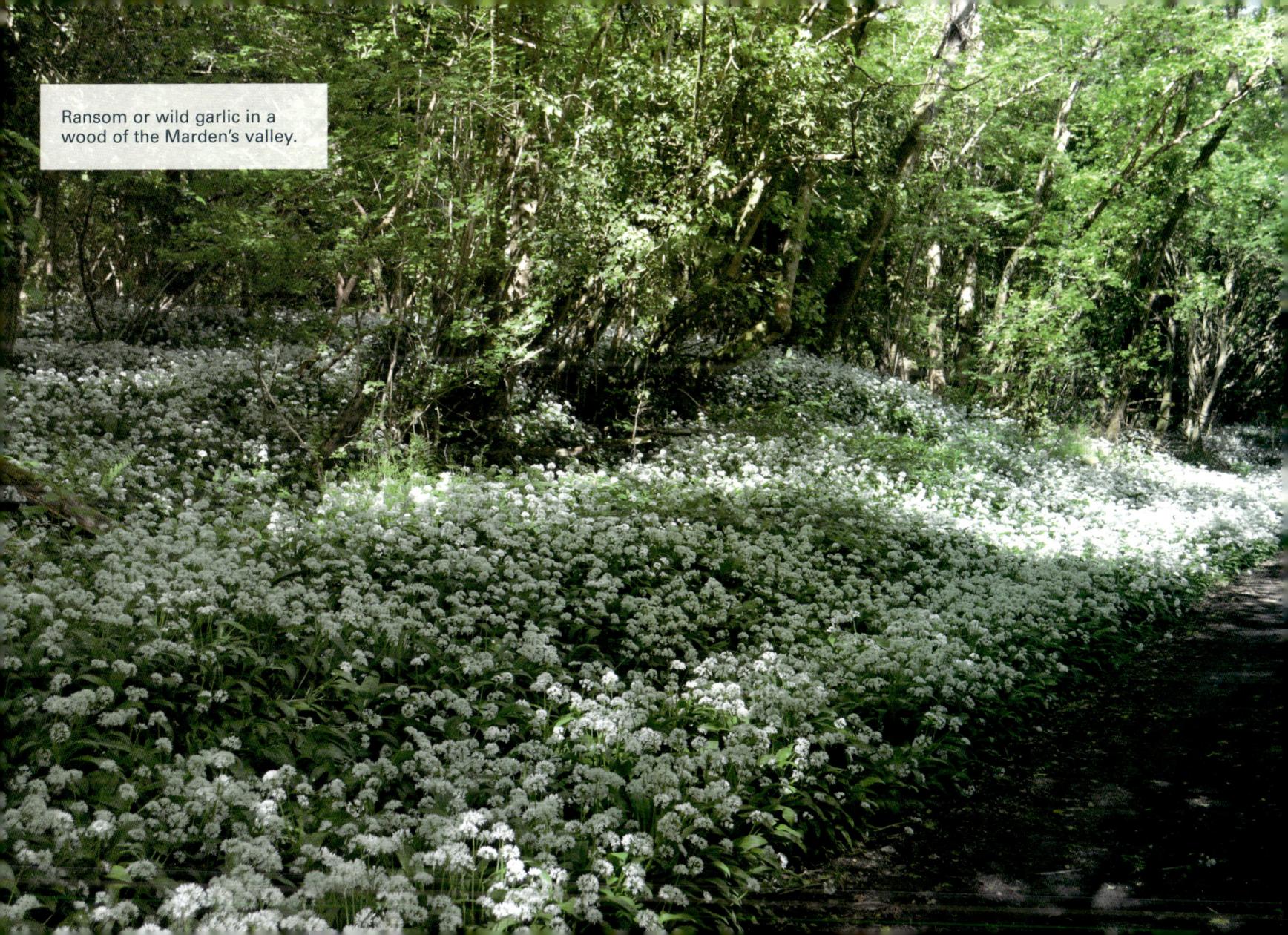

Ransom or wild garlic in a wood of the Marden's valley.

Back on our course along the main river, we have now reached Chippenham. A pleasant town to explore, Chippenham has lots of historic buildings, especially around the old market place, and, beside the river, a park that was made for strolling in.

Today it is an extensive town of some 35,000 people, but if you could strip away all the nineteenth- and twentieth-century development you would see that the original town occupied only a small area within a loop of the Bristol Avon. It grew as a river crossing in Saxon times and also thrived as a market town, and in modern times has particularly expanded across the flat landscape to the north-west, on the opposite side of the river from the old town, where it has engulfed what was once the separate settlement of Hardenhuish.

At this point we will have a look at some of the main historic features, beginning with the old market place. The central area of this was originally open and is called The Shambles, an old name for a butcher's premises. These were seen as messy places with blood everywhere, hence our modern 'shambles' meaning an event that has gone horribly wrong. The Shambles was built upon in the nineteenth century, but next to it a lovely old building, called Yelde Hall, survives. This is a timber-framed medieval building dating from the early fifteenth century that was originally a market and meeting hall, and which has also served as a prison and fire station in its time.

Across the market place there is a large and prominently sited war memorial constructed in 1920, with an urn added in the 1990s to commemorate a local councillor. To one side there is a pleasing view of the parish church's tower that was built in 1633 and a row of town houses that display the wealth of some of the town's Georgian inhabitants.

The fourth side leads into the high street, where there is the Angel Hotel. A plaque on the front states that this was an 'important eighteenth-century coaching inn', and though the building's frontage dates from that century, most is actually of the seventeenth century.

Nearby, in the pedestrianised high street, is the Buttercross. This was the central shelter in the old market place, and the present structure dates from the eighteenth century, although there was such a feature in the market place for maybe a century longer. In 1889 its location was to be built on, as referred to above, and so the Buttercross was sold to the owner of Castle Combe Manor – a lovely village some 5 miles away to the west – who used it as a garden feature. It was brought back to the town in 1995 and set up in its present location.

Heading down the high street we pass a tall and rather flat-looking Victorian building that looms above us at the bottom reach the Town Bridge. Sadly much of the medieval bridge, with its eighteenth-century ornamentation, was demolished when the road across it was widened in the 1960s.

Above The Bristol Avon at Chippenham.

Right: Yelde Hall.

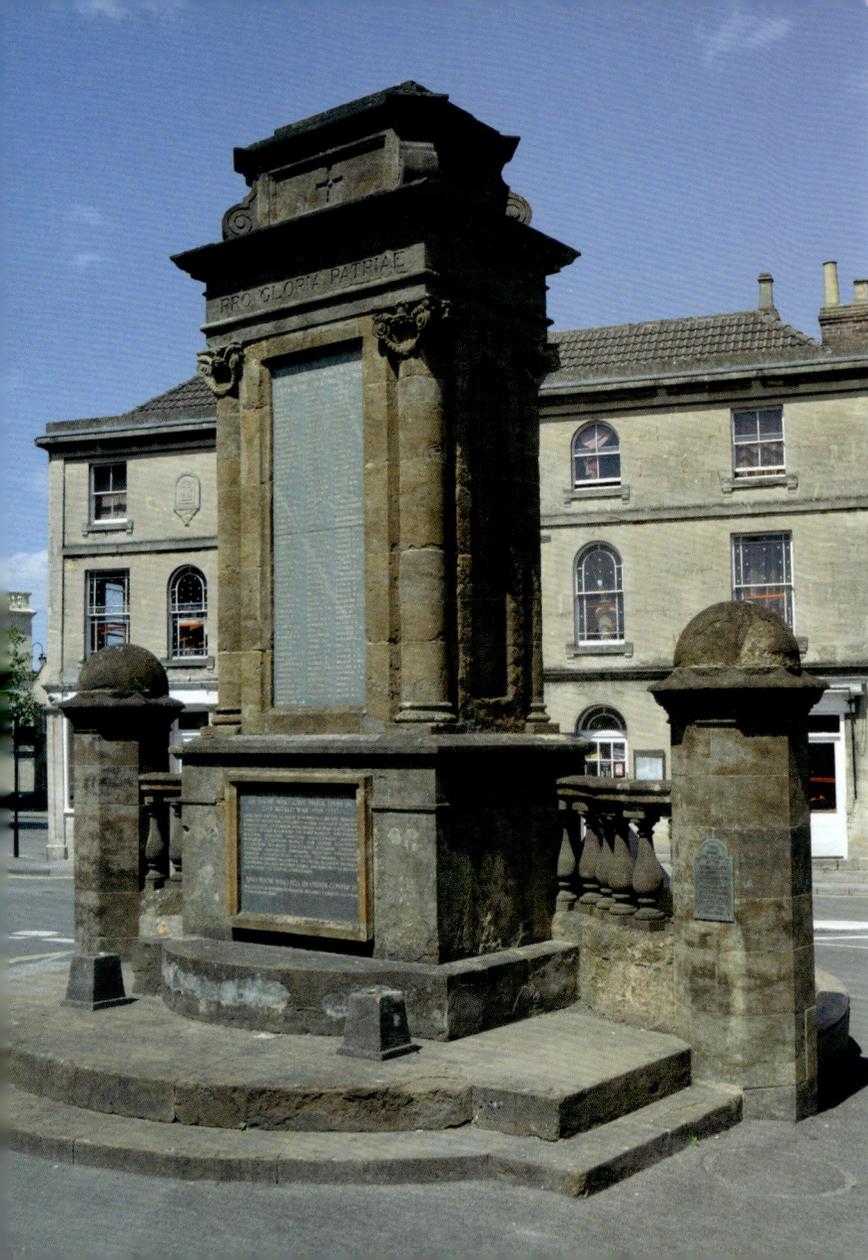

Above: The Georgian town houses and the parish church.

Left: Chippenham's war memorial.

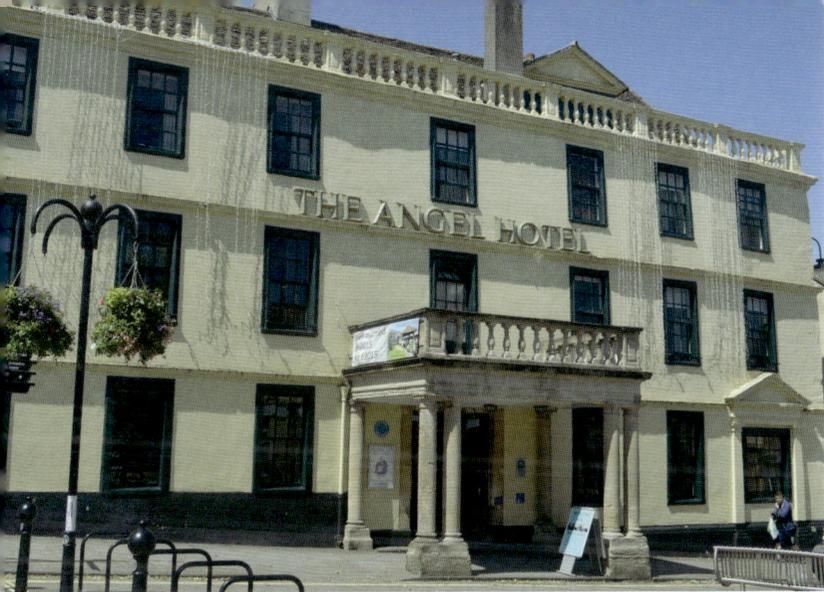

Above left: The Angel Hotel.

Above right: Chippenham's high street.

Below: The Buttercross.

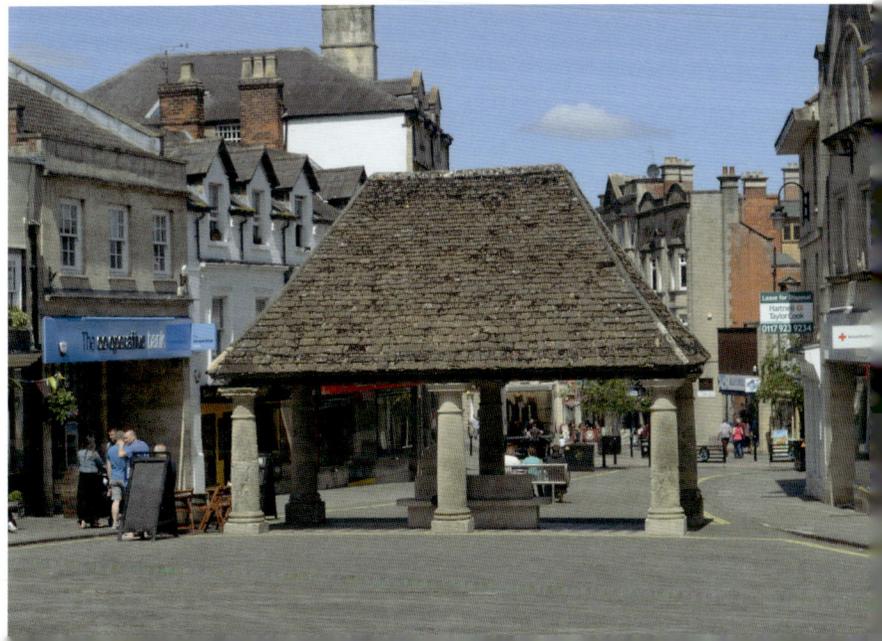

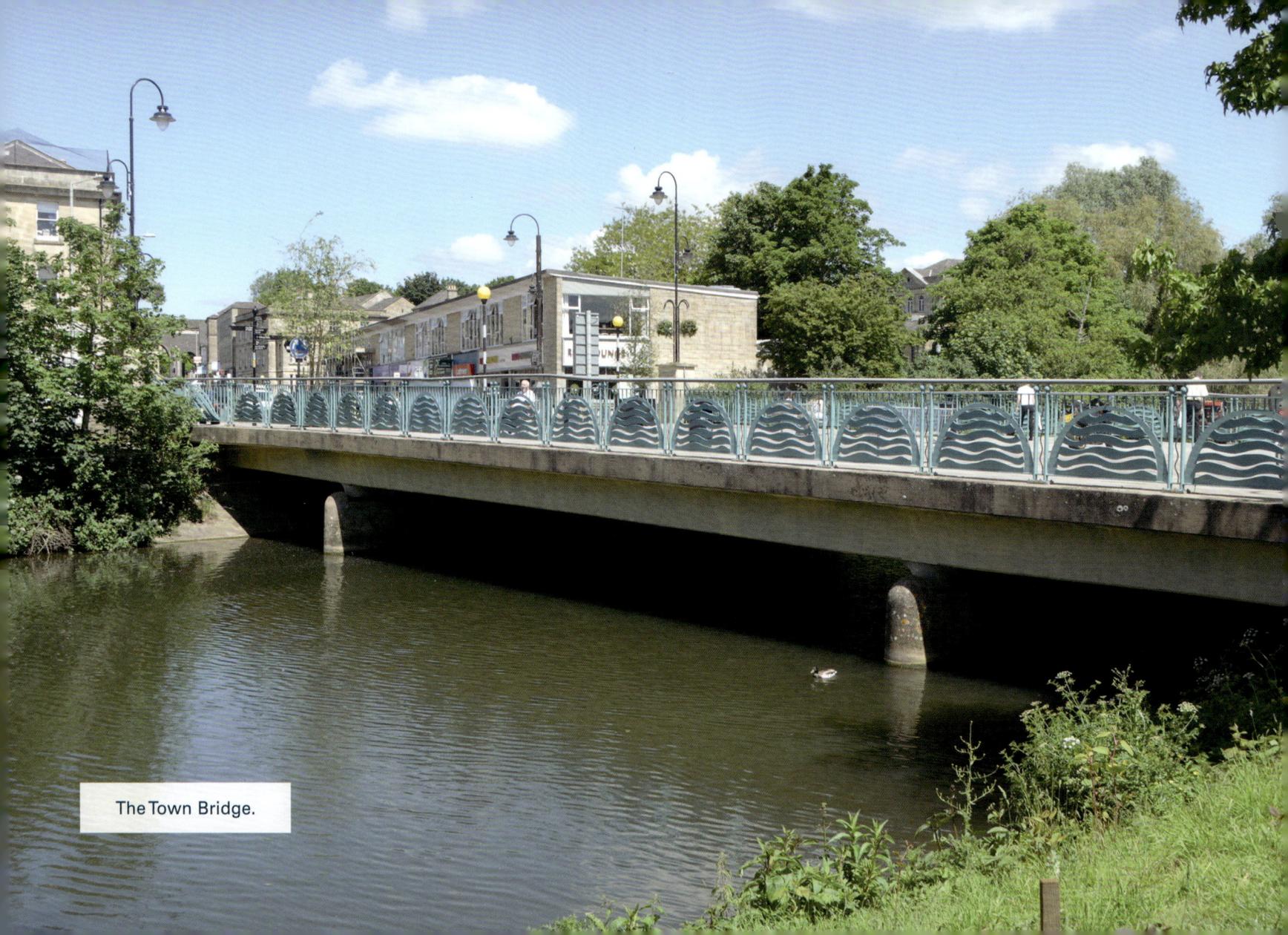

The Town Bridge.

One final thing to mention about Chippenham before we leave is its importance as a railway town. Not only was it an important stop on the London to Bristol line, but it was also the start of the line built by Isambard Kingdom Brunel in the 1850s that ran through Melksham and Trowbridge and on to the south coast at Weymouth.

After leaving Chippenham, the river loops around Lackham Farm, one of the four campuses of Wiltshire College and a working farm for agricultural training of students. It is also around here that the eye is drawn to several overhead power lines that criss-cross above the flatlands of the valley.

On the other side of the loop another watercourse appears a little way up the hillside to the south of the river. This is our first encounter with the Wilts & Berks Canal, which is always referred to in this abbreviated form. We will find out more about the canal later, but here I will just mention one feature on the stretch we are passing. This is the Double Bridge, reopened in 2009 by the Duchess of Cornwall after restoration by the Wilts & Berks Canal Trust. It is so-called because it is twice as wide as other bridges on the canal, possibly because two landowners were in dispute when the bridge was built, and so each was given their own 'lane' across it.

A little further on we pass the hamlet of Reybridge, named after the eighteenth-century Rey Bridge that crosses the river here. There is a very attractive pair of cottages by the bridge, which are of a similar age.

While Wiltshire is rightly renowned for the attractiveness of its villages and the high survival of historic buildings in them, the next settlement we come to is a real gem, even by this county's high standards. We will start our inspection of Lacock on the south-east side of the village, where the Bristol Avon is crossed by what seems like an extremely long bridge. It is actually two bridges with a causeway in between, and some of the structure dates from the late Middle Ages. The length of this feature testifies just how much land must have been subject to regular flooding in the days before modern drainage.

From here we get views of Lacock Abbey and its grounds. The abbey was actually a nunnery, founded in the thirteenth century by Ela, Countess of Salisbury, where the nuns belonged to the Augustinian order. Before the Dissolution of the Monasteries, Henry VIII had declared himself head of the church in England and so considered that the religious houses and all their lands were his to sell. This was also rather convenient, since around this time he had an expensive war to fight in France, and was planning to build forts along the south coast to fend off any French raids.

In the case of Lacock, he sold the abbey to Sir William Sharington, who knocked down the abbey's church, converting and extending its cloister into a house for himself. Later owners made further alterations, including members of the Talbot family in the eighteenth century.

In the nineteenth century the house, which retained the name of Lacock Abbey, was the home of William

Above: Double Bridge.

Left: The Wilts & Berks Canal seen from Double Bridge.

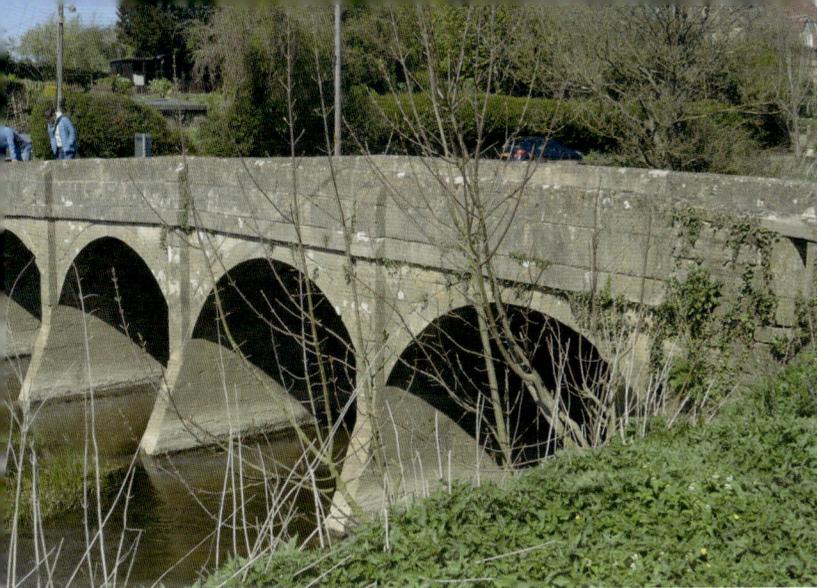

Above left: Rey Bridge.

Above right: An early spring view of the Bristol Avon at Lacock.

Below: Cottages at Reybridge.

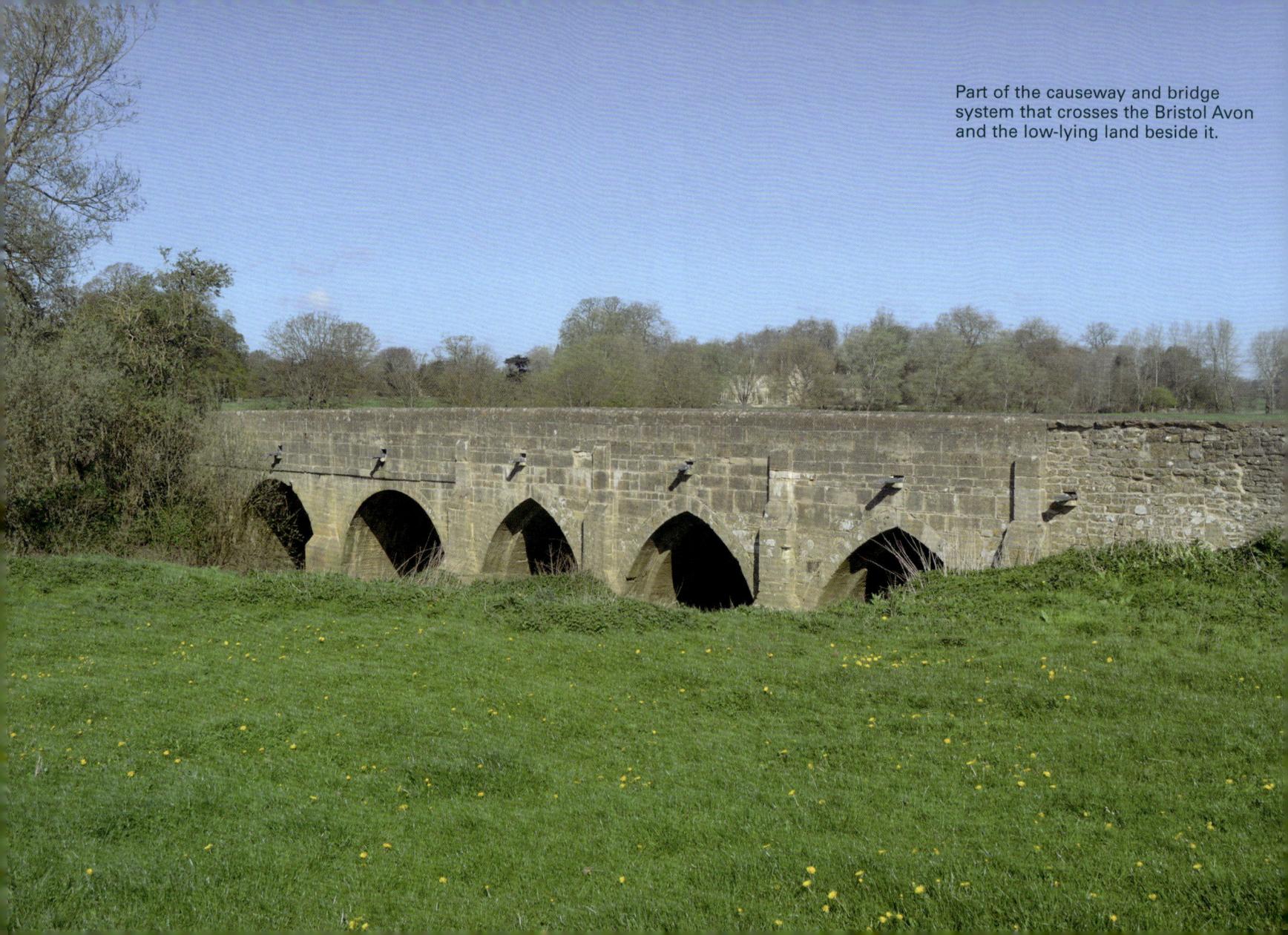

Part of the causeway and bridge system that crosses the Bristol Avon and the low-lying land beside it.

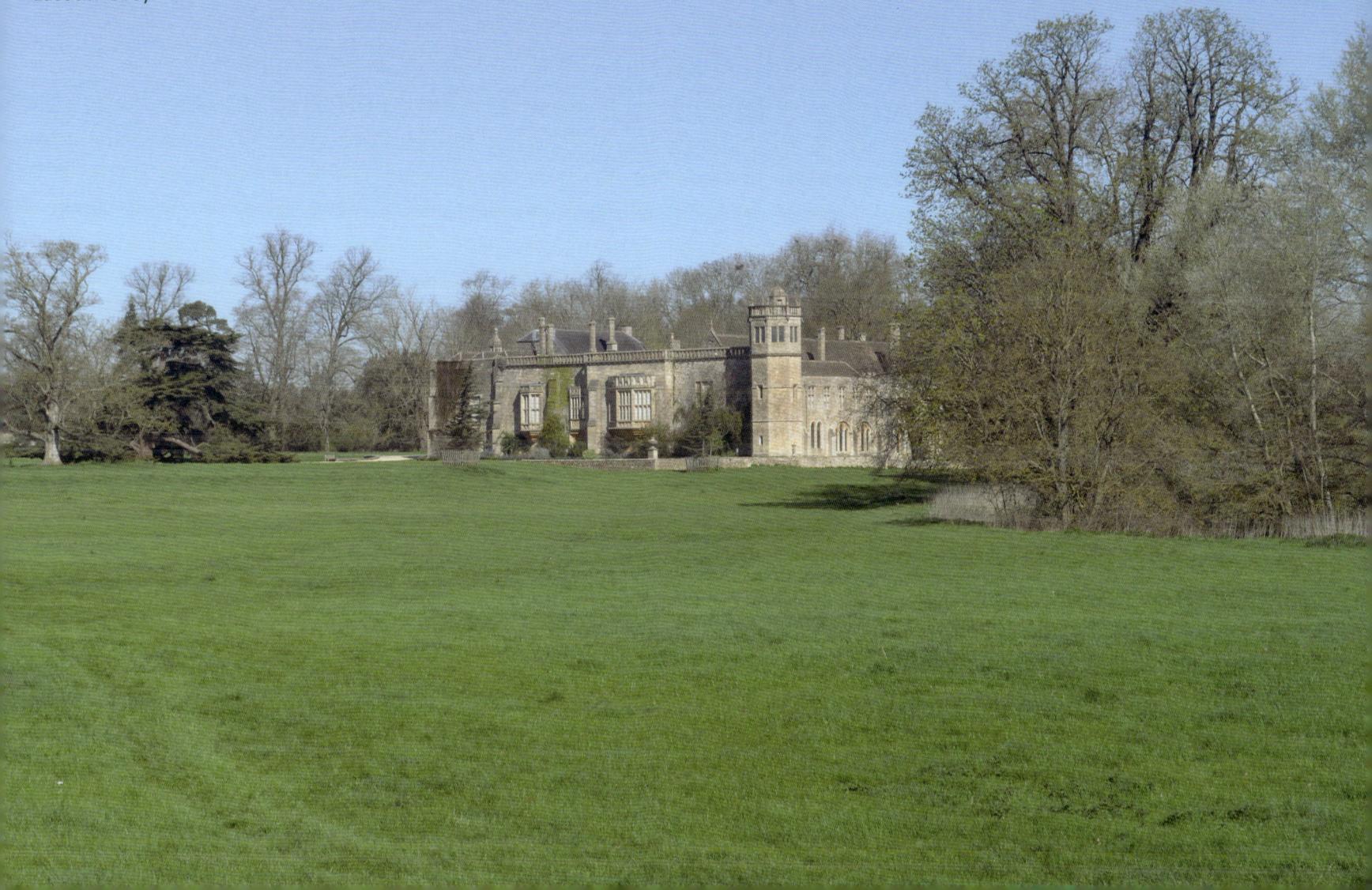

Lacock Abbey.

Henry Fox Talbot, who is often seen as the inventor of photography – even if this is not strictly the case. Technically, he was the first person to publish the details of a viable photographic process.

Before him, others had managed to capture images on paper coated with silver salts, but these quickly faded. Fox Talbot's first triumph was working out how to stabilise such images. The publication of his method in 1839 came as a result of an announcement that same year by a Frenchman, Louis Daguerre, that he had succeeded in producing stable images by a different process, though Daguerre did not give details at the time.

Fox Talbot had a second success in 1841 when he announced his developing process, which allowed multiple prints to be made from a single negative. This was very useful for publications and a great advantage over his French rival, who could only make one 'daguerrotype' from each picture taken.

Fox Talbot had a wide range of other achievements, including being a Member of Parliament, being the first person to recognise that chemical elements each had their own spectra and could be recognised in compounds with other elements from these spectra, and being an expert in the Assyrian civilisation of the ancient Near East.

Nowadays, the abbey and its grounds are in the care of the National Trust. The entrance to the abbey and a museum dedicated to Fox Talbot and the history of photography are housed in a sixteenth-century building that was perhaps a barn, but may have been a stable built for Sir William Sharington.

In 2014 the abbey 'starred' in *Wolf Hall*, the period drama set in the reign of Henry VIII, and parts of two Harry Potter films were also filmed there. The presence of so many old buildings without modern ones among them has also made Lacock village itself an ideal location for the filming of period dramas.

The village lies on the side of the abbey away from the river, and is justifiably popular with tourists. Like other towns and villages around abbeys, such as Malmesbury, Lacock would have grown to provide 'support services' for the abbey.

The Bide Brook flows though the northern part of the village before joining the main river. If you follow the lane called Nethercote Hill north from near the church, you soon encounter a lovely eighteenth-century packhorse bridge on this tributary. The Bide Brook temporarily divides here, with one stream flowing directly under a modern bridge and the other looping under the packhorse bridge and crossing a ford. The bed of the river has been cobbled here to allow vehicles to cross the ford, where it is still in use as the only vehicular access to properties on the lane beyond. The packhorse bridge was called 'Dummer's Dridge' on an early-nineteenth-century map – is the latter a spelling mistake for 'bridge', I wonder?

Leaving Lacock, we travel around 3 miles down the valley to the town of Melksham. Like Chippenham, it

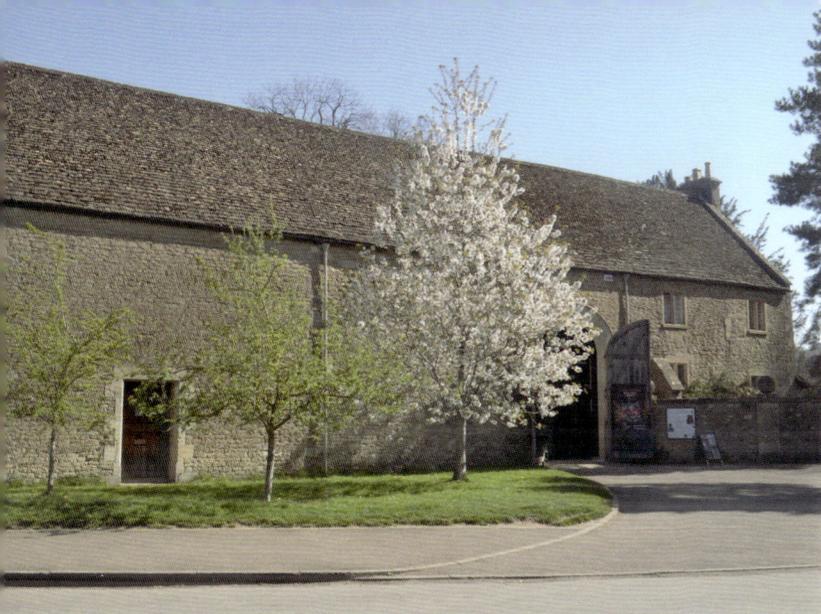

Above left: The Fox Talbot Museum and Abbey entrance.

Above right: Buildings in Lacock, including the National Trust shop.

Below: The junction of High Street and West Street, including the Victorian fountain.

Above left: Church Street.

Above right: The Packhorse Bridge and ford on the Bide Brook.

Below: The houses opposite the Tithe Barn.

grew as a river crossing point and market town for local agricultural produce, and also because of the woollen cloth making industry. The Old English origin of the name 'Melksham' is similar to 'milk village', which probably attests to the productivity of local farming.

Again, as at Chippenham, the town has pleasant riverside walks very close to the town centre, particularly in King George V Park on the east side of the river.

Melksham's eighteenth-century road bridge links the town with an industrial area on the west side of the Bristol Avon. It has a story that has spread the river's name around the world. This story starts at Limpley Stoke, which is further down the river. In 1885 a pair of entrepreneurs called E. G. Browne and J. C. Margetson bought what was then called Avon Mill, which is the present Limpley Mill, as we will see later. The mill was an ideal site for their proposed rubber business because it had been converted for manufacture of this material a few years earlier by a previous owner.

In 1890 they moved to Melksham, calling themselves The Avon India Rubber Co. Ltd, which was perfectly fair as they were still beside that river. Their trade was helped by the invention and increasing popularity of the motor car, but over the years the business also made tyres for other types of motorised vehicle, as well as bicycles and other rubber products such as hose, sheeting and even tennis balls. Other factories were built across Britain and abroad. The Melksham factory remained important

though – for instance, one and a half million tyres were made on this site in 1961.

In 2000 the Melksham site was sold to another tyre-manufacturing company, although the Avon company's headquarters only moved to a location just south of the town.

Continuing beyond Melksham we enter a rather busy little area, historically speaking at least. A mile beyond the town the river's west bank is overlooked by Monkton House, much of which dates from Elizabethan times. Then a bend or two later there is a lovely, very geometric and rather narrow stone bridge. At first I thought this was an ornamental feature of Monkton House's grounds, but it turns out to be another packhorse bridge, in this case built in 1725. The bridge was on a route across the valley between the villages of Broughton Gifford, off to the north-west beyond Monkton House, and Whaddon to the south-east.

A short distance further on we come across the bridge abutments where another former railway crossed the river. This was the Devizes Branch Line, which left the existing line between Trowbridge and Chippenham by the village of Holt and ran east through Devizes to join the surviving Westbury to Newbury and London line near Pewsey. It was built by the Wiltshire, Somerset & Weymouth Railway and opened in 1857. Like the other lines we have seen, it fell foul of the Beeching cuts and closed in 1966.

Holt itself is just a mile to the west. Here we find The Courts Garden, which is in the care of the National

Above left: The bridge at Melksham. The industrial area where tyres are manufactured is in the background.

Above right: A very rural Bristol Avon in Melksham.

Below: 'Hey everybody, follow the swan! He knows where the food is!'

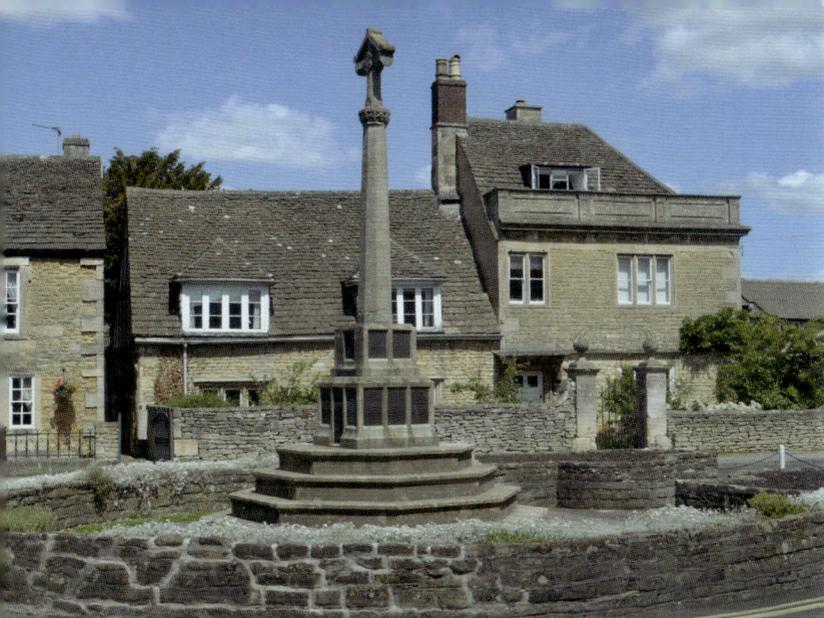

Above left: Melksham's war memorial in Canon Square, built after the First World War. There are two rectangular blocks between the cross shaft and the steps. The larger records the names of over 100 local men killed in the war. The second block was added above it after the Second World War to record those killed in that conflict.

Above right: The packhorse bridge near Monkton House.

Below: A Nonconformist chapel in Melksham.

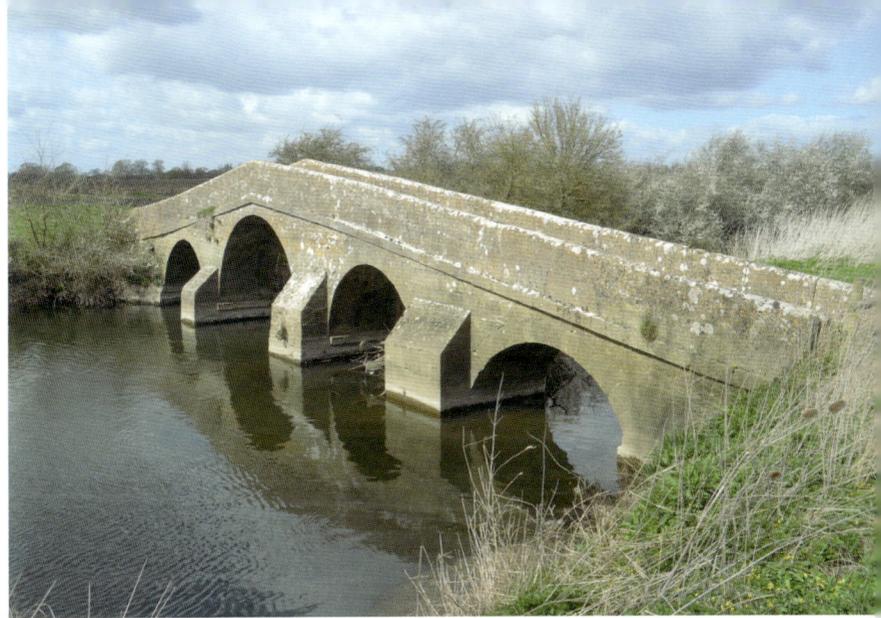

Former bridge abutments of the old Devizes Branch Line.

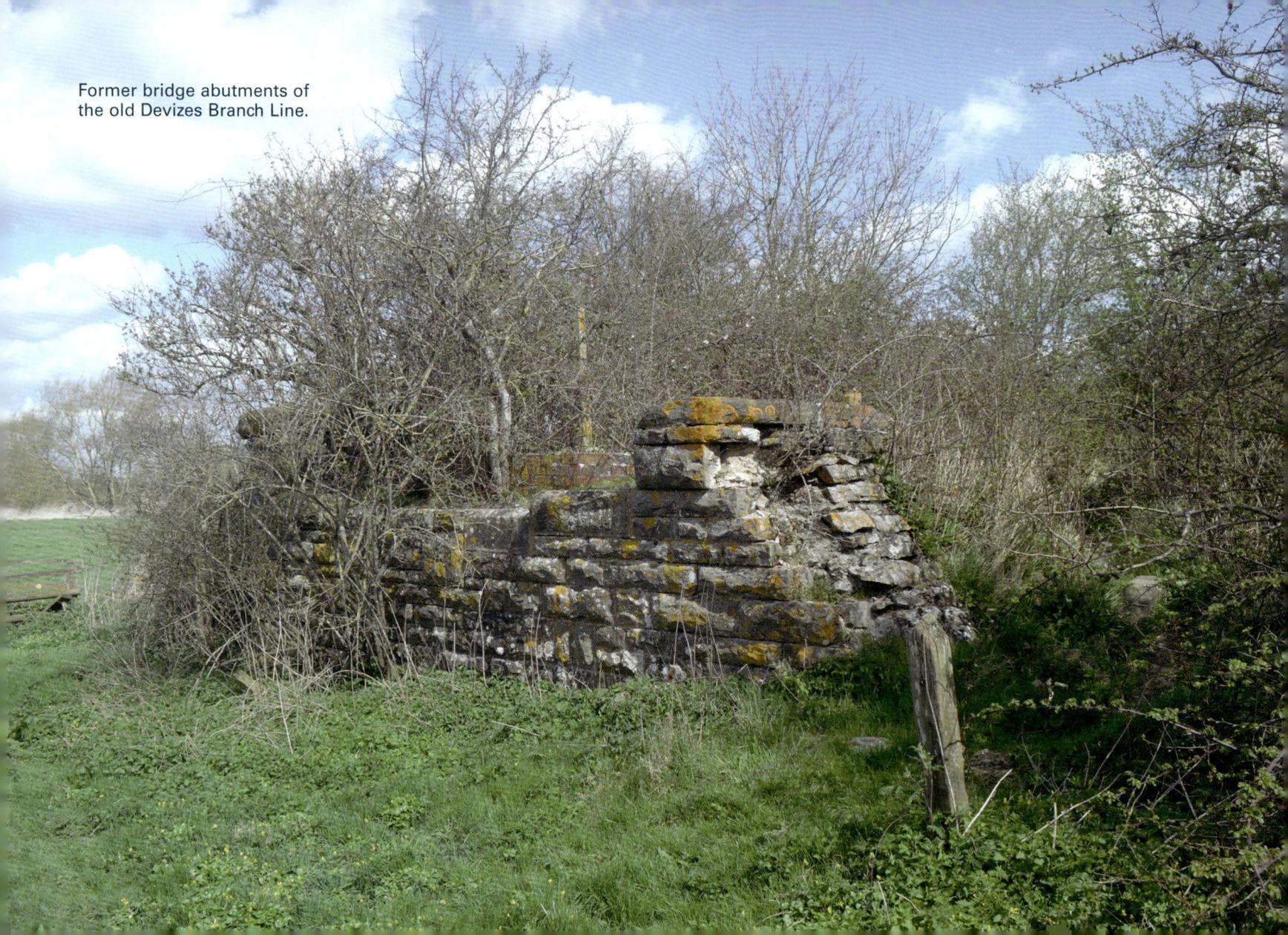

Trust. This is the garden of an eighteenth-century country house that contains a variety of areas, each modelled in a different style, including a kitchen garden, a water garden and an arboretum.

Close to the centre of the village there is a pub called The Old Ham Tree. The name is something of a gift for those of us with an unsophisticated sense of humour, conjuring up images of meat joints growing on trees, or begging the question 'did it grow from a ham bush?', but the adjacent area is called Ham Green, so it was presumably named from a tree on the green. The main road through the village forms one side of this triangular green. The two side-roads which flank the other sides, then join to run down past the parish church, are rather unusually called 'The Star'.

Back on the river, we next come to a meeting of watercourses. First the Semington Brook joins from the east, having flowed from the village of that name a mile or two away. The main river, whose course has been roughly to the south-west since Lacock, now takes a westward turn – almost as though it has just realised it is supposed to flow into the Bristol Channel, not the English one.

Whaddon village is on a small hill to the south, and just beyond that is the Kennet & Avon Canal.

Above left: The Old Ham Tree and nearby buildings in Holt, including Ostler Cottage on right. The pub dates from the late eighteenth century. Ostler Cottage was built around 1700, with two eighteenth-century cottages to the left.

Above right: Ham Green.

Below: Iron footbridge on the Semington Brook just before it joins the main river.

The little parish church at Whaddon.

3

A NEW COMPANION

For the rest of the journey this canal is an integral part of the river's surroundings. At first it shares the river's narrow valley, then from Bath onwards the river is also the canal, so this seems like a good point to give some of its background.

As early as the sixteenth century the idea of a coast-to-coast waterway linking the Bristol Channel and the Avon with the Thames and London was considered, particularly when it was noted how close the rivers were. Tetbury is only around 10 miles from the upper Thames, and at one point two streams, one that flows into the Tetbury Avon and the other into the Thames, are only a mile apart. Such a route would avoid the long sea journey around the south coast that was then necessary to transport goods from the Bristol area and South Wales to London. It took until the eighteenth century, when there was a great rush of canal-building, for anything to be done about it. In fairness, though, there had been a lot of opposition from the powerful owners of turnpike roads, who saw the canals as

a threat to their income from tolls on their roads.

In the early part of that century a new idea was coming into play – a route that left the Avon much lower down its course than Tetbury and linked to the Kennet, a tributary of the Thames, at Newbury. For one thing, it must have been realised that the upper course of the Avon would have required a lot of work to make it navigable.

The relevant sections of the Avon and Kennet were made navigable under the supervision of the engineer John Hore, who began with the Kennet and then in 1727 added six locks to the Avon between Bristol and Bath.

Then, in 1793, a scheme for the linking section of new-build canal put forward by the surveyor John Rennie was accepted by the Kennet & Avon Canal Co., which was to fund construction and then operate the canal. Work began the following year, the completed canal opened in 1810. This linking canal was 57 miles long, while the whole project from the mouth of the Avon to Reading (where the Kennet flows into the Thames) covered 87 miles.

Today we tend to think of canals as scenic features associated with leisure time, enhanced by the sight of pretty canal boats moving at a much more relaxed and gentle pace than modern forms of transport. When first constructed, though, they were the freight lines of their day, enabling large amounts of goods to be transported around the country. Although transport on them may have been slow, bigger loads could be carried with much less danger of damage to fragile goods than on a cart being pulled along the often poor quality roads of the time.

However, some thirty years after the Kennet & Avon Canal came into full operation, it had a major competitor. Around 1840 London and Bristol were linked by the Great Western Railway, and new lines were being laid to many other places along the canal's route. The early railways may have given freight a bumpier ride than the canals, but they were a great deal quicker. This speed made many differences – for instance, now milk and other agricultural produce from the West Country could be delivered to London overnight, meaning it was still fresh when it reached the consumers.

A modern equivalent would be if, following the construction of the motorway network in this country from the 1950s, we had now found a new and much better form of transport, and the motorways were becoming overgrown through lack of use! The decline of the Kennet & Avon Canal was inevitable, although it was dragged out for a century and in the 1950s the canal very nearly closed.

Fortunately, the value of canals for pleasure pursuits was being realised around this time, and over the next few decades the Kennet & Avon Canal was restored. In 1990 it was reopened in its entirety for leisure use, and today it is used for cycling, walking and fishing as well as pottering along in narrowboats.

We will now have a look at a selection of features of the canal back to the east of where it first comes into proximity with the Avon.

A mile or so east of Whaddon lies the village of Semington. An attractive bridge with a mixed construction of stone and two types of brick carries the road that runs north from the village across the canal. Before the recent construction of a bypass, this road was the A350, the main road that runs north-south through west Wiltshire and links to the south coast at Poole.

The views along the canal in both directions are worth seeing, especially that to the east where there is a lock and the old lockkeeper's house next to it. The scene evokes Charles Dickens' novel *Our Mutual Friend*, which gives a good indication of the life of a lockkeeper through the character of 'Rogue' Riderhood. He lived in such a house for several days at a time, alternating with a colleague, and could expect to be hailed at any time of day or night during these periods to open the lock for passing vessels.

Between the bridge and the lock is the location where another canal once linked to the Kennet & Avon. This is the Wilts & Berks Canal that we saw before between

A swing bridge on the Kennet & Avon Canal, to the west of Semington, which has been opened to allow the passage of a canal boat.

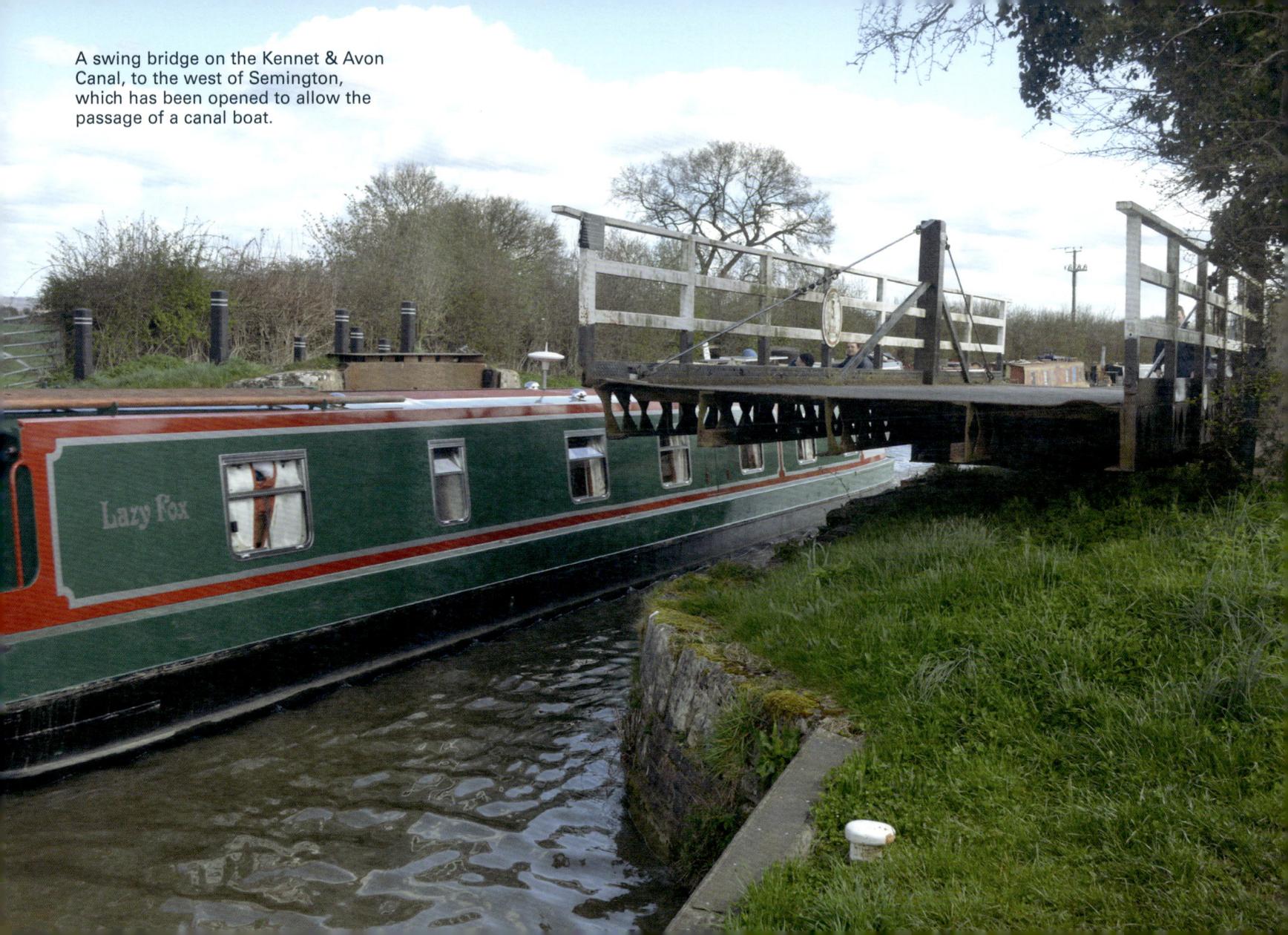

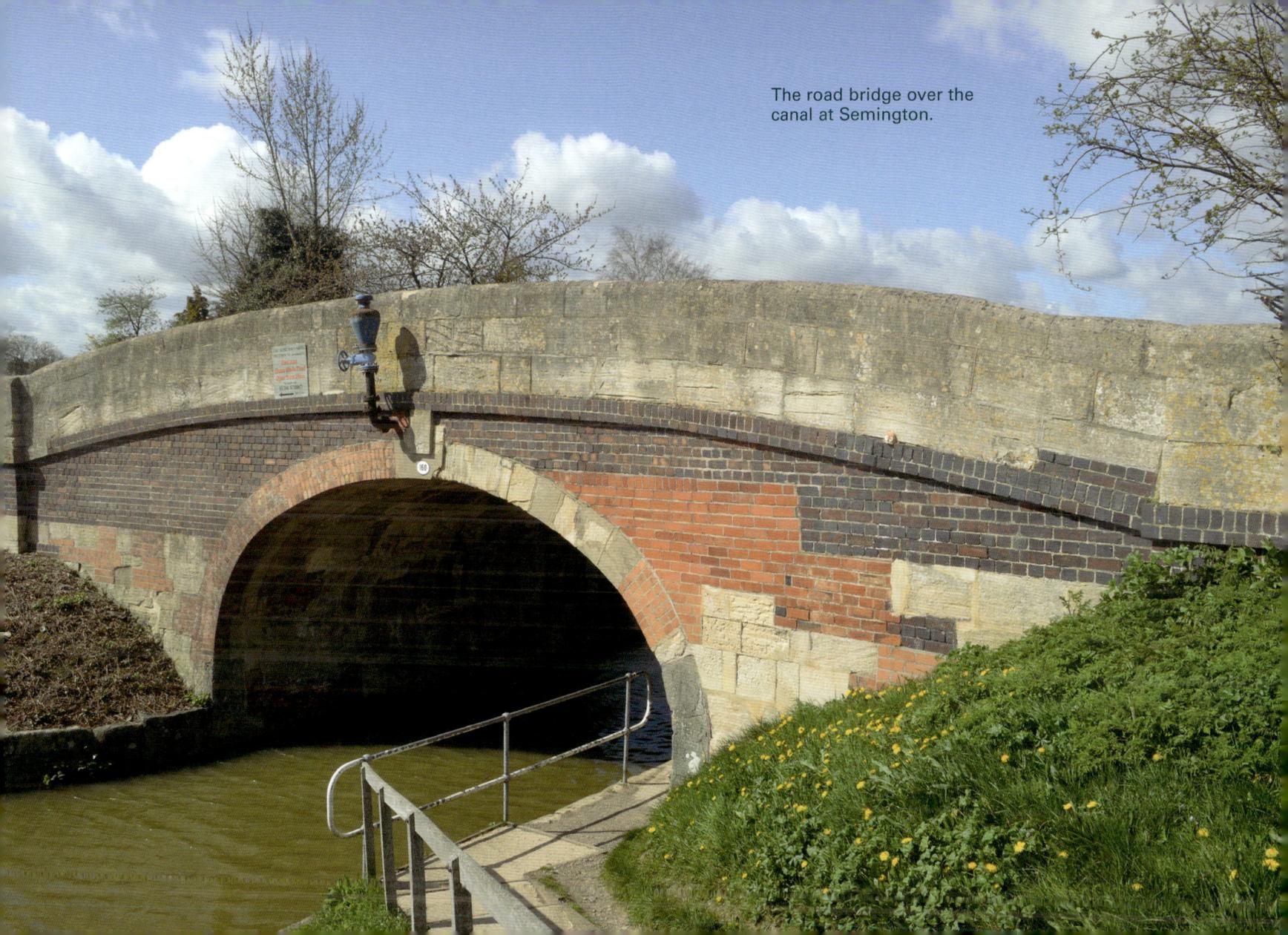

The lock and former lockkeeper's house at Semington.

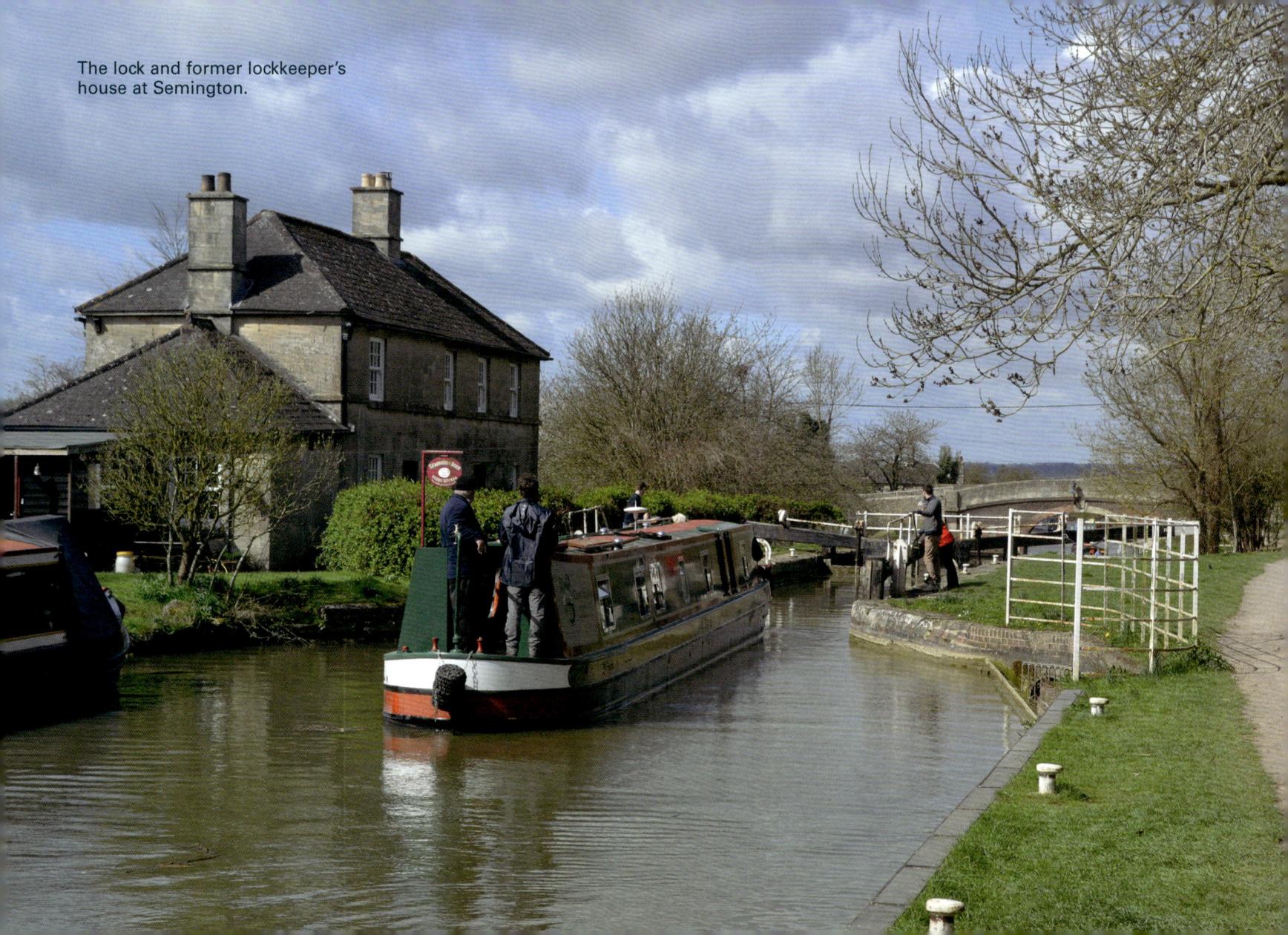

Chippenham and Lacock. It ran from Semington to link the Kennet & Avon Canal to the Thames at Abingdon – a distance of 52 miles. Like the Kennet & Avon, the Wilts & Berks opened in 1810 and is testament to the complexity of the canal network that was forming at the time. The canal was to be called the Wiltshire and Berkshire Canal, but someone wrote an abbreviated form in an early legal document and this version of the name has been used ever since.

This canal closed in 1914, but since 1977 the Wilts & Berks Canal Amenity Group has been working to restore it. As part of this scheme, a new cut for the canal joins the Kennet & Avon to the west of the bridge we have been looking from.

Five miles east of Semington we find Caen Hill Locks near Devizes, the most spectacular sight on the canal and rightly one of Wiltshire's most popular tourist attractions. There is a series of sixteen consecutive locks, which together with another seven just to the west at Foxhangers, and another six a little further to the east in Devizes itself, forms the Devizes Flight. In total, the twenty-nine locks raise the canal by 237 feet in 2 miles, taking it out of the Avon valley and into the chalk uplands to the east. As a testament to the leisurely pace of canal travel, and the patience of those who indulge in the hobby, it apparently takes a vessel 5–6 hours to pass through the sixteen locks at Caen Hill alone!

I should also mention that the Kennet & Avon Canal Museum is at Devizes Wharf at the top of Caen Hill Locks.

We will go no further, especially as the full route of the canal deserves a book of its own, although I include here an illustration from Berkshire. This shows pillboxes on either side of a lock on the western outskirts of Reading. These are part of GHQ Line – Blue, which followed the Kennet & Avon Canal and was one of the defensive lines set up by the military after the withdrawal from Dunkirk in 1940 to defend the country in the event of a German invasion, which for a time seemed a very real possibility.

Going back to the Bristol Avon, we need to make another diversion to the south to visit Trowbridge, Wiltshire's county town. Its historic centre lies about a mile from the river on its tributary the Biss. Again the town was a river crossing, and there has been a market here for over 800 years. In the fourteenth century the local cloth production industry really took off. Trowbridge Museum and Art Gallery has much information on this industry, including a nationally important collection of materials. There is also plenty of evidence of the industry's success in the quality of many of the town's buildings, especially those of the Georgian period.

The town has expanded towards the Avon, engulfing the village of Hilperton but not Staverton, which has been defended on a peninsula by the courses of the Avon, the Biss and the Avon canal.

In 1889, Wiltshire County Council was formed and Trowbridge was chosen as the county town. Its advantage was its roughly central location within Wiltshire, which

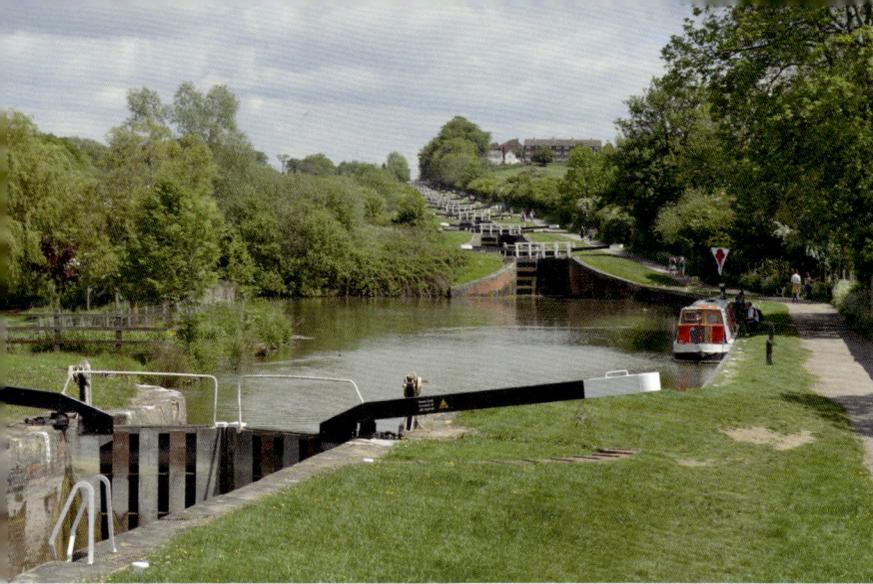

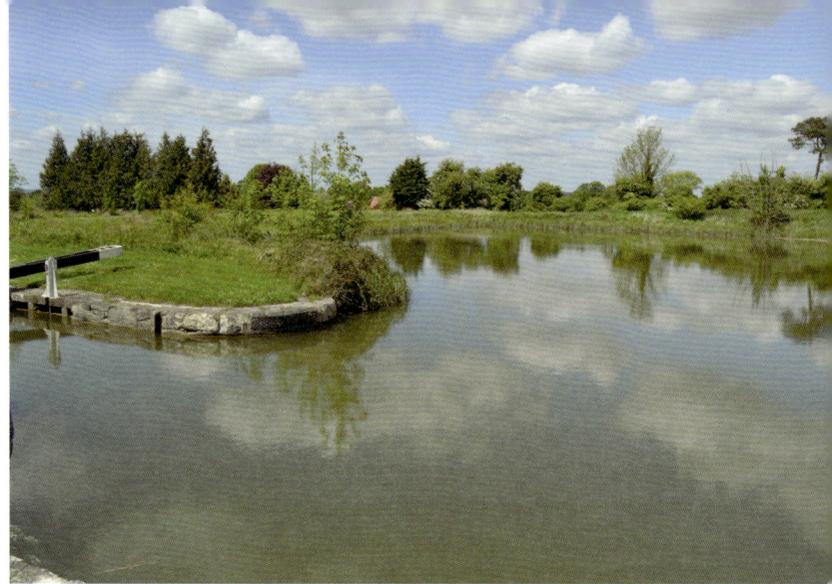

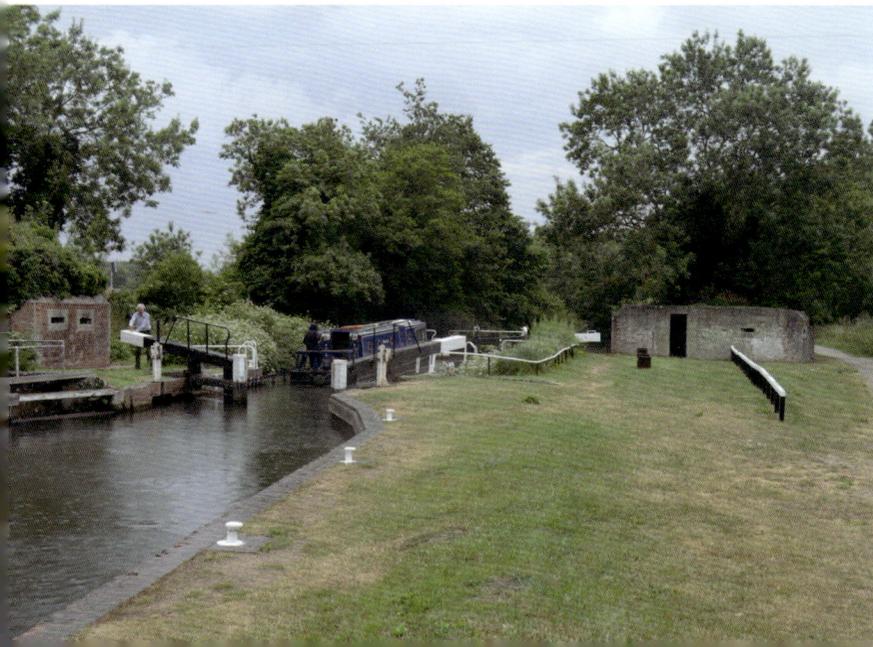

Above left: Caen Hill Locks.

Above right: One of the reservoirs between locks at Caen Hill.

Below: Garston Lock, Berkshire.

meant that councillors and others from either end of the county could get there for a meeting and return home the same day.

Two years earlier, Trowbridge's town hall was built on the site of a house called The Limes. The local council also bought that house's grounds and opened them up as The People's Park. In the late nineteenth century there was an increasing realisation that the inhabitants of expanding industrial towns were losing their access to the countryside and its leisure opportunities, and public parks such as this were seen as a solution to this problem.

The Biss flows through this park, where it has been made into an ornamental feature. Just before this, its course takes it though Biss Meadows Country Park; which has a very rural feel despite its proximity to the town centre and a flyover!

Now following the Biss downstream from The People's Park and around the south-west side of the town, we encounter a building that straddles the river and that is thought to be a unique survivor. This is the Handle House, which dates from the 1840s. It was used for the drying of teasels that were used in the adjacent mill to raise the nap of woollen cloth – there are gaps in the brickwork that allowed air to circulate and speed up the drying process.

A little further downstream there is the Town Bridge, built in 1777 by a local architect called Esau Richards. Beside it is an unusual circular structure that is twenty years older and is called The Blind House. It was used as a lock-up, mainly for drunks while they were sobering up – presumably the name comes from their being 'blind' drunk. It is recorded that the building was damaged in riots in the town in 1826, making you wonder how many of these rioters had previously spent time inside the Blind House.

Three miles to the north-west of Trowbridge lies the lovely town of Bradford-on-Avon. It is at the point where the river has cut a narrow valley through the limestone uplands of the Cotswolds and Mendips. The old part of the town occupies the steep hillside on the valley's northern side, and so the town is considered to be at the southern tip of the Cotswolds. Occupants of properties in the upper part of the town have fine views southward to the chalk escarpment on the northern edge of Salisbury Plain.

It is another town that made its money in the textile trade and then displayed that wealth in its buildings. However, the star attraction here is much older than the town houses.

In 1856, Canon Jones of Holy Trinity church noted carved angels in a nearby building, which suggested it had once been a church. He called in an expert on matters medieval, James Irvine, who dated the building to the eleventh century, right at the end of the Saxon period.

The building had been abandoned as a church when Holy Trinity was built after the Norman Conquest, and over the intervening centuries it had been used for a variety

Above left: Trowbridge's town hall glimpsed from the park.

Above right: A view in Biss Meadows Country Park.

Below: Some locals enjoying the river Biss in The People's Park.

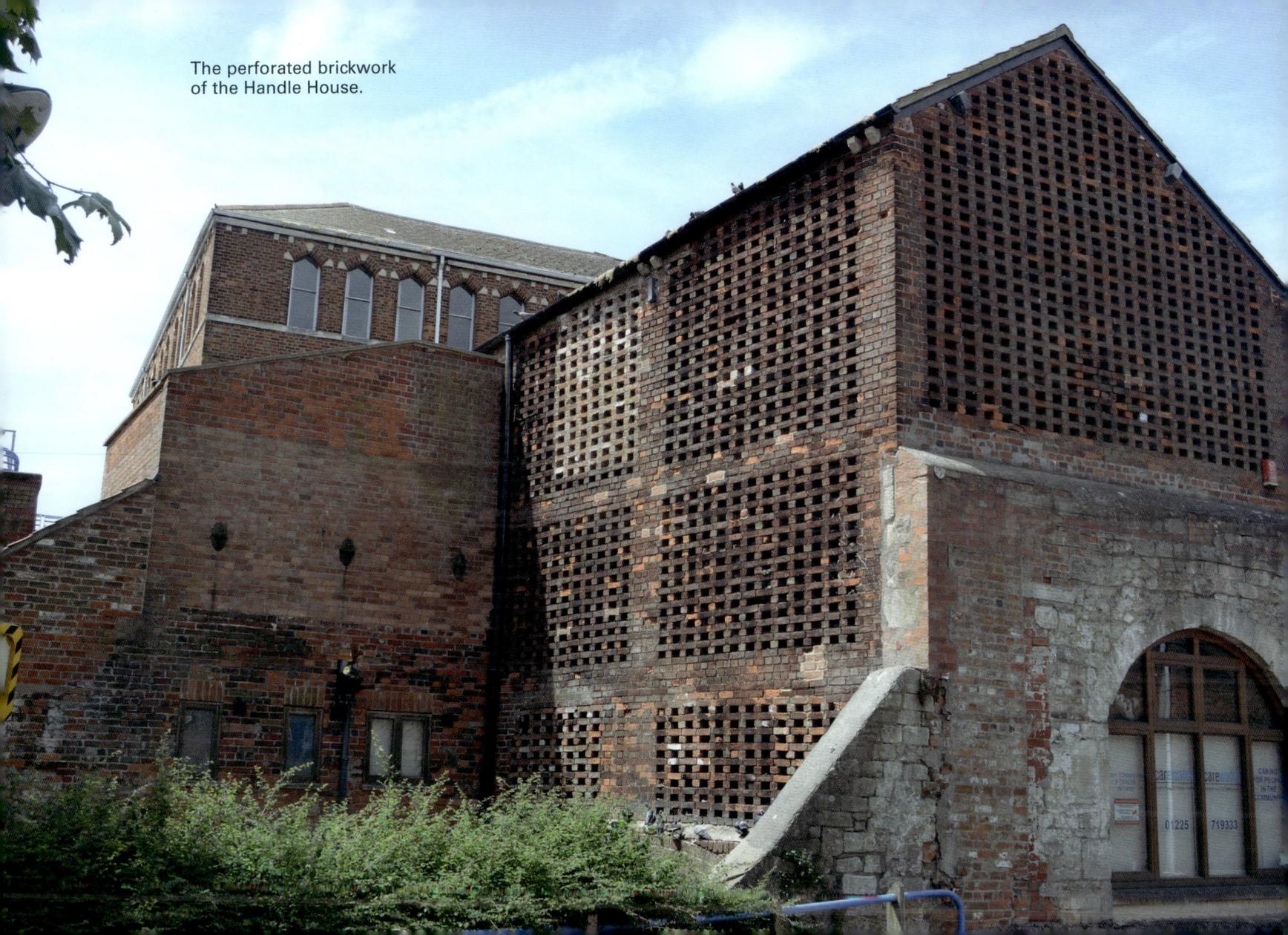

The perforated brickwork of the Handle House.

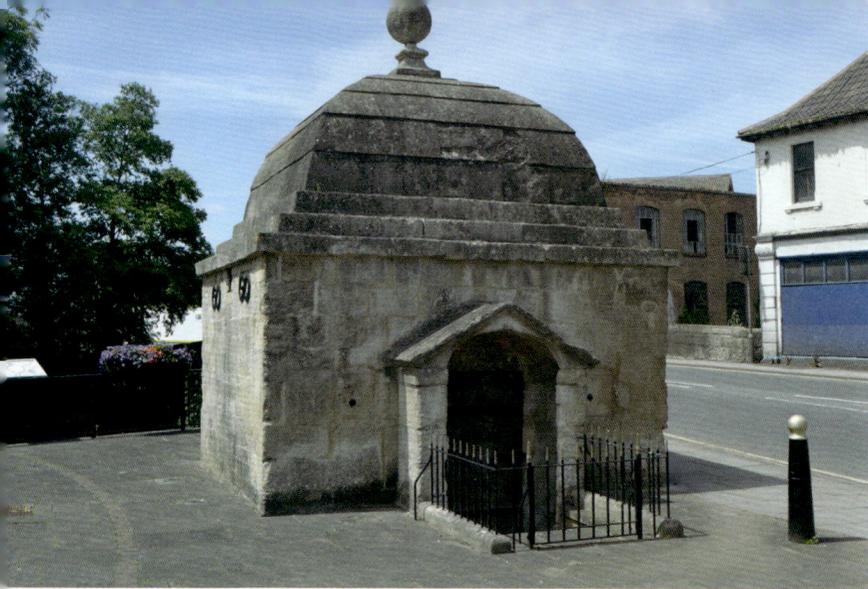

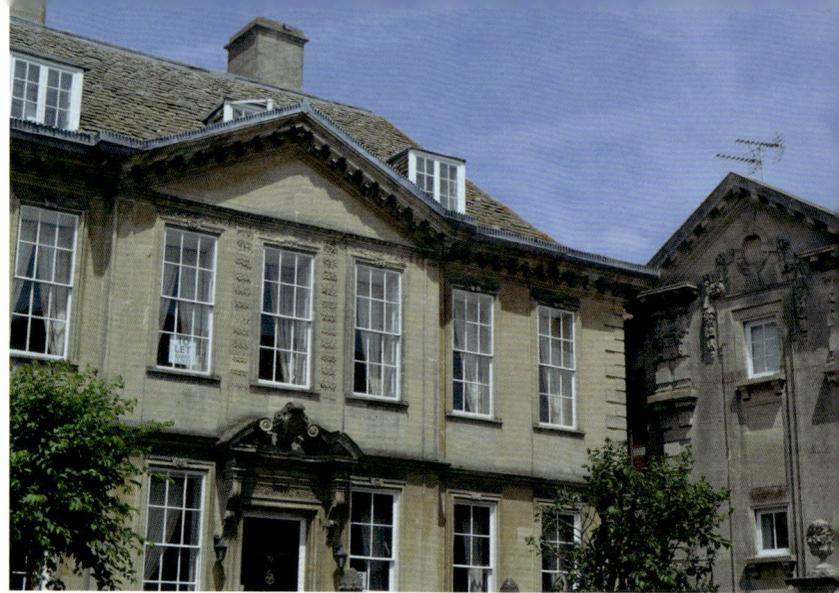

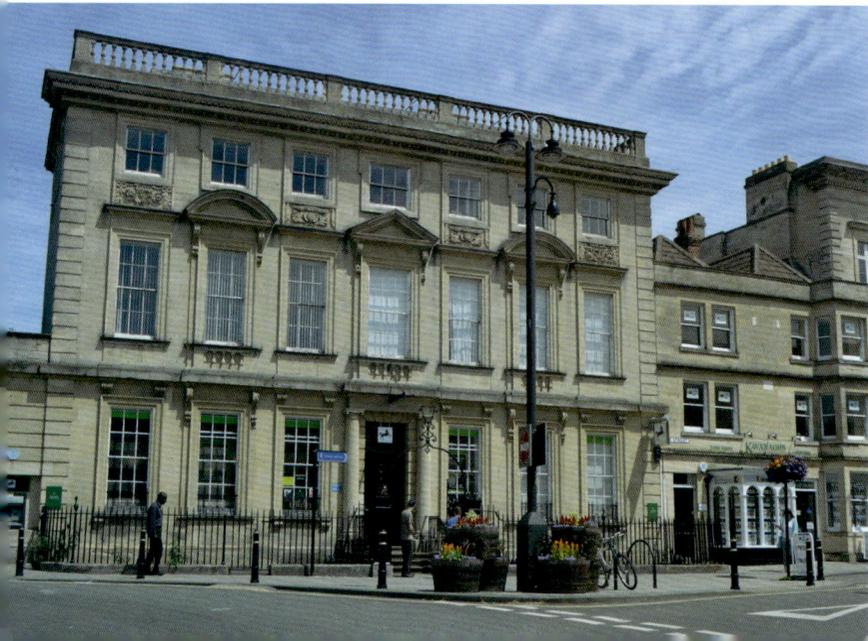

Above left: The Blind House.

Above right, below and opposite: A selection of Trowbridge's Georgian buildings.

of purposes – a school, a house and a store being among them – and at the time of Canon Jones' discovery, it was surrounded by warehouses.

In the 1870s the features associated with these later uses were removed and what was now recognised as the church of St Lawrence was restored as close to its condition of Saxon times as possible. Today it is in a more open location that allows it to be appreciated from a distance, and academic debate still continues about its exact age. The Saxon saint Aldhelm, who we encountered previously in his role as Abbot of Malmesbury, is known to have built a church in Bradford-on-Avon around AD 700. The debate centres around how much, if any, of the fabric of the building dates from Aldhelm's time, and how much is of the tenth or eleventh century, which is indicated by the form and design of the building.

Canon Jones's church of Holy Trinity parish church is just across the road. In comparison you might say that it is only Norman, and then only in places, for much of the structure dates from the later Middle Ages. But this would be extremely unfair, for it is an attractive historic building that would get more of the attention that it deserves were it not for its older brother.

I will pick out some of the other features of the town here, but like Malmesbury this is a place where this is something of interest wherever you go in the town centre.

The Town Bridge crosses the River Avon as the main approach into the town. Parts of the structure date from the thirteenth century, although the bridge was widened and altered some 400 years later. On the bridge there is a lock-up that looks very similar to the one in Trowbridge, although it is claimed that this one may have been a chapel originally. If so, it presumably dates back to the bridge's thirteenth century construction. The top of the lock-up is surmounted by one of the town's emblems – the Bradford Gudgeon. This is a sixteenth-century copper-gilt weathervane, which, as the name suggests, is shaped like a fish.

There are also some fine seventeenth-century buildings on the south side of the bridge, and a footbridge just downstream was renamed McKeever Bridge after Ed McKeever from the town, who won gold in the sprint kayak event at the 2012 London Olympics.

Several hundred yards south of the Town Bridge, beyond the railway station, the Kennet & Avon Canal widens out by a lock and a road bridge to form the Canal Wharf. This makes an ideal stopping-off point for canal users, and a conveniently-located pub is one of the local facilities.

On the south-west side of the town is Barton Farm, where the main attraction is the fourteenth-century Tithe Barn. This was a grange or outlying property of Shaftesbury Abbey, at least 20 miles to the south in Dorset, which was the wealthiest nunnery in England. This 168-foot-long building helps to prove the point about that wealth, showing just how much produce from its lands here the abbey needed to store. There is also a fifteenth century granary nearby.

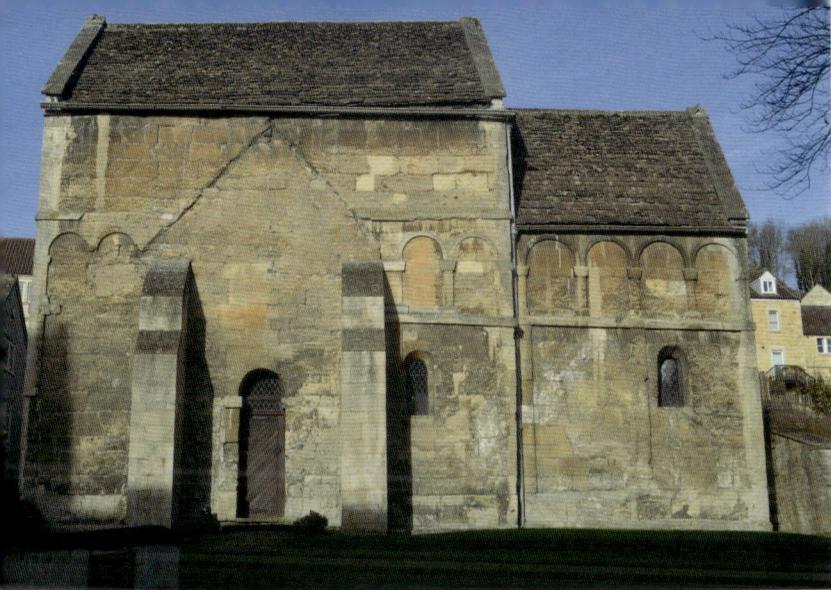

Above: The Saxon church of St Lawrence in Bradford-on-Avon.

Right: Holy Trinity, the Norman church.

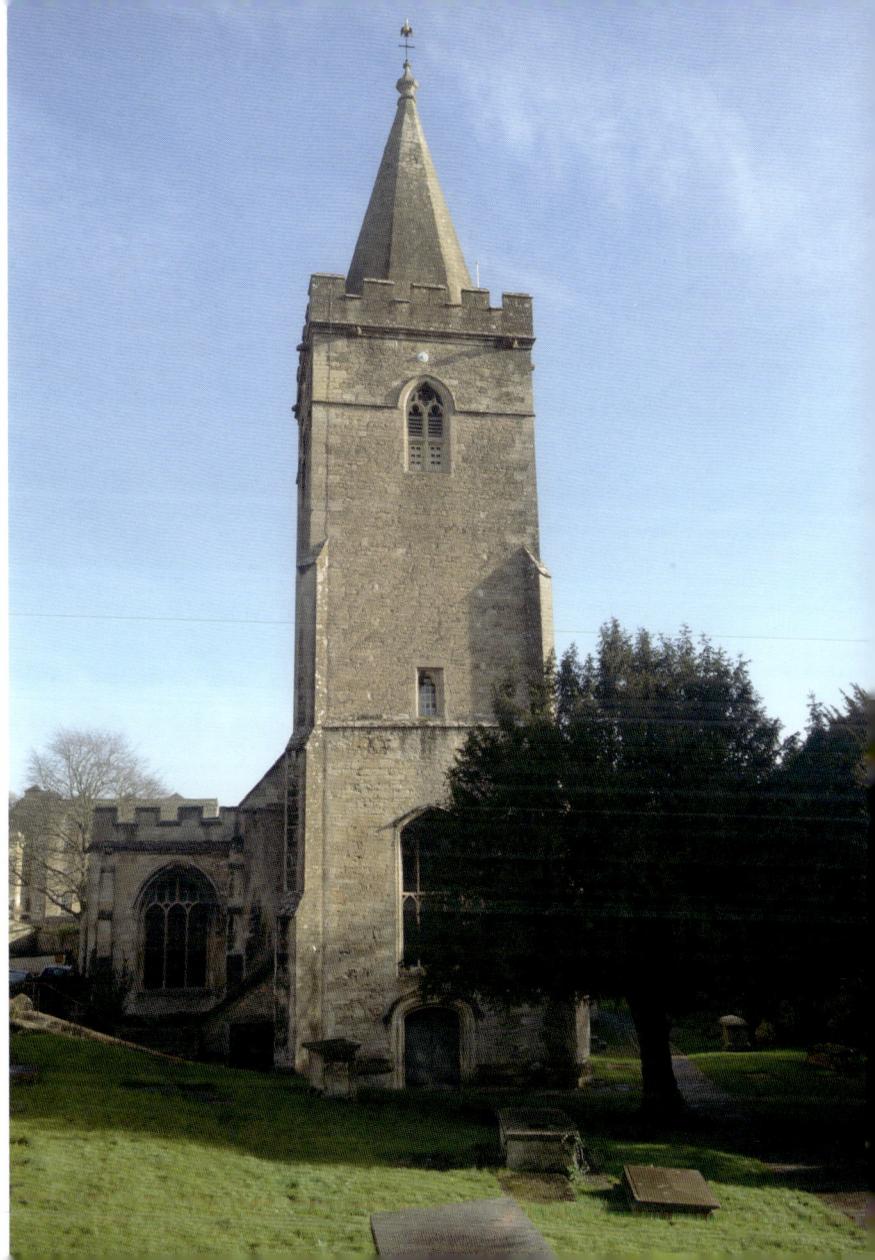

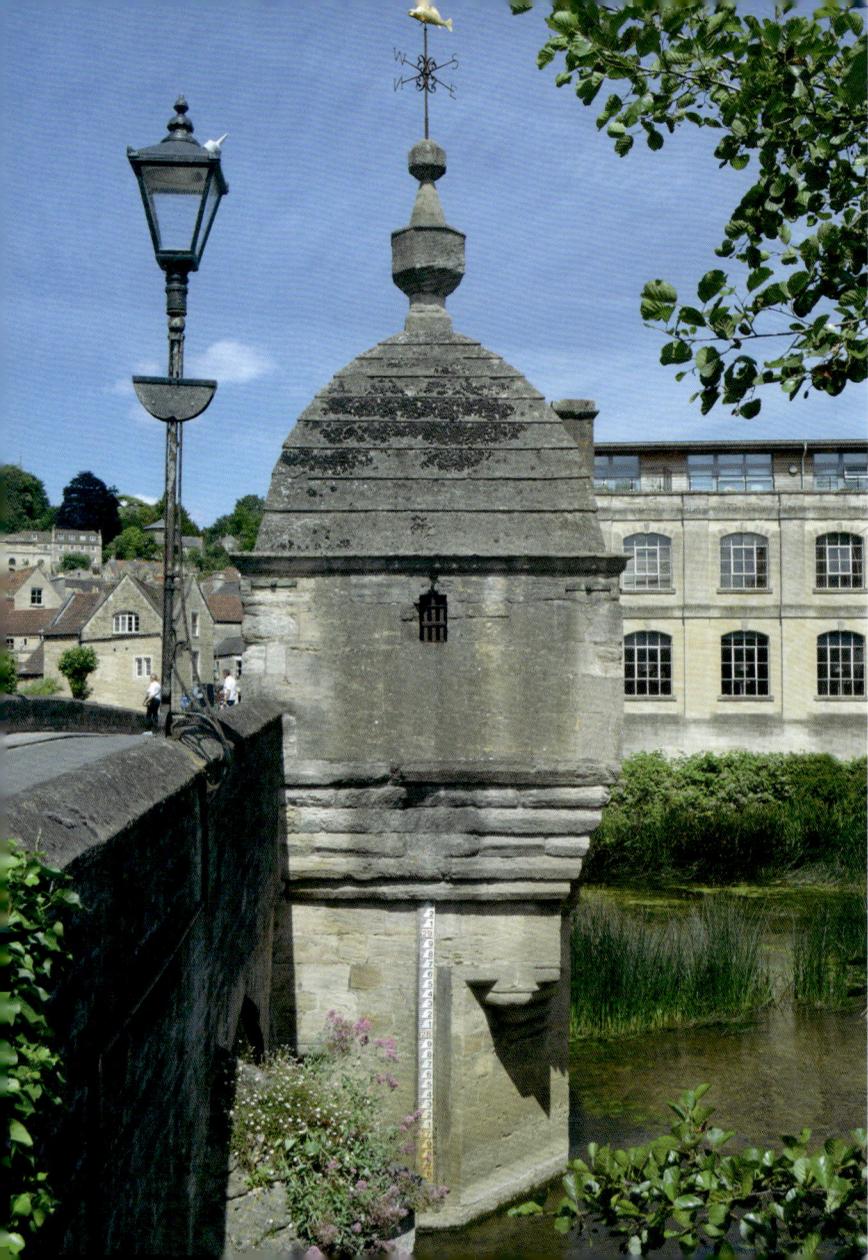

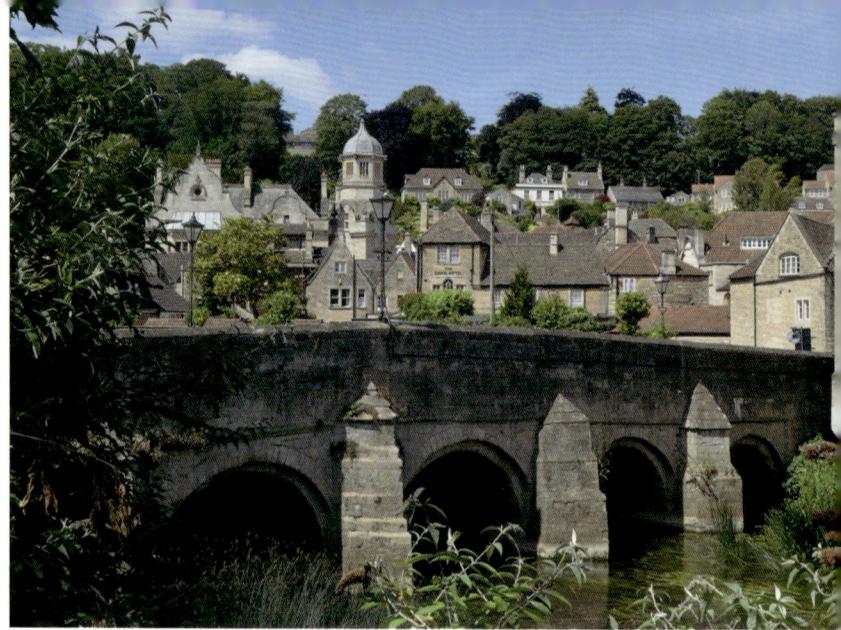

Above The Town Bridge and a view of the town from the south side of the Bristol Avon.

Left: 'The Bradford Gudgeon' atop the former lock-up.

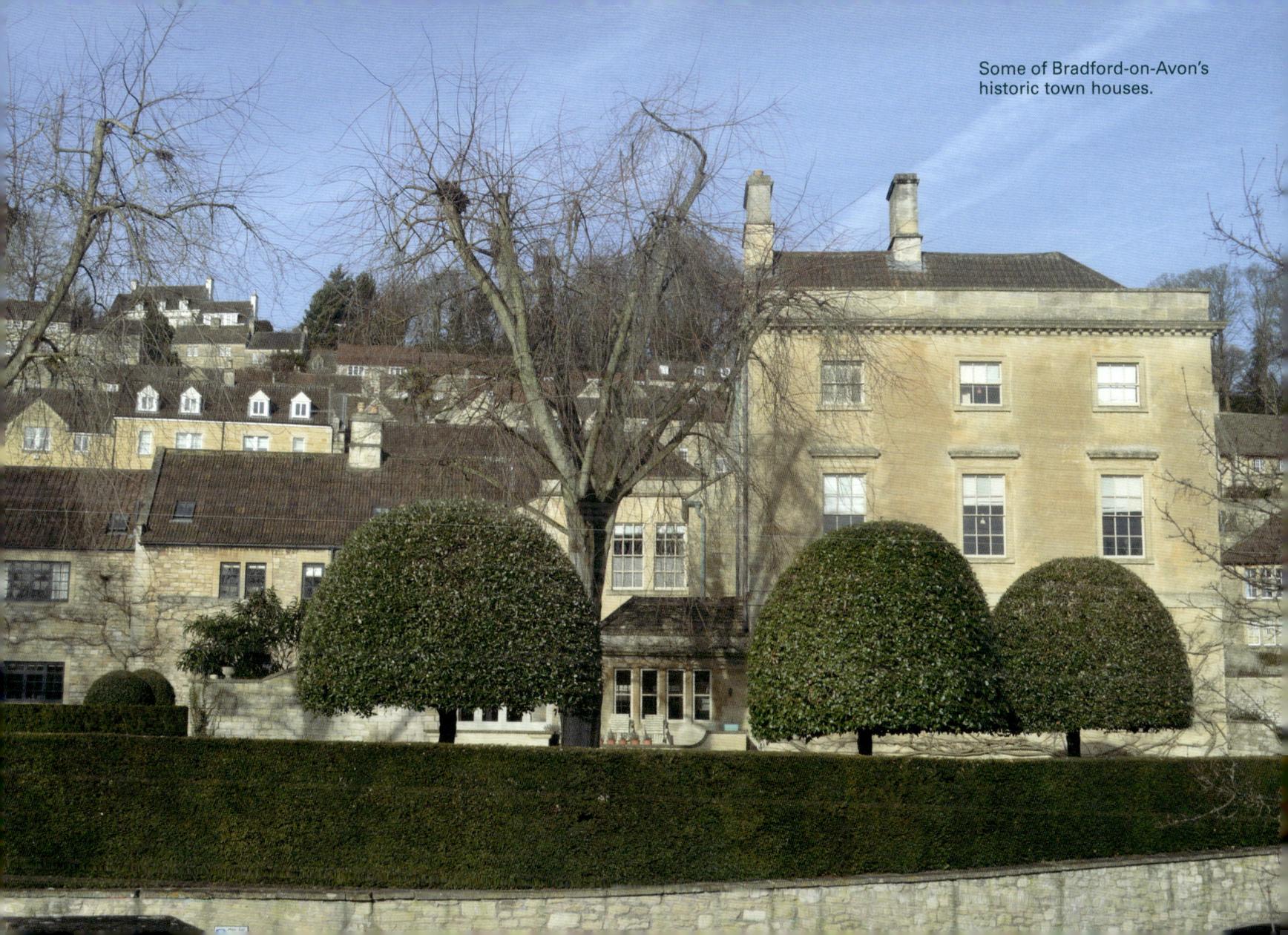

Some of Bradford-on-Avon's historic town houses.

Canal Wharf, not seen
during a heatwave.

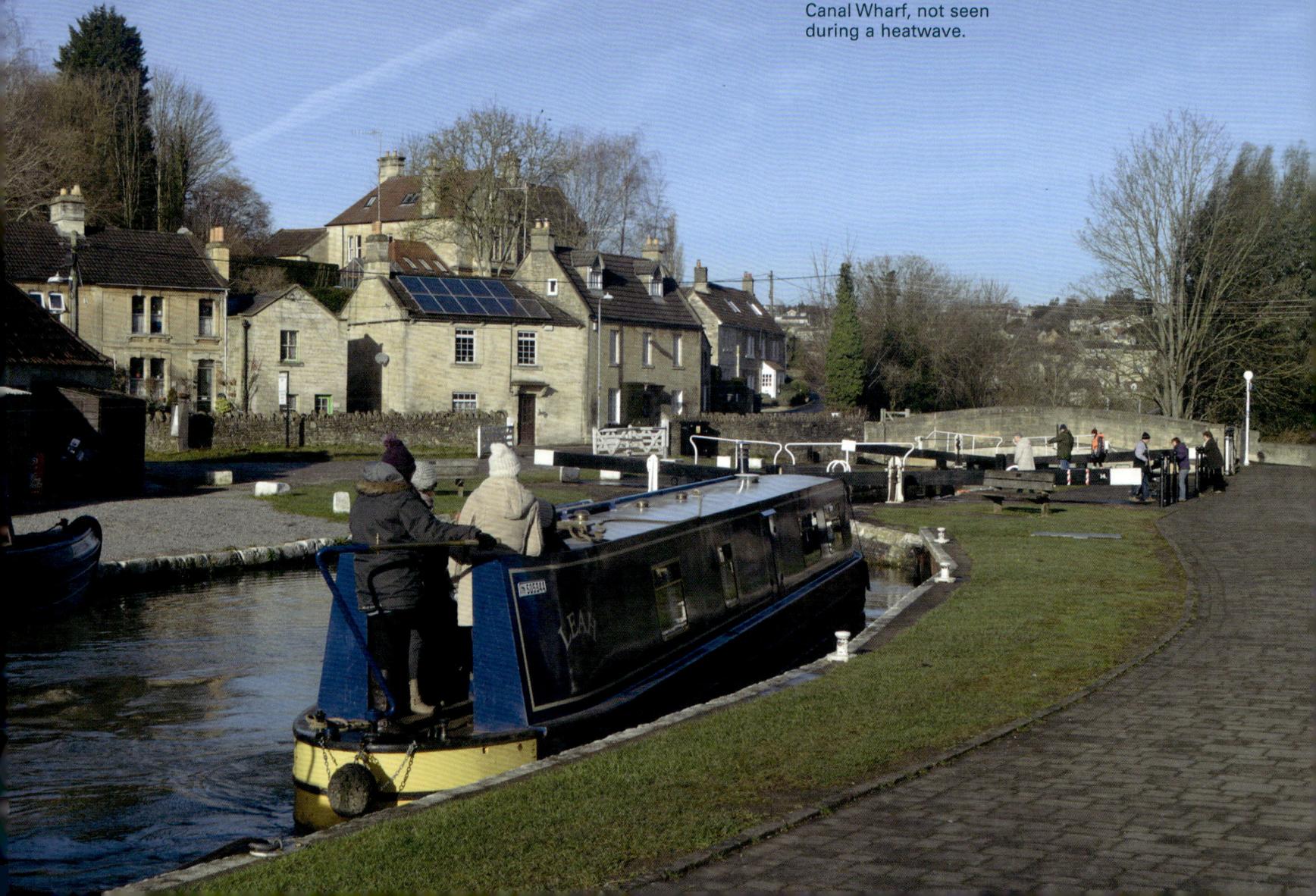

The iconic gorge on the Bristol Avon is the one that starts at Clifton on the other side of Bristol, but there are two more before that, the largest of which starts at Bradford-on-Avon and continues almost as far as Bath. One of the best ways of appreciating the scenery here is to see it from the train that runs along the bottom. Another, which makes for a pleasant afternoon stroll, is to walk from Bradford-on-Avon to Avoncliff Aqueduct. There are two good routes, one running by the river through Barton Farm Country Park and the other a little higher up beside the canal – so you can choose one for the outward leg and the other for the return, giving a round trip of about 3 miles.

The aqueduct at Avoncliff is the first of two spectacular examples in this gorge. Within a few miles they carry the Kennet & Avon Canal from one side of the river to the other, then bring it back again. This is because of the need to keep the canal at roughly the same height along its course, which is particularly difficult because of the gorge's terrain.

The Avoncliff Aqueduct is 330 feet long and has three spans. The central one crosses the river and is 60 feet wide, while the side-arches, one of which crosses the railway, are each 34 feet across. On the top, footpaths along either side of the canal give wonderful views in both directions. There is a mill and weir down on the river just upstream, and at the south end of the structure there is the 300 year old Cross Guns Inn.

Before we head further downriver, there are two places a little way inland to the south of the river that we should visit.

The first is Westwood, which is just over the hilltop from the Avoncliff Aqueduct. Here, beside the parish church, is Westwood Manor, which is in the care of the National Trust. The house dates from around 1650 and many of its internal features such as the plasterwork are original. There are also two rare musical instruments. The building is only open for a few days a week between April and September.

The other is Iford Manor, a short distance to the west. This is situated on one of the Bristol Avon's major tributaries, the River Frome, which passes through the town of the same name in eastern Somerset. It is also the first of two tributaries with this name. For a short distance here, the Frome forms the county border, and Iford Manor is on the Wiltshire side. The house has a façade dating from around 1730 that has been added to a much older building. It has an excellent natural setting overlooking the Frome, which was further enhanced by the garden architect Harold Peto, who lived here from 1899 until his death in 1933. He terraced the surrounding land and added a great many features, including architectural fragments from his collection. He also added a statue of Britannia to the 600-year-old bridge that crosses the Frome here.

The Frome joins the Bristol Avon at Freshford, the first settlement in Somerset along its course, and one which has quite an informative name. This name has been around

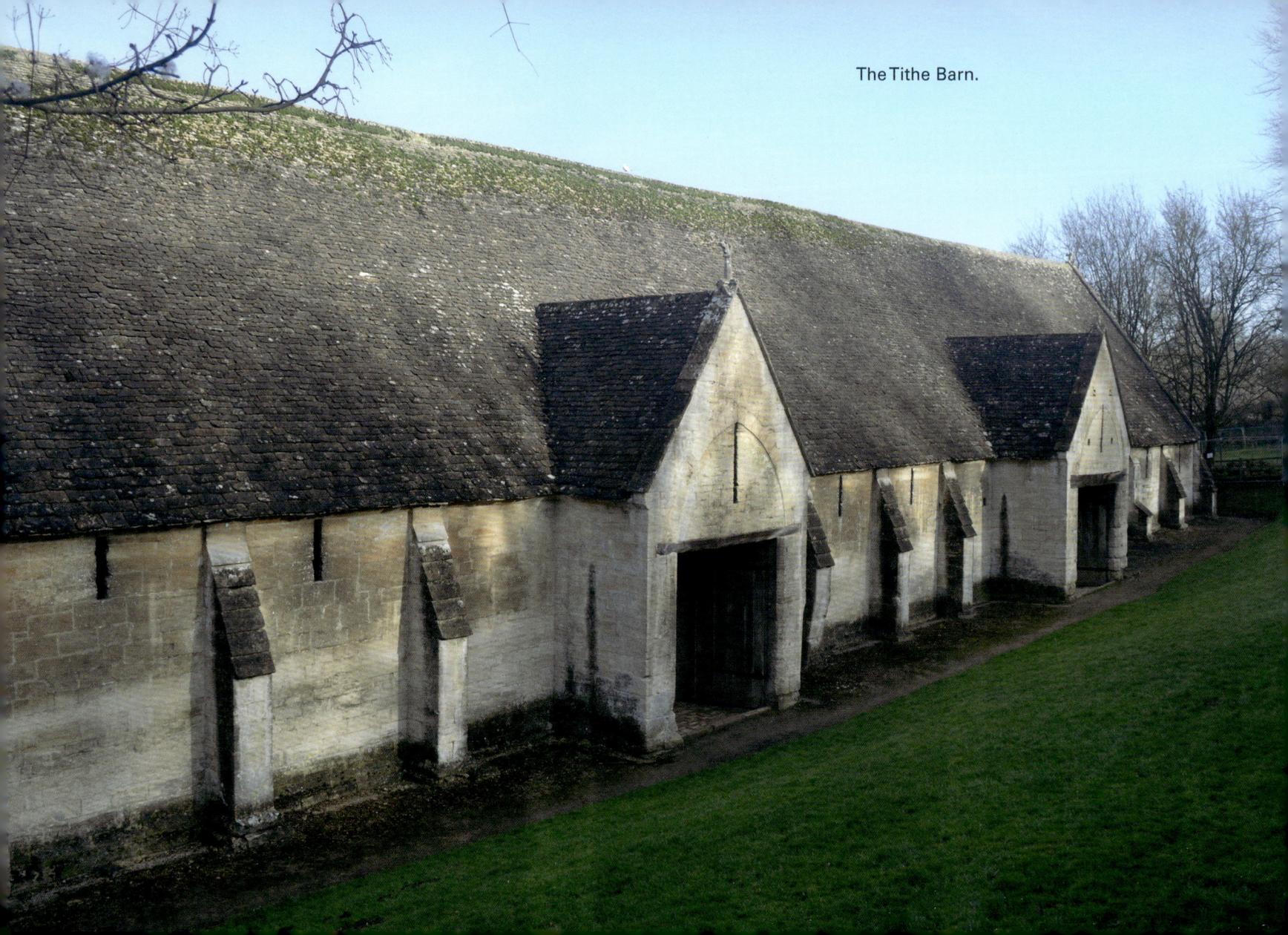
The Tithe Barn.

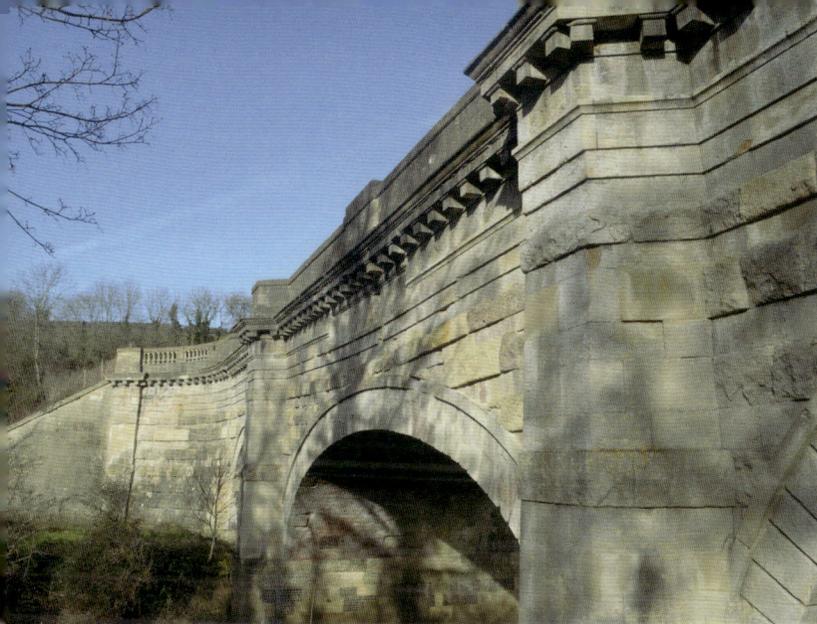

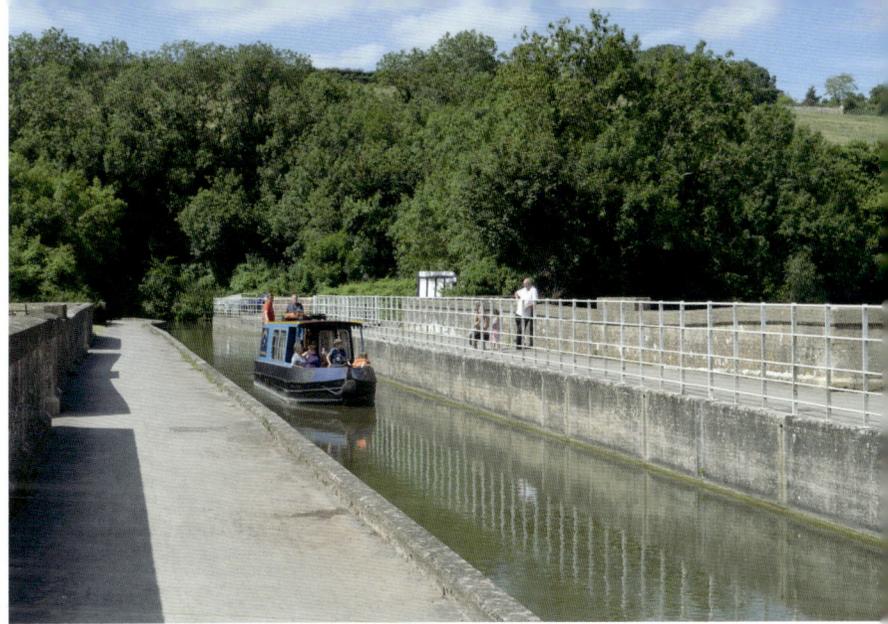

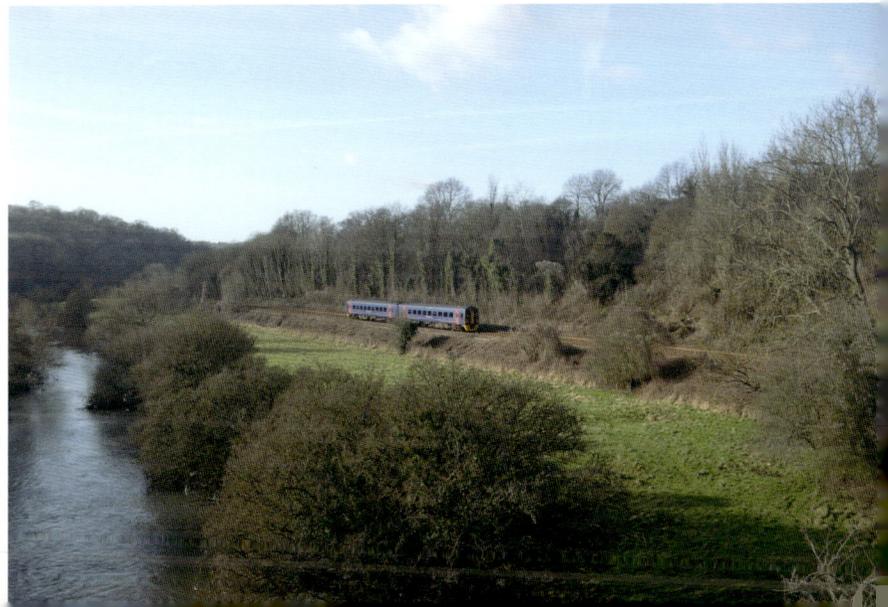

Above left: Side view of Avoncliff Aqueduct.

Above right: The canal crossing the aqueduct.

Below: The view downriver from Avoncliff Aqueduct.

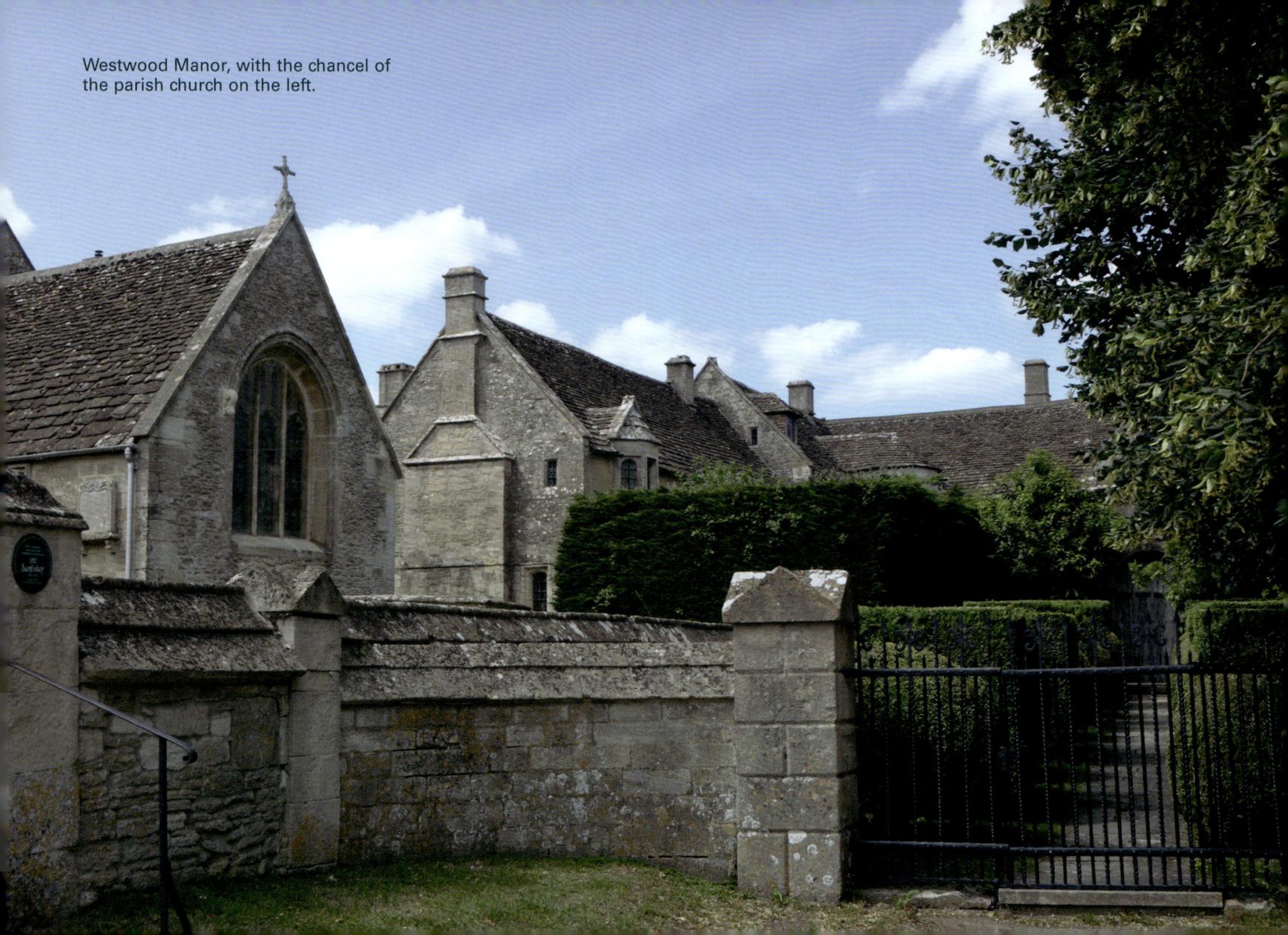

Westwood Manor, with the chancel of the parish church on the left.

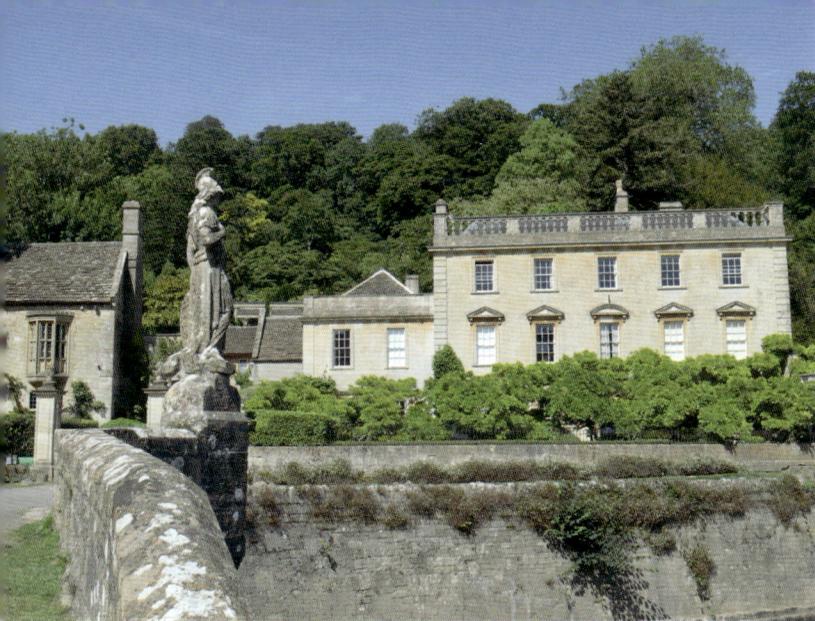

Above left: Iford Manor, with the statue of Britannia in the foreground.

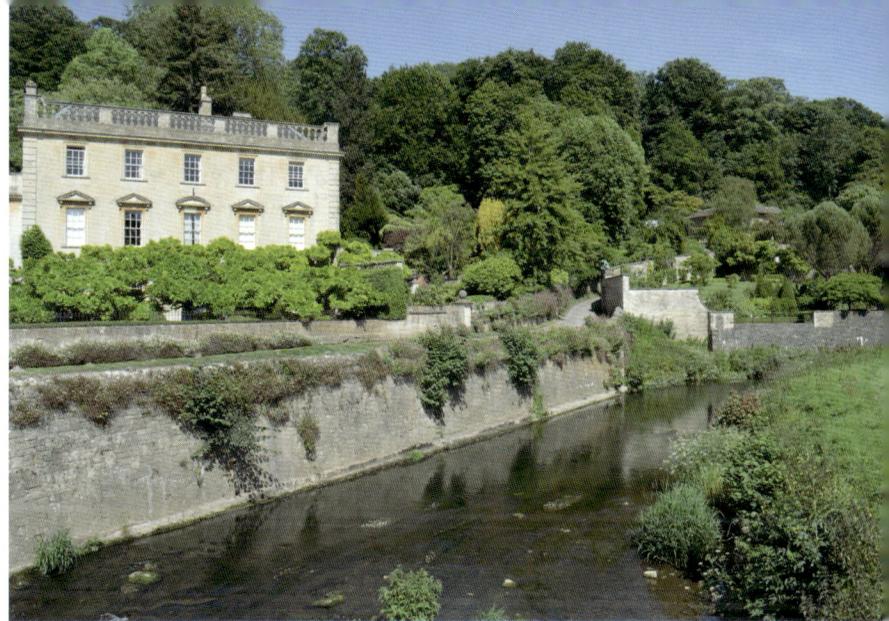

Above right: The River Frome at Iford Manor.

Below: Cottages near Iford Manor.

for over a thousand years and suggests a ford across fresh water, presumably because the brackish water of the tidal river did not reach this far inland. The village of Saltford that we will see on the other side of Bath was clearly within the tidal range.

The next village on this bank, Limpley Stoke, is now on the western side of the valley because the river has turned north. To complicate matters a little more, Limpley Stoke is in a little spur of Wiltshire that juts into Somerset. Further on, the county boundary heads up to the top of the hills on the east side of the valley and continues along here for a few miles.

Limpley Stoke village extends up the side of the valley, and at the bottom by the river is Limpley Mill. A fulling mill is first recorded here in 1614 ('fulling' is the process of cleaning wool and cloth of impurities and thickening it at the same time). A fire in 1854 left it derelict and roofless, but things improved with the start of rubber manufacture by a local timber merchant Giles Holbrow, who sold it to the entrepreneurs we met at Melksham.

A little further past Limpley Stoke we encounter the second of the great aqueducts, the Dundas Aqueduct. It was named after the canal company chairman, Charles Dundas. Like the Avoncliff Aqueduct 4 miles back, it has three spans and crosses both the Avon and the railway. It was built of Bath stone and the central, river-crossing span is 64 feet wide, while those on either side are each 20 feet wide.

At the aqueduct, the Limestone Link joins the canal and follows it as far as Batheaston. This is a 36-mile-long footpath that links the limestone uplands of the Mendips and Cotswolds, running from a location close to the Iron Age hillfort of Dolebury Warren in the Mendips to Cold Ashton in Gloucestershire.

The Somersetshire Coal Canal also joined the canal here. This was constructed around 1800 to bring the products of the Somerset coalfield to the markets of Bath and Bristol. It was planned that two branches would link to Radstock and Paulton. The former was unsuccessful, having to be replaced by a tramway for part of its route, but the one from Paulton supplied Bath with coal for nearly a century at a good profit until coal reserves started to run out and technical problems affected the working of the canal. A short stretch has been restored to create Brassknocker Basin, which is about a third of a mile along the canal from the Dundas Aqueduct end.

Claverton Pumping Station is about a mile and a half down the Bristol Avon from Dundas Aqueduct. This is one of two such stations on the course of the Kennet & Avon Canal designed to augment the water level in the canal when necessary. It was opened in 1813 and used a waterwheel powered by the river itself to raise water 48 feet to the canal. Though closed in 1952 after a period of dereliction, the pumping station it was reopened in 1978 by volunteers from the Kennet & Avon Canal Trust and continues in use, as well as being open to visitors.

A footpath runs alongside the river between the Dundas

The view from Freshford to Winsley,
back on the Wiltshire side of the valley.

Above: Limpley Stoke village on the side of the valley.

Left: Limpley Mill.

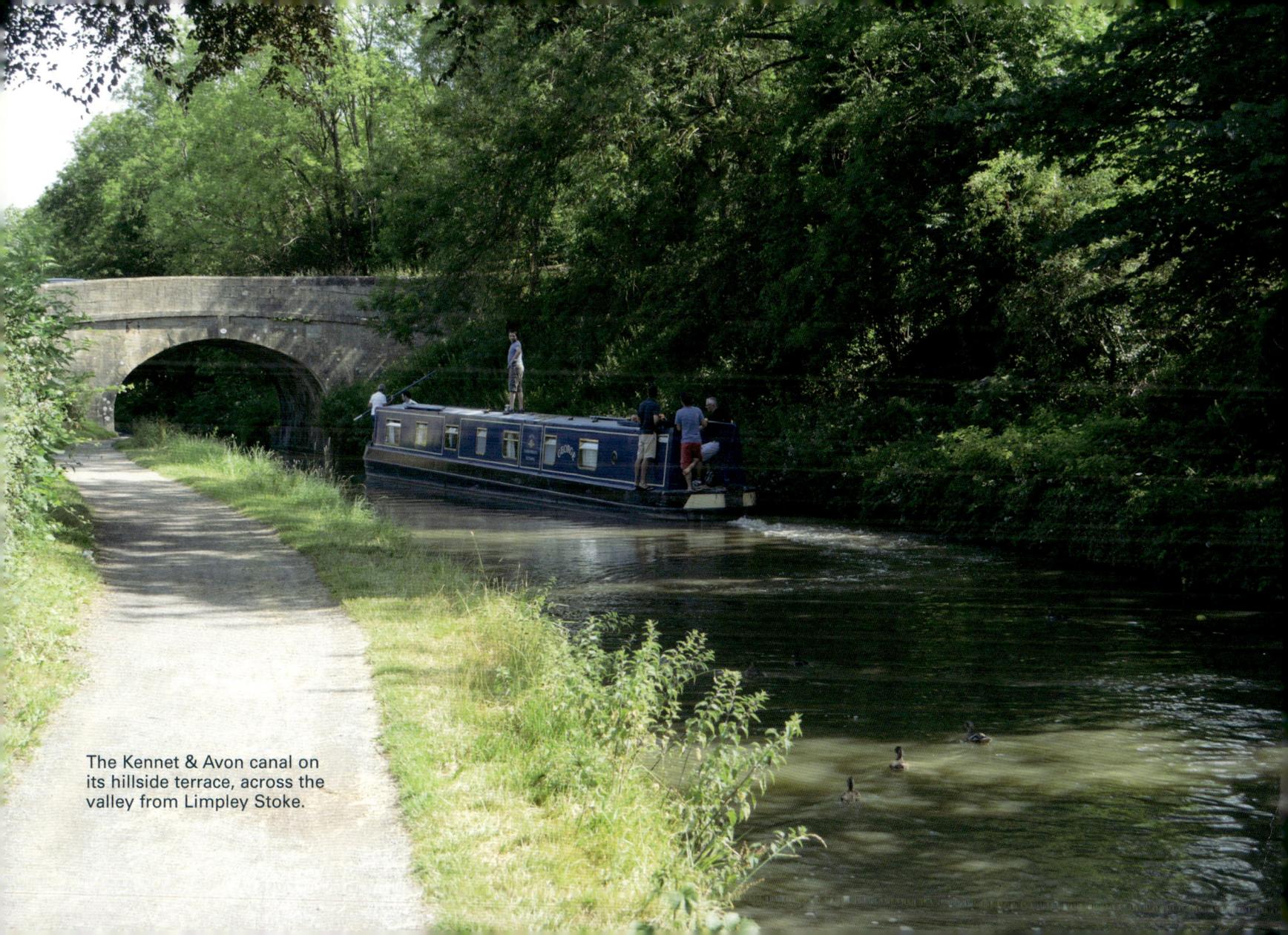

The Kennet & Avon canal on its hillside terrace, across the valley from Limpley Stoke.

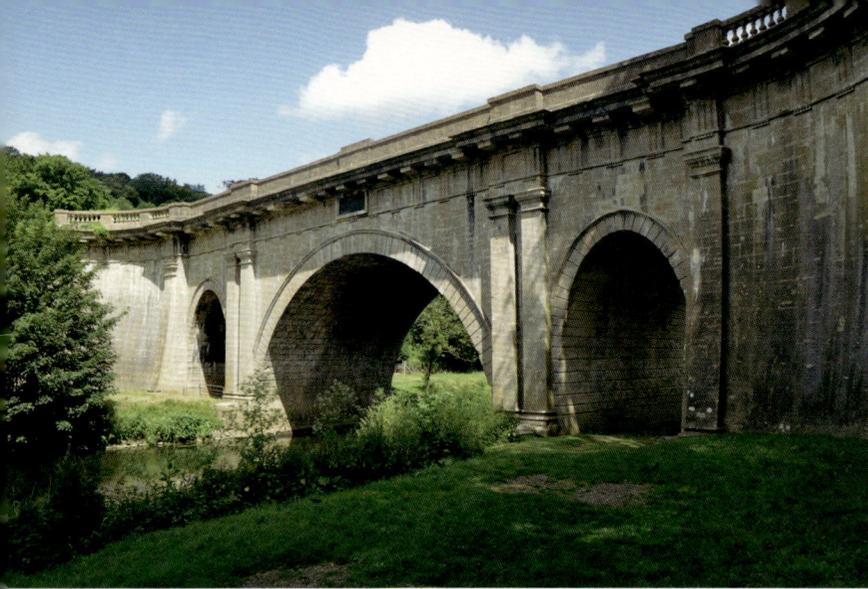

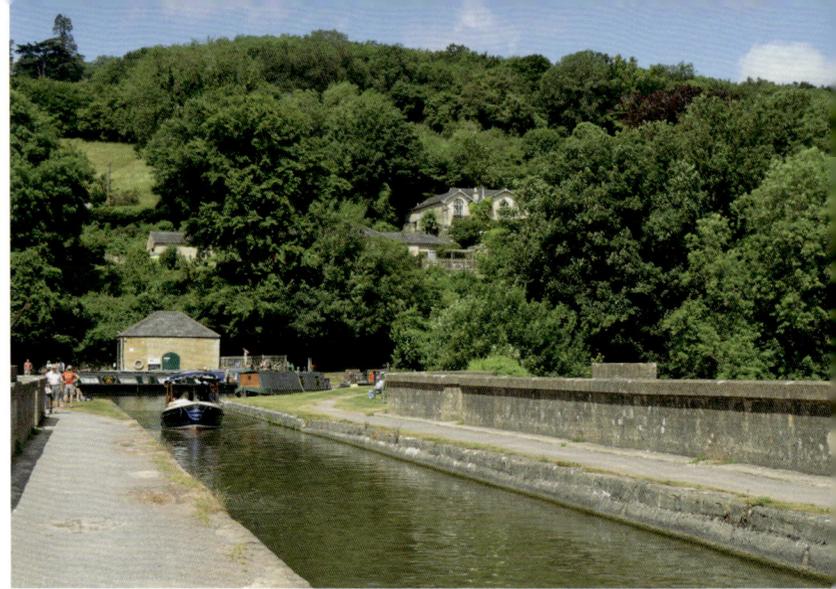

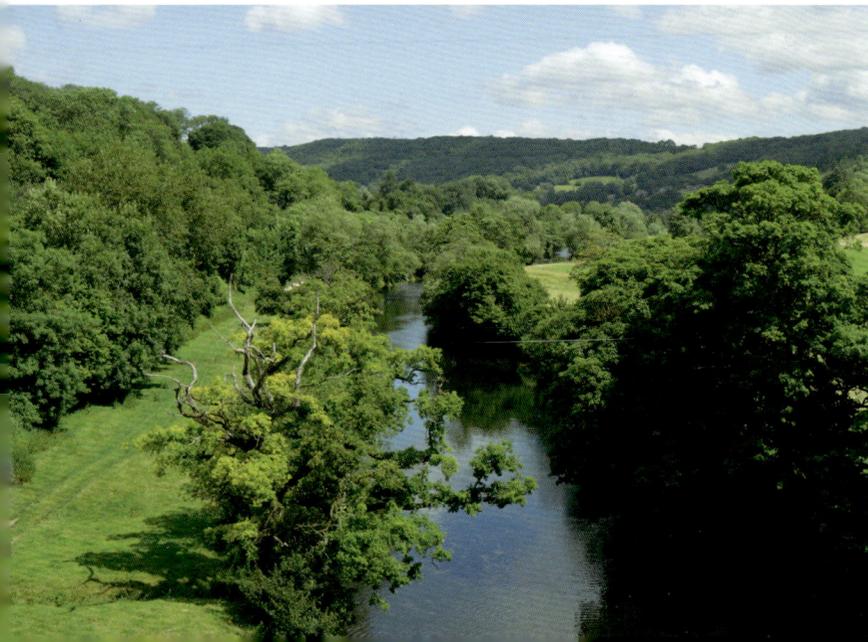

Above left: Side view of the Dundas Aqueduct.

Above right: The canal crossing the aqueduct.

Below: The view north and downriver from the Dundas Aqueduct.

The much narrower Somerset Coal Canal at its junction with the Kennet & Avon Canal.

Somerset
Coal Canal

· OPENED 1801·
TO PAULTON 10 MILES
WITH BRANCH TO RADSTOCK
· CLOSED 1898·

FIRST QUARTER MILE
RESTORED 1986-88
FOR MOORINGS AND
BOAT BASE

PRIVATE
GARDEN

BOAT SKIPPERS
PLEASE STOP HERE AND PICK
UP CREW BEFORE PROCEEDING
THROUGH THE LOCK

Aqueduct and the hamlet of Warleigh, which is on the east side of the valley near the pumping station. Keep this fact to yourself, though, for if you like a quiet walk it is ideal. The canoeists who you normally see on rivers will be up on the canal hereabouts, and the cyclists, and most other walkers, should have preferred the canal towpath to this one. In fact, the whole of the stretch of the valley that runs north from Limpley Stoke to the edges of Batheaston feels particularly rural. When within the valley it seems difficult to believe that you are actually very close to the Bath urban area, whose eastern suburbs are just over the western lip of the valley.

A tower called Brown's Folly is a prominent landmark on the hilltop on the east side of the valley beyond Warleigh. It lies literally just inside Wiltshire and was built in 1848 by Wade Brown, the owner of the manor house at the village of Monkton Farleigh, which is down the other side of the hill. There was quite a fashion for such towers around the country around this time – they were partly intended to catch the eye from miles around as they still do, but also to provide employment in their construction for local people during an agricultural depression. Today there is a nature reserve with woods and open grassland around the folly, where there are also quarries for Bath stone, which must have provided the material for the tower. Some of the underground quarries now provide excellent roosts for bats.

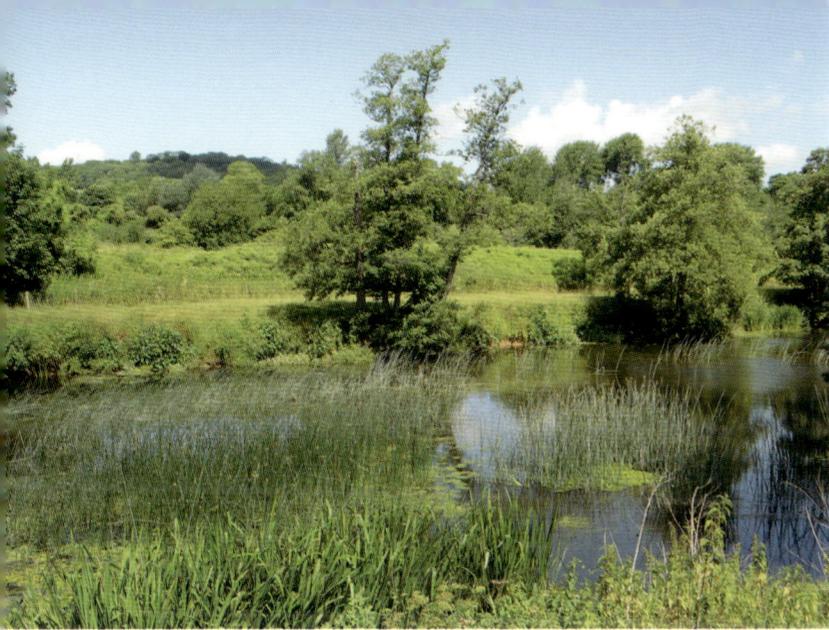

Above left: The peaceful river north of the Dundas Aqueduct.

Above right: The view from Warleigh to Claverton across on the west side of the valley beyond river, railway and canal. The large building on the hilltop is on the edge of the Bath urban area and is the American Museum, billed as the 'only museum of American decorative and folk art outside the United States'. It is housed in a country house built around 1820.

Below: Looking east from Bathampton to the east side of the valley, with Brown's Folly visible on the hilltop.

4

IN AND AROUND BATH

Three miles north of the Dundas Aqueduct the river changes course, turning to the south-west to head towards the city of Bath. In doing so, it is effectively running around Bathampton Down, the hill on the east side of the city that has been on the river's left for the past few miles.

The valley bottom widens out around this turn, and the proximity of the city is shown in the names of the three villages here, which all begin with 'Bath'. Bathford and Batheaston are on the outside of the bend, while Bathampton is on the inner side, below the hill that bears its name.

Between Bathford and Batheaston we cross a tributary of the Bristol Avon called the By Brook. This is formed by a pair of streams that rise not far south-west of one of the Bristol Avon's own sources near Acton Turville. They join near Castle Combe in Wiltshire and the By Brook flows south from its Cotswold origins in a much more direct fashion than the Avon. After leaving Chippenham, the main London to Bristol railway runs through the valley of the By Brook to join at Bathampton with the more scenic line we have been following.

The Fosse Way that we last met on the Gloucestershire–Wiltshire border follows part of the main street through Batheaston, and by leaving this street and by heading up Penthouse Hill we can find our way to one of the famous landscape features of the area: Solsbury Hill.

The hill was made famous by the song 'Solsbury Hill', recorded by Peter Gabriel in 1977 soon after he left Genesis and began his solo career. If you know the words of this song, you will appreciate why I was disappointed not to see any eagles after I had climbed to the top.

The hilltop, which was given to the National Trust in 1930, has an Iron Age hillfort as well as earthworks left by cultivation in the Middle Ages and remains of stone quarrying from the nineteenth century. It is also a fantastic viewpoint, with Bath off to the south-west – hence the reference to 'city lights' in Peter Gabriel's song, as well as a great swathe of the Avon valley.

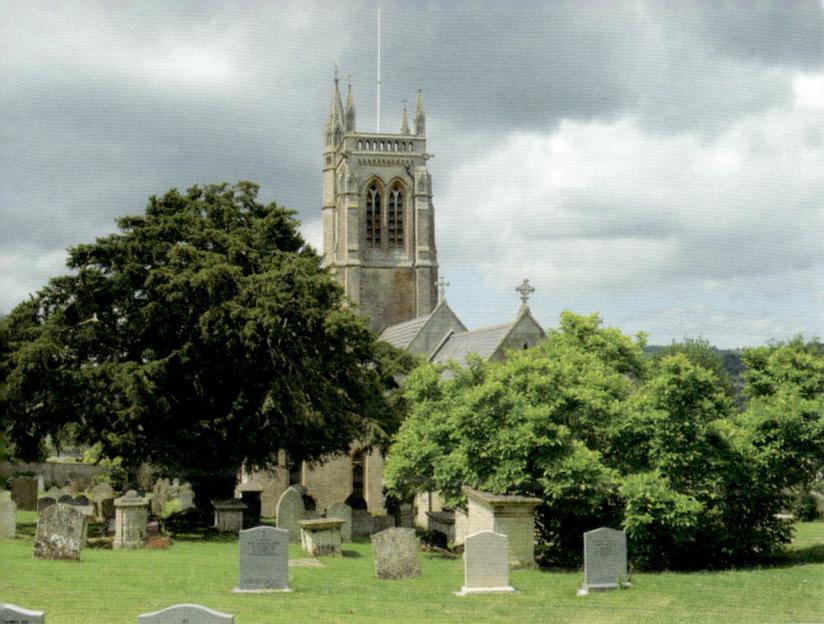

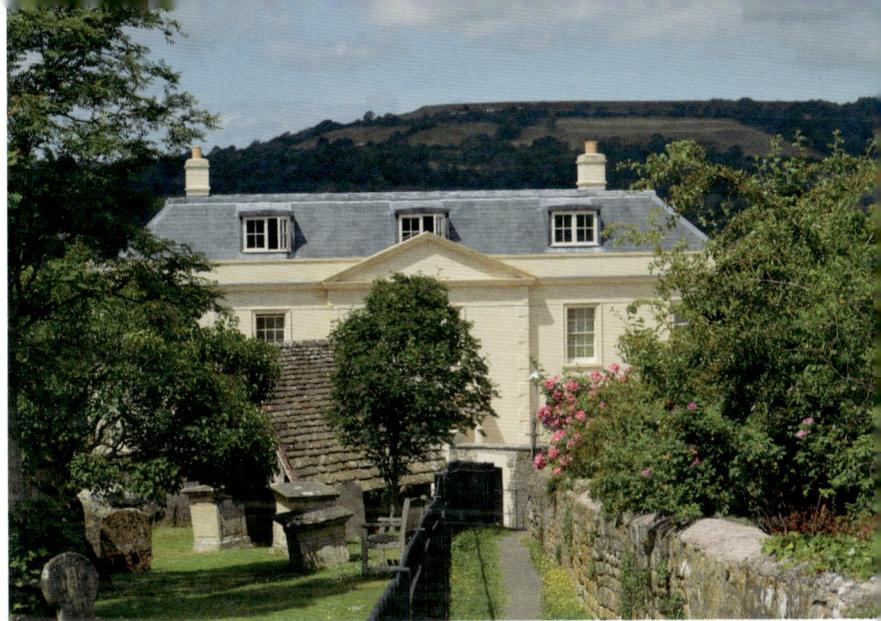

Above left: The parish church at Bathford.

Above right: A view in Bathford with Solsbury Hill in shadow beyond.

Below: The park at Batheaston in part of the former grounds of Batheaston House, which was built in 1712.

Further afield you see the Mendips to the south and the Marlborough Downs and the chalk escarpment of Salisbury Plain to the east in Wiltshire. On a clear day the Westbury White Horse can be made out on the latter, nearly 20 miles away.

The occasional addition of the word 'Little' to the name suggests that there should be a 'Great Solsbury Hill' nearby, but you will search on maps for this in vain. The 'bury' element comes from an old English word for a fortification – presumably referring to the Iron Age hillfort here – and it has been noted that the first element is similar to the name of the local Celtic deity Sulis, about whom more later. The hill has been suggested as the location of the battle of Mount Badon, perhaps partly because of the similarity of 'Badon' and 'Bath', which took place around AD 500 and in which the Britons resoundingly defeated the invading Saxons and pushed them back to eastern England for a considerable time. There seems to be no clear evidence for this, nor for the association of this victory with King Arthur.

Back down in Batheaston, a very pleasant and reasonably priced feature helps us to reach Bathampton. This is Batheaston Toll Bridge, which crosses the Bristol Avon just above Bathampton Weir. The present bridge and the toll house on the Batheaston side were built in 1872, incorporating part of an earlier bridge. Next to the weir there is the Bathampton Mill pub, which as its name implies is a converted early nineteenth century mill.

Going through Bathampton, where we might notice the much-extended church and some scenic views of the Kennet & Avon Canal as we take the bridge over it, we head up onto Bathampton Down. Like Solsbury Hill, this has its own Iron Age hillfort, though its defences are less easy to see among the woodland, and it has also been claimed as the site of the battle of Mount Badon. Bath's university is up here, and there is also a golf course. The area called Bushey Norwood on the east side of the hilltop is in the care of the National Trust, and is excellent for a stroll.

Walking around the open areas of the hilltop you see much evidence of old quarrying – much of the Bath stone of which the city was built came from here. In the eighteenth century, the entrepreneur Ralph Allen invested in quarries on the hill and built himself a grand house, Prior Park, up there.

Then, in 1752, he erected a rather unusual folly. This is the Sham Castle, which was set on the western slope of the hill so that it could be seen, and presumably boasted about, from Allen's townhouse in Bath, as well as the rest of the city. This is still the case today, with the area below the folly being kept clear of trees. Close up it is clearly just the frontage of a castle, and even then it is not entirely convincing, but the point is that it was intended to be seen from afar. You also wonder whether the name 'Sham Castle' was Allen's own idea or one devised by cynical locals!

Batheaston Toll Bridge.

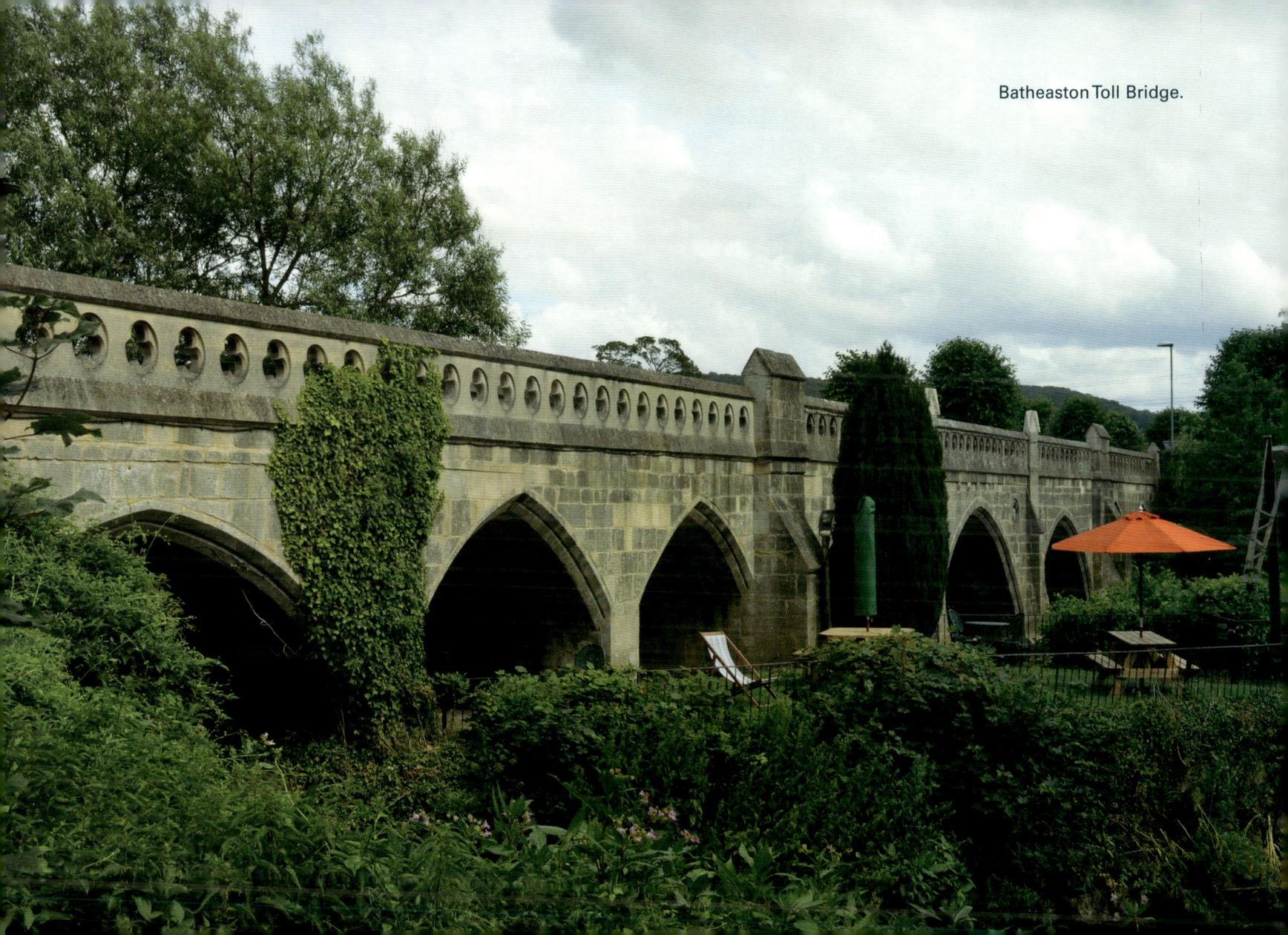

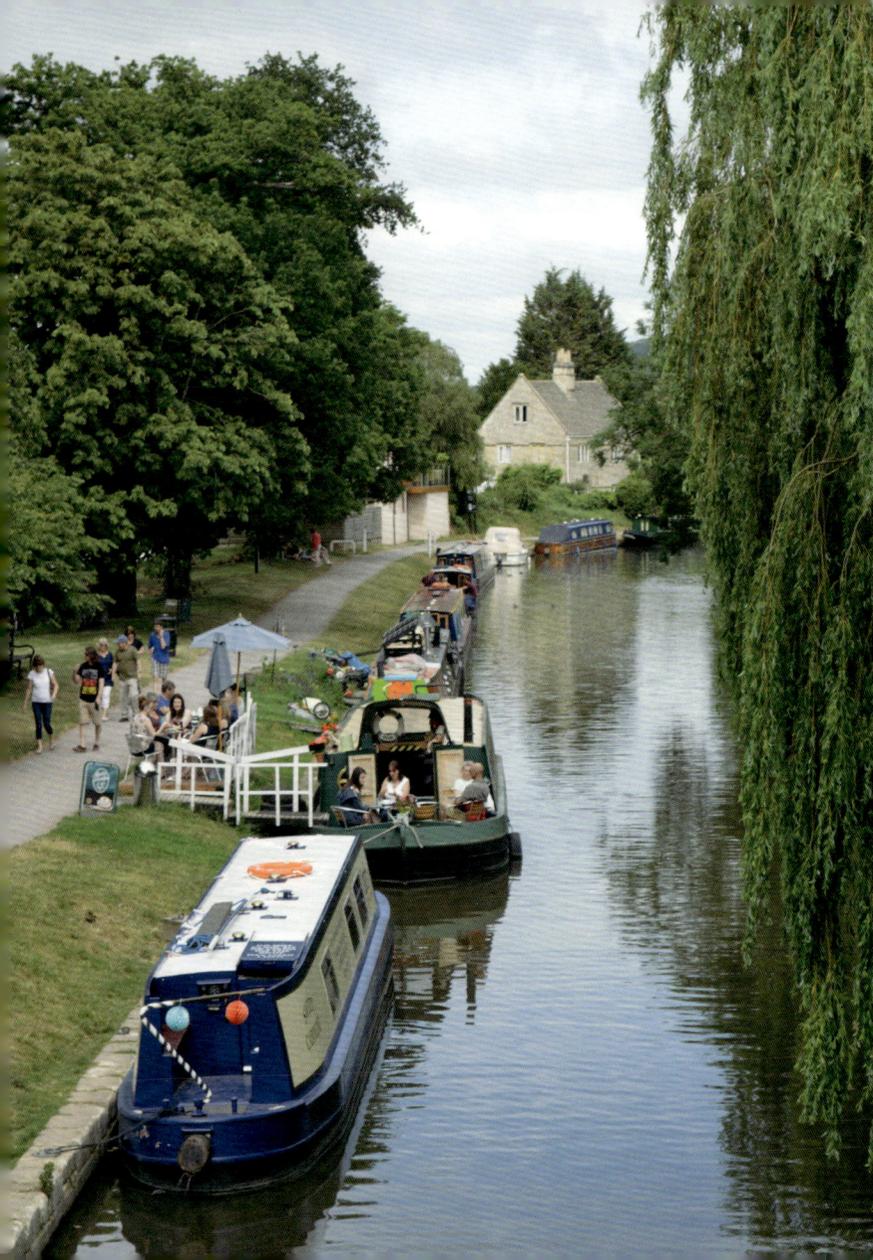

Above: The open parkland on Bathampton Down, east of the university.

Left: The Kennet & Avon Canal at Bathampton.

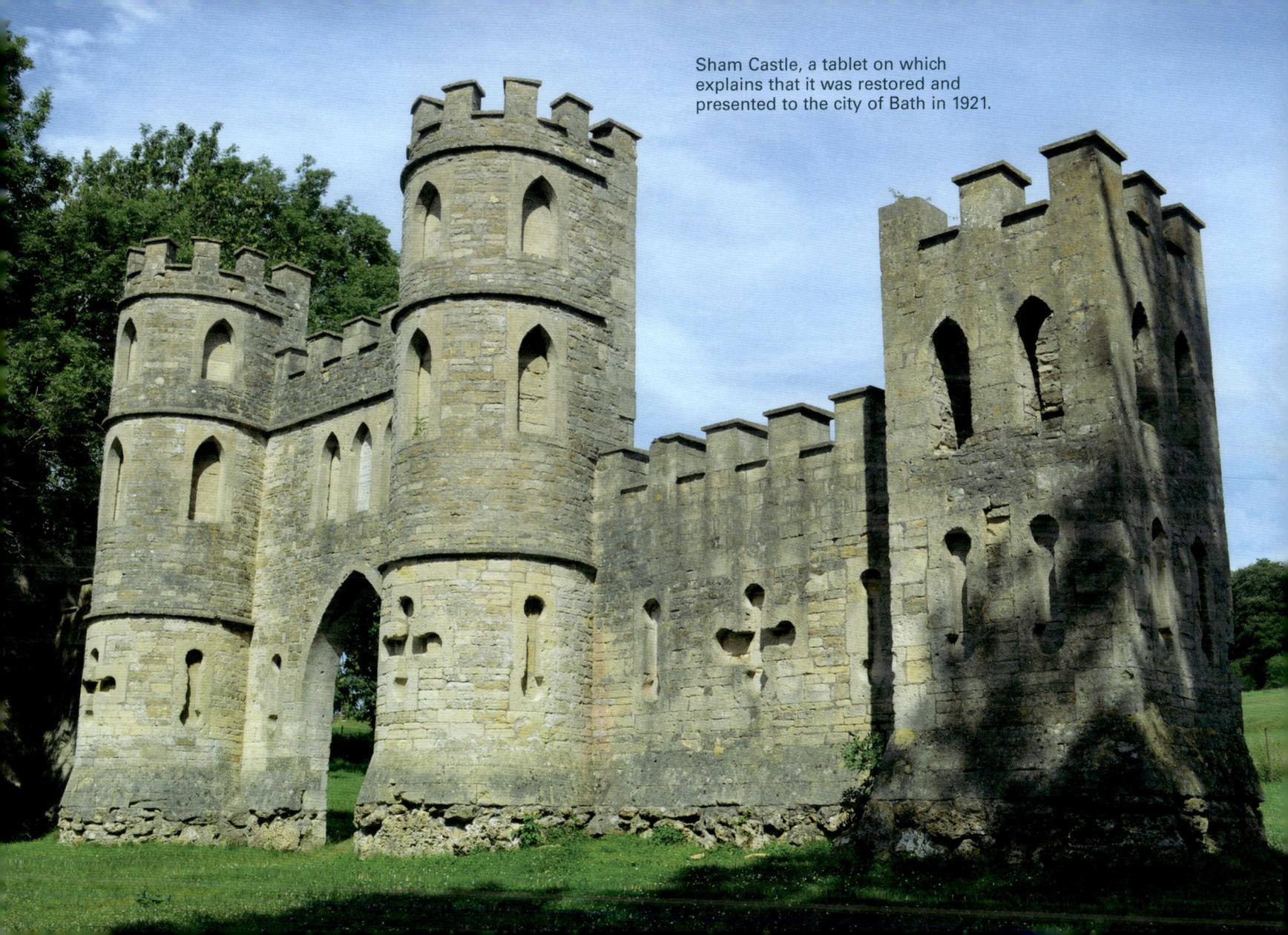

Sham Castle, a tablet on which explains that it was restored and presented to the city of Bath in 1921.

Bath itself is such a major feature of the Avon, and the city's history is so strongly linked to the river, that I should start with some background.

The source of the water in the springs that made Bath famous is the underlying limestone. Rainwater falling on the hills to the south of the city percolates through this limestone, and at depths of around 2 miles its temperature is raised, sometimes close to boiling point, by the Earth's internal heat. It then finds its way back to the surface here through faults within the rock.

There is archaeological evidence that the springs were used in prehistoric times. A Roman temple was built here around AD 60, and the place was given the Latin name of Aquae Sulis. This means the 'waters of Sulis', a Celtic goddess associated with the location, which is additional support that the place was significant in pre-Roman times. Continuing a Roman tradition of assimilating a local deity with one of their own that had a similar function, Sulis and Minerva were combined into the single presiding deity of Sulis Minerva. Over the next few centuries, the spring was enclosed within a bath complex of caldarium, tepidarium and frigidarium – the hot, tepid and cold baths through which the bather progressed as part of what was seen as a health-giving procedure. There is evidence of visitors coming here from across the Roman Empire – in the settled conditions of the empire, wealthy people must have travelled like medieval pilgrims, using religious sites as reasons, or excuses, for their trips.

We tend to think today that the Romans left Britain in AD 410. In fact, all that happened that year was that the remaining units of the Roman army went to fight for a usurper on the continent – they were never to come back, but no one knew that at the time. The army numbers in Britain had been declining for decades, and at the same time people had been leaving the towns established by the Roman administration to go back to a more agricultural economy, often based on the estates of villas. This economy was successful, and though many people still saw themselves as Romans, they were perhaps happy not to have a central government demanding more and more taxes.

This was probably the case at Bath, where some people seem to have remained in the town. Things changed in AD 577, though, when the Saxons of Wessex, under their rulers Ceawlin and Cuthwine, defeated the rulers of the cities of Gloucester, Cirencester and Bath at the Battle of Deorham. Thereafter the local Britons, as they were now known, pulled back to the south-west, and Bath fell into Saxon hands.

A church was constructed here in the seventh or eighth century, and there are references by writers in Saxon times that suggest the baths were still in use. Then in the ninth century King Alfred rebuilt the place as one of his burhs – the fortified towns that were key to his plans to reconquer land from the invading Danes who had very nearly taken over his kingdom of Wessex. The street pattern of Alfred's

Bath seen from a viewpoint in Alexandra Park, on top of Beechen Cliff to the south of the city. Bath Abbey is near the centre, with the Empire Hotel to its right.

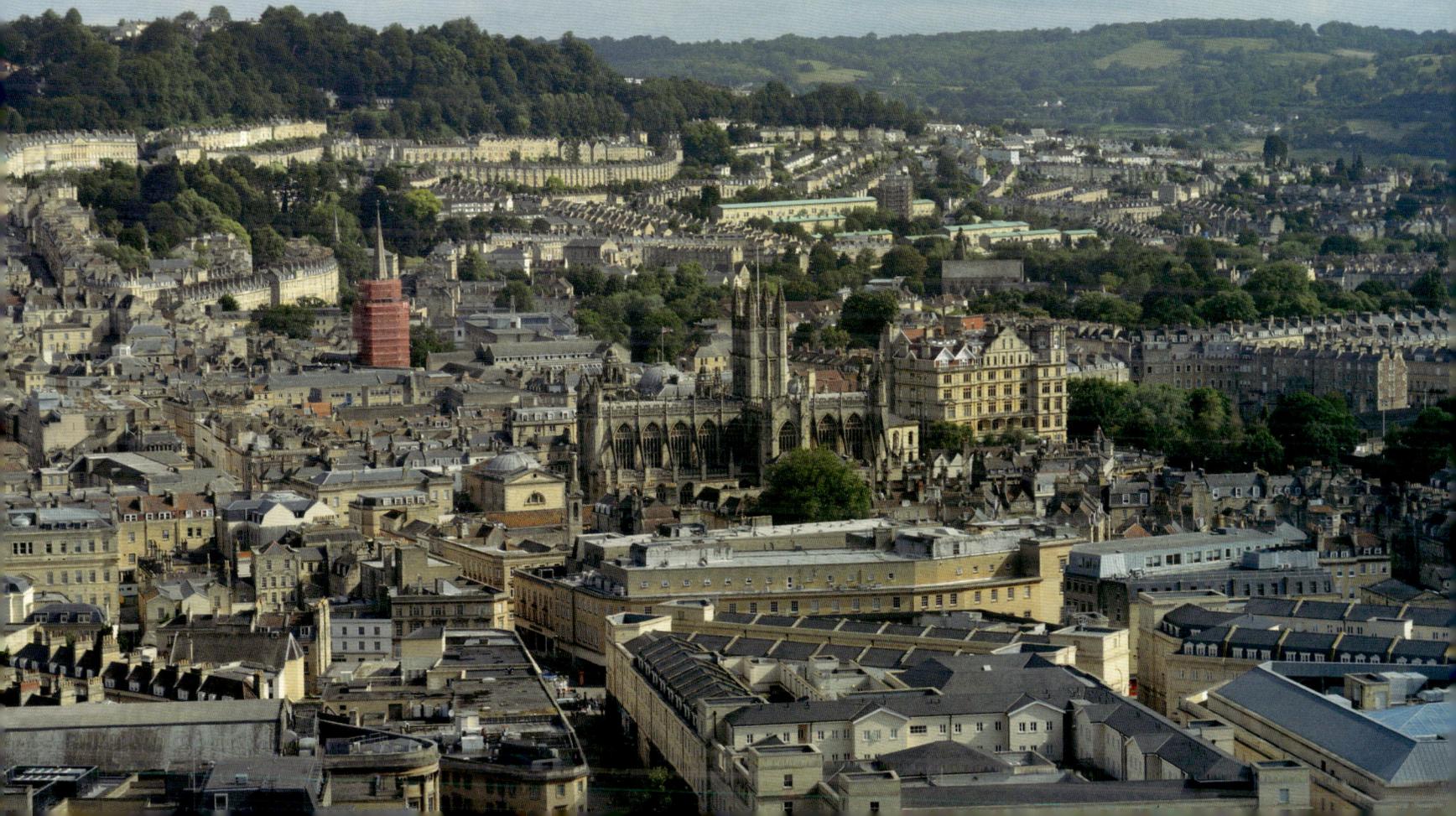

town is very different from the underlying one of the Roman town, suggesting the latter had decayed a great deal by then.

Another major change came in 1088, just after the death of King William the Conqueror. His son gave, or perhaps sold, Bath to John of Tours, the old king's physician. John became bishop of Wells and abbot of Bath, and, since by his time Bath was the larger place, he moved the seat of his bishopric from Wells to Bath. He also planned the rebuilding of the church as his cathedral, perhaps as a former physician John had views on the health-giving properties of the baths, because he also built a new bath building around the springs. Later bishops moved the bishop's seat back to Wells, but the title remains Bishop of Bath and Wells.

An important scientific figure was a contemporary of John of Tours. This was Adelard of Bath, who was born in the city and retired to the monastery here in the early twelfth century. In between, he travelled extensively to Europe and the Middle East, and translated Arabic scientific works into Latin, helping to improve the scientific knowledge of western European Christians.

Bath did well during the Middle Ages. Abbeys require a variety of what we could today call 'support services'. Stone was being quarried in the area and, like towns upriver in Wiltshire, there was a flourishing cloth trade whose goods could easily be transported on the river. By the 1220s Bath had a mayor, which is good evidence of an organised and partly self-governing town.

However, not a great deal survives of medieval Bath. Besides the abbey and another church, there are fragments of its walls and the surviving street pattern, but not much beyond that because of the large-scale building of Georgian times.

Then in the sixteenth century it became common for ordinary people to visit the city for cures in the springs. Legislation was passed ensuring their right to do so free of charge and the city built a bath complex. What really got things started was a visit by Queen Anne in the early 1700s. At the time there was nothing like a royal visit to make a place fashionable, and this was built on in the following decades by two men in particular – Richard 'Beau' Nash and Ralph Allen, who we have already met.

Beau Nash (1674–1761) was born in South Wales and came to Bath in 1702. Within a couple of years he had set himself up as an 'arbiter of elegance' or 'master of ceremonies' for the city, a role he continued in for the rest of his life. Though an unofficial role, it gave him a great deal of influence. He vetted newcomers, deciding whether they could join the 'company' – the social elite of the city at the time – helped to arrange social events, acted as matchmaker and even informally regulated gambling. He also established a form of social informality that broke down barriers between the upper and middle classes in the city.

Ralph Allen (1693–1764) was an extremely shrewd local businessman who first made his money through the postal service, then through stone quarrying. In 1712 he

became Bath's postmaster, and around eight years later was in charge of delivery services across the South-West, where he made considerable improvements. One was the abolition of the requirement that all post had to travel via London, and the other was a system of signing for mail that stopped the postmen and boys from taking payments for delivering undeclared items. For the rest of his life he stayed with the service, enjoying further promotions to control much of the country's post.

Allen was well rewarded financially for his service and invested his wealth in stone quarries on Combe Down as well as Bathampton Down. Here he was also an innovator. The quarrymen had previously sold the Bath stone in rough blocks, but Allen had them cut it with smooth faces, ready for immediate use in the new buildings of the city. He converted his former post office in what is now North Parade Passage into his town house, with John Wood the Elder designing additions in the latest Classical style.

John Wood the Elder was the architect for much more than Allen's house. He effectively acted as town planner for the rapid contemporary expansion of the city, as well as being the architect of much of the building. When he died in 1754, his work was continued by his son, John Wood the Younger.

Another of Nash's associates was Dr William Oliver (1695–1764), who gave him medical advice. Oliver came to Bath in 1725 partly because of his friendship with Ralph Allen, and because of his strong belief in the curative properties of the waters he founded the Mineral Water Hospital, which opened in 1738, built to the design of John Wood the Elder from stone donated by Ralph Allen. The title 'Royal' was added later, and the building is still a hospital today.

People came to visit or live in Bath not just for bathing, but also for the balls and other social events, many of which were organised by Nash, as well as the drinking and gambling that always accompanied such matters. Improvements in the conditions of roads, especially the new turnpikes, and of the organised stagecoaches that used them, made it easier for visitors from London and elsewhere to get here than it would have been even a hundred years before.

Another famous person of a slightly later date who was associated with the city deserves mention here. This is Jane Austen (1775–1817), who lived here between 1801 and 1805. Her parents were married in Bath, later moving to Steventon in Hampshire where her father George was rector and where Jane was born. On her father's retirement the family moved back to Bath, where they stayed until just after George's death in early 1805. Towards the end of their stay the family lived in Gay Street. The Jane Austen Centre is in is sited in the same street today, with displays on Jane and the Bath of her time here. Her novels *Northanger Abbey* and *Persuasion* include scenes set in the city.

In 1987, Bath was granted the status of a World Heritage

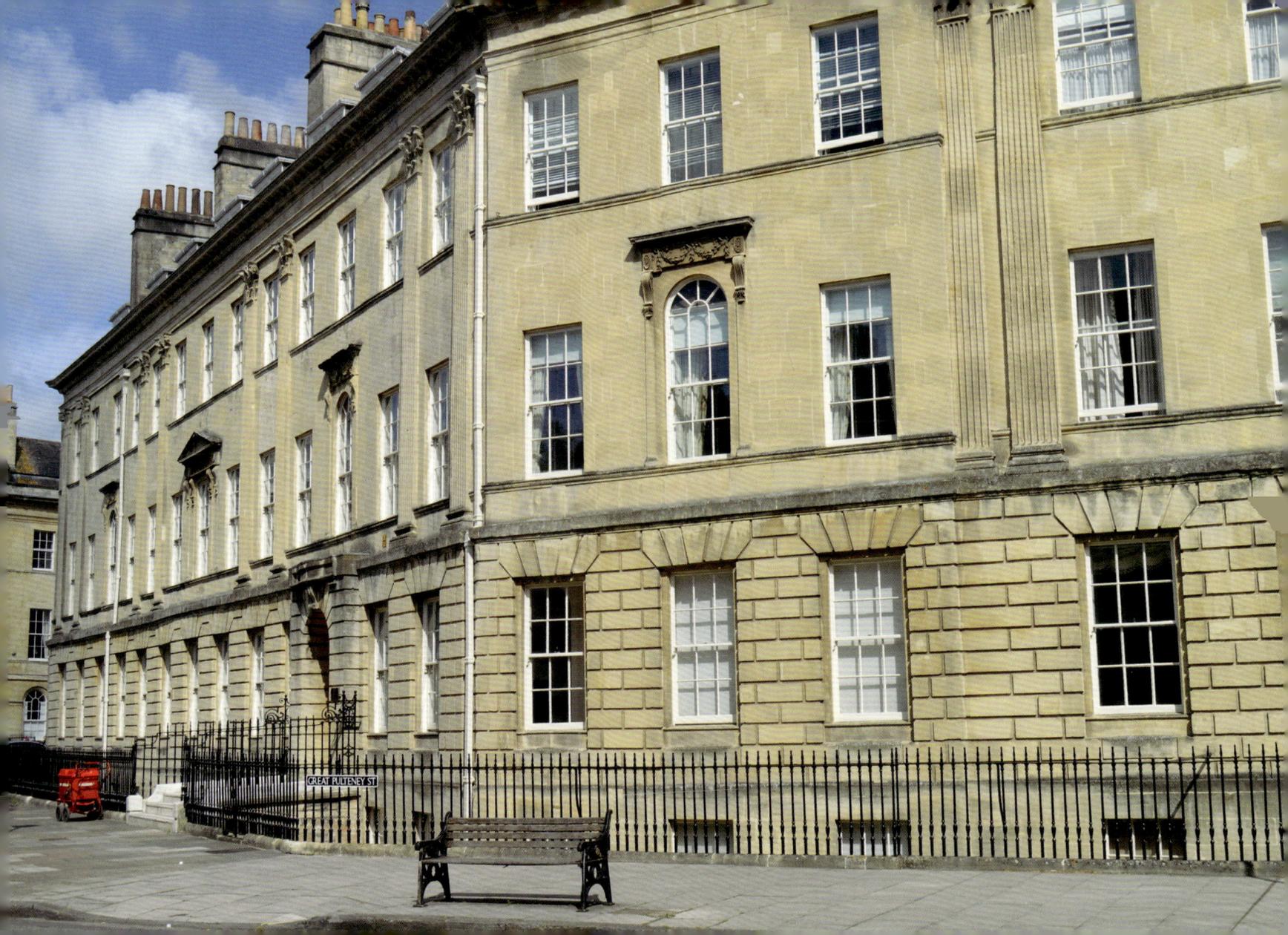

Opposite, this page and overleaf: Architectural details of Georgian Bath.

Site by UNESCO (the United Nations Educational, Scientific and Cultural Organisation). Such sites are those of cultural or natural significance at a level of world importance, and Bath was given this status for the baths themselves and for the Georgian architecture, which covers such a large area in such a state of completeness that it is an architectural landscape rather than simply a group of buildings. Bath is the only whole city in the United Kingdom that has this designation.

We will look at some of the features of the city in detail, starting on the river on the east side of the city centre. Here is the iconic Pulteney Bridge, on which a plaque records 'Architect Robert Adam. Erected 1769–74'. Adam was a Scot who came from a family of architects. He lived from 1728 to 1792, and was famous for introducing a style of architecture heavily influenced by those of Ancient Greece and Rome. Pulteney Bridge was named after a female relative of the Earl of Bath and is considered one of Adam's masterpieces.

Pulteney Weir and Pulteney Radial Gate are just below the bridge. They were constructed in 1968–72 for flood defence purposes and now form the end of the navigable Avon for vessels coming from the sea. Pulteney Bridge is the one of the endpoints of the River Avon Trail, the other being at Pill near the river mouth.

Next on the river's western side is the Empire Hotel, which was built in 1900/01 and converted into apartments in the 1990s. Beside it is the Parade Gardens, which from a vantage point on the east side of the river are overlooked in spectacular fashion by Bath Abbey.

Very little of John of Tours' building survives. Construction of the present abbey began in 1499 and lasted for over a century, being disrupted during the Reformation, and even the seventeenth century completion was patchy, with the nave only getting a timber roof. It wasn't until the nineteenth century that this was replaced with stone, as befits such a building.

On the east side of this stretch of the river there is The Rec, Bath Rugby's ground. The city has had a rugby club since 1865, and it moved to its present ground when the land here was leased from the Bathwick Estate for the enjoyment of a number of sports, including rugby, hence the official title of 'The Recreation Ground'. Bath has been one of the most successful English sides, especially during the 1980s and 1990s. This is a very attractive ground, enhanced by the abbey as a backdrop. Today other sports, as well as rugby, remain important – the ground's East Stand is mobile, being taken away at the end of the rugby season to allow the area to become a cricket pitch. The land here is low-lying, and one of the reasons for the construction of Pulteney Weir was the reduction of flooding at The Rec.

A few hundred yards south along the river we reach a location that passes unnoticed by most visitors, but which in the context of this book deserves commemoration. It is the end point of the 57-mile-long section of the

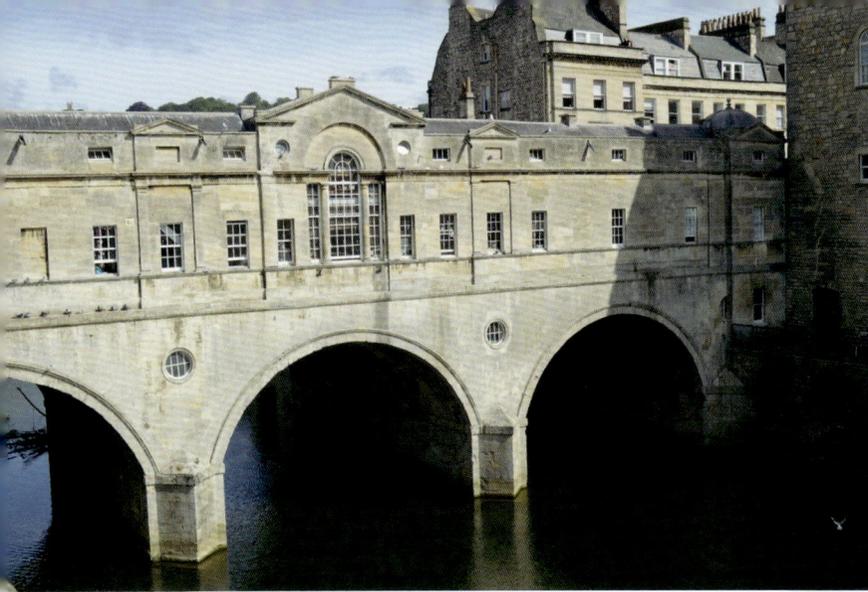

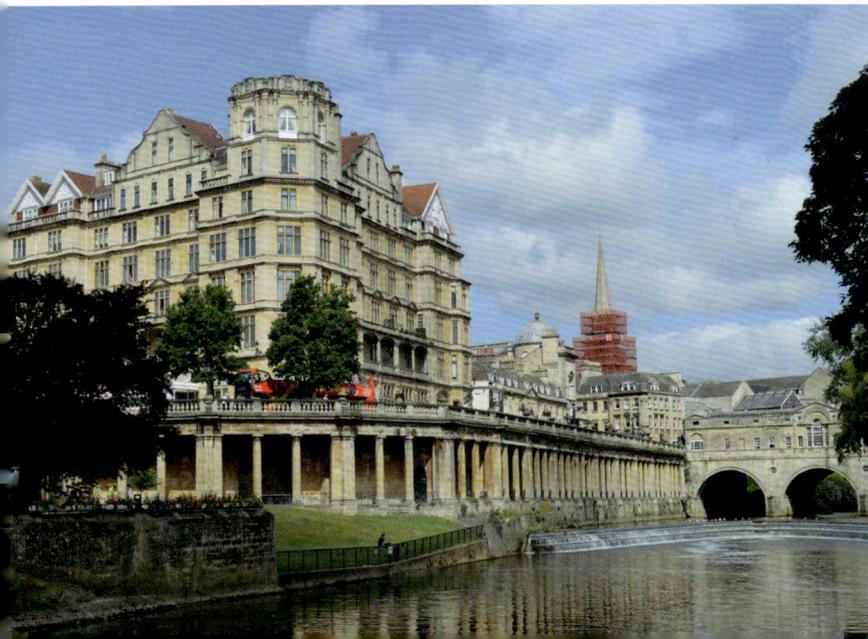

Above left: Pulteney Bridge.

Above right: In very practical fashion, Pulteney Bridge was constructed with buildings on top of it, including this row of shops.

Below: The Empire Hotel and Pulteney Weir.

Bath Abbey above the
Parade Gardens.

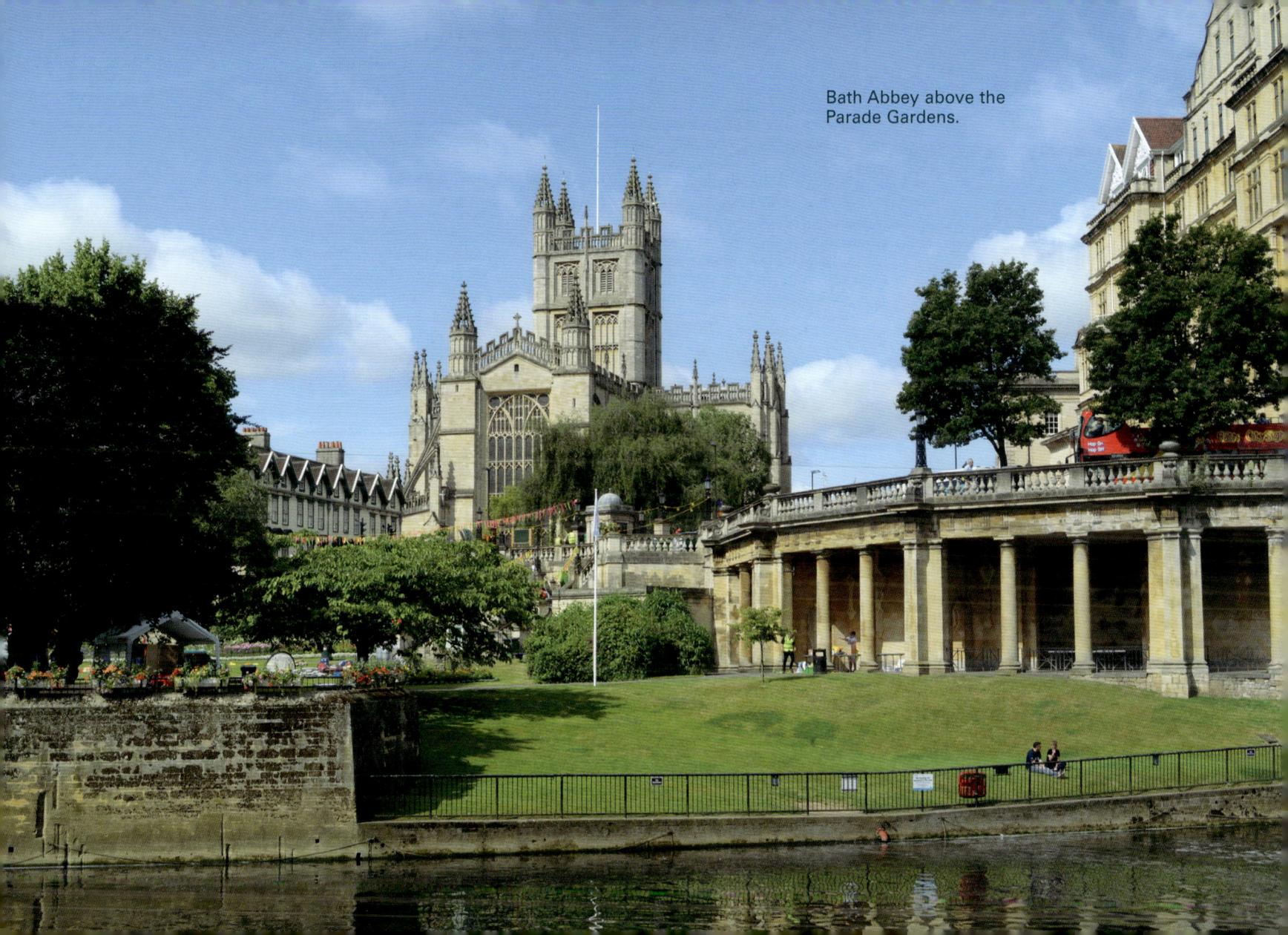

Kennet & Avon Canal that was built to link the existing rivers, and which we have been following from Whaddon. The location is marked by a finger-post that tells you that Bristol Harbour is 18 miles down the Avon, and that Reading is 75 miles back along the canal. There is also Bath Bottom Lock here and the adjacent Thimble Mill, which pumped water back from the river into the canal.

From now on, with the exception of the Floating Harbour in Bristol, the river and canal share the same course. The six locks constructed by John Hore in the 1720s are still in operation; they are numbered 1 to 6 from the Bristol end and are located at Hanham, Keynsham, Swineford, Saltford, Kelston and Weston. Together they give a rise of 30 feet in 12 miles.

We will now head away from the river to the central part of the city that was behind the abbey as we looked from the river earlier. To the south of the abbey, Ralph Allen's townhouse in North Parade Passage is not easy to see. It is close to Sally Lunn's Eating House, forever associated with the Bath bun and its original creator, who may or may not have actually existed.

Round to the west of the abbey we find the baths, which are still one of the city's main visitor attractions. The Assembly Rooms here were designed in 1769 by John Wood the Younger, and The Grand Pump Room through which visitors first enter was built between 1789 and 1799. Although the water was coming from the same springs as the Romans used, it is surprising to learn that Nash, Allen and their friends never saw the Roman bath complex. It was not until some systematic investigation in 1881 that the main Roman bath was rediscovered. The superstructure topped by statues of Roman emperors and generals was constructed over this between 1889 and 1897.

Further west we can join Gravel Walk to get to the Royal Crescent. The walk was laid out in the Georgian period to link the Crescent and the rest of Bath's expanding western suburbs with the city centre. It was designed with the sedan chairs of the wealthy citizens in mind, and its use by strolling lovers such as two characters in Jane Austen's novel *Persuasion* gave it the alternative name 'Lovers' Walk'.

The famous Royal Crescent is on the higher ground on the north-west side of the city and was built between 1767 and 1774 to the design of John Wood the Younger. At the time the area was still open land, so the Crescent would have been even more impressive than it is today, being visible from a large section of the Avon valley. And of course the views from the Crescent would have been a great selling point.

We cannot really complain about what blocks those views today, though. These are the trees of one of the earliest public parks in the country – Royal Victoria Park. It was formally opened in 1830 by the Princess Victoria, who was so impressed that she allowed the word royal to be included in its name. Seven years later Victoria became queen, and in that year the Victoria Majority Monument was erected here in the park to celebrate.

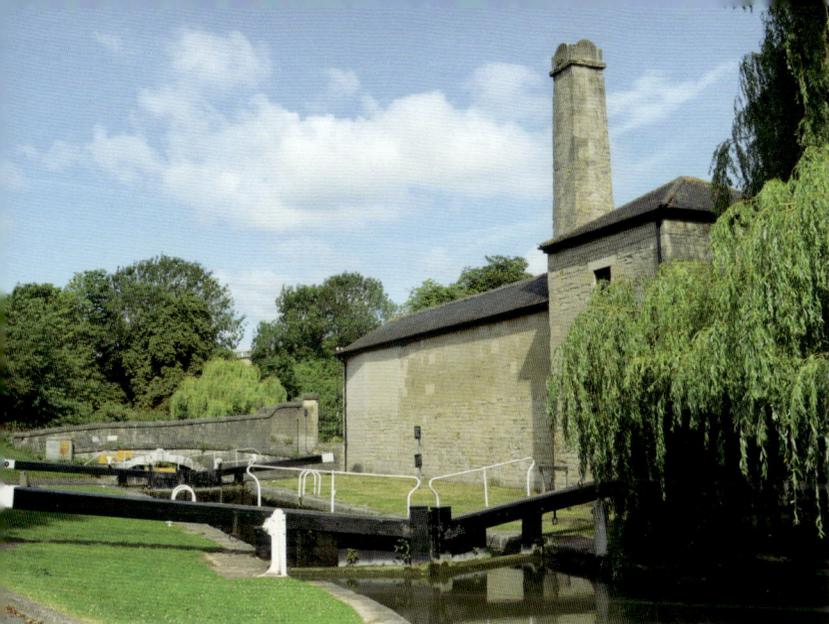

Above: Bath Bottom Lock and Thimble Mill.

Right: The fingerpost at the junction of the Kennet & Avon Canal and the Bristol Avon.

Above: A detail of the frontage of the Pump Room.

Left: Sally Lunn's in North Parade Passage.

Royal Crescent.

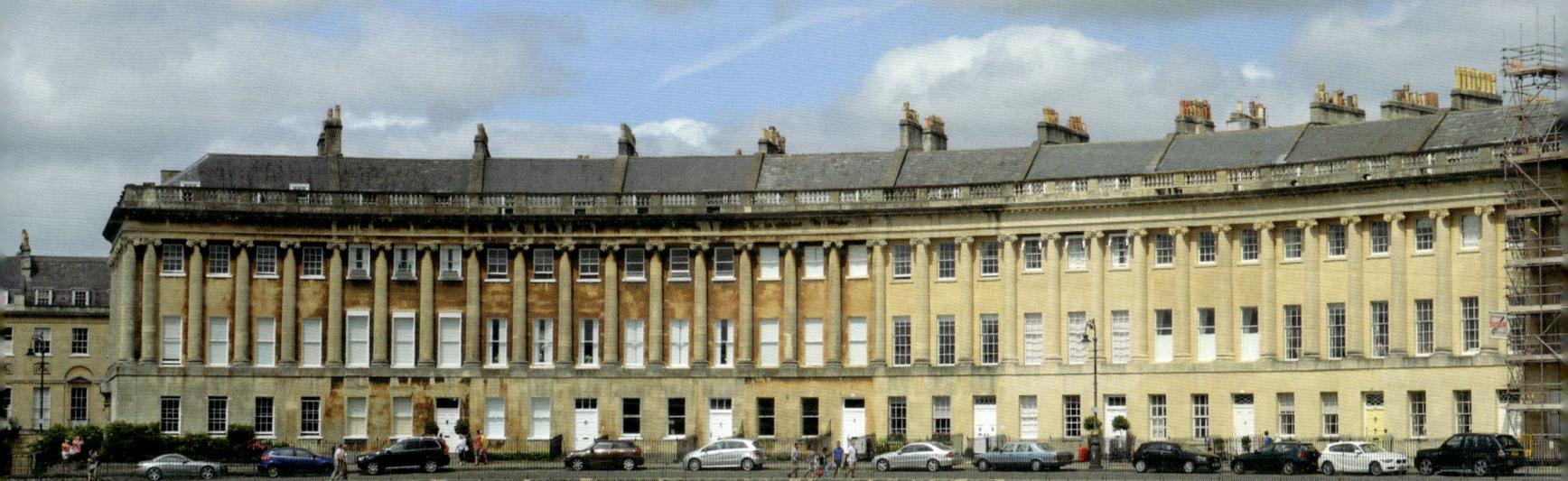

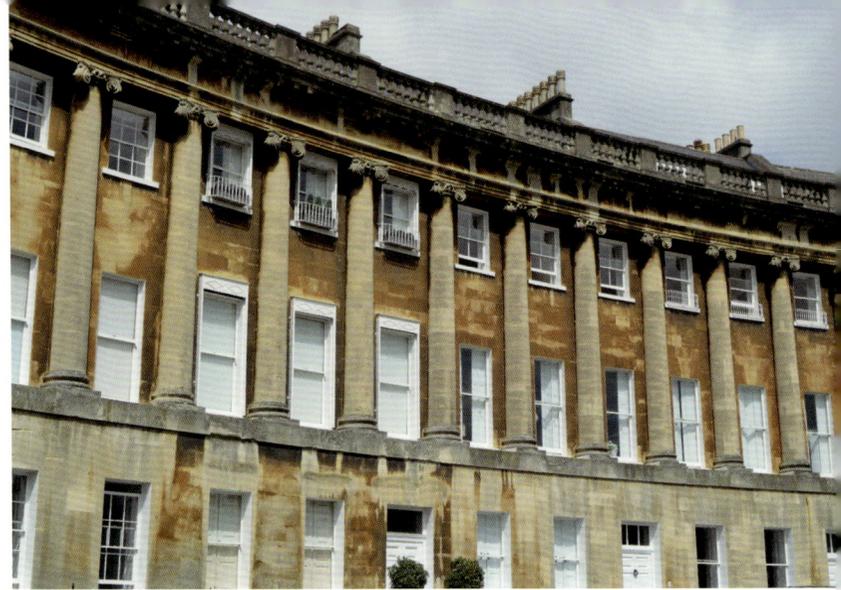

Above: A detail of Royal Crescent.

Left: The Victoria Majority Monument in Royal Victoria Park.

5

TOWARDS BRISTOL

On leaving Bath, the river takes a course towards the north-west, although it meanders quite a bit as it does so. Less than a mile from the edge of modern Bath, we reach the village of Newton St Loe.

Seventy years ago the writer Arthur Mee described the village as 'one of the quiet corners of the world, a delightful little place, a small church on a hilltop, a great park round about, and fine views everywhere.' Although a busy road in the valley can be seen here and there, this holds true today, with the hills round about blocking views back into Bath and of the more distant Bristol conurbation in the opposite direction.

The place is not named after a saint as it might appear, instead it bears the name of a Norman called Roger St Loe, who became the lord of the village in 1100. The older buildings here are a delight to look at, showing how the local stone looked before Ralph Allen had its faces smoothed out.

There are two areas in particular that I would recommend if you were visiting. The first is the little triangular village green, with its tree and what is apparently a Victorian fountain but looks like a large bowl on a column. Then there is the parish church and the street leading up to it, which is lined with some delightful seventeenth- and eighteenth-century buildings. On the north side there is Stonewalls, which has an ammonite set above the front door and, higher up, a sundial with the date 1715. On the south side is the local Duchy of Cornwall office in a building constructed as a rectory in the eighteenth century, and next to it the former school. An inscription above the door of the latter says it was built in 1698 as the expense of one Richard Jones of Stowey, which is 8 miles to the south-west. It was converted into a parish meeting room in 1911.

Looking across the valley from Newton St Loe, there is a very noticeable building on the opposite hillside – Kelston Park. It was designed in the 1760s by John Wood the Younger for Sir Caesar Hawkins, a medical officer who served both King George II and his successor George III.

The fountain in Newton St Loe.

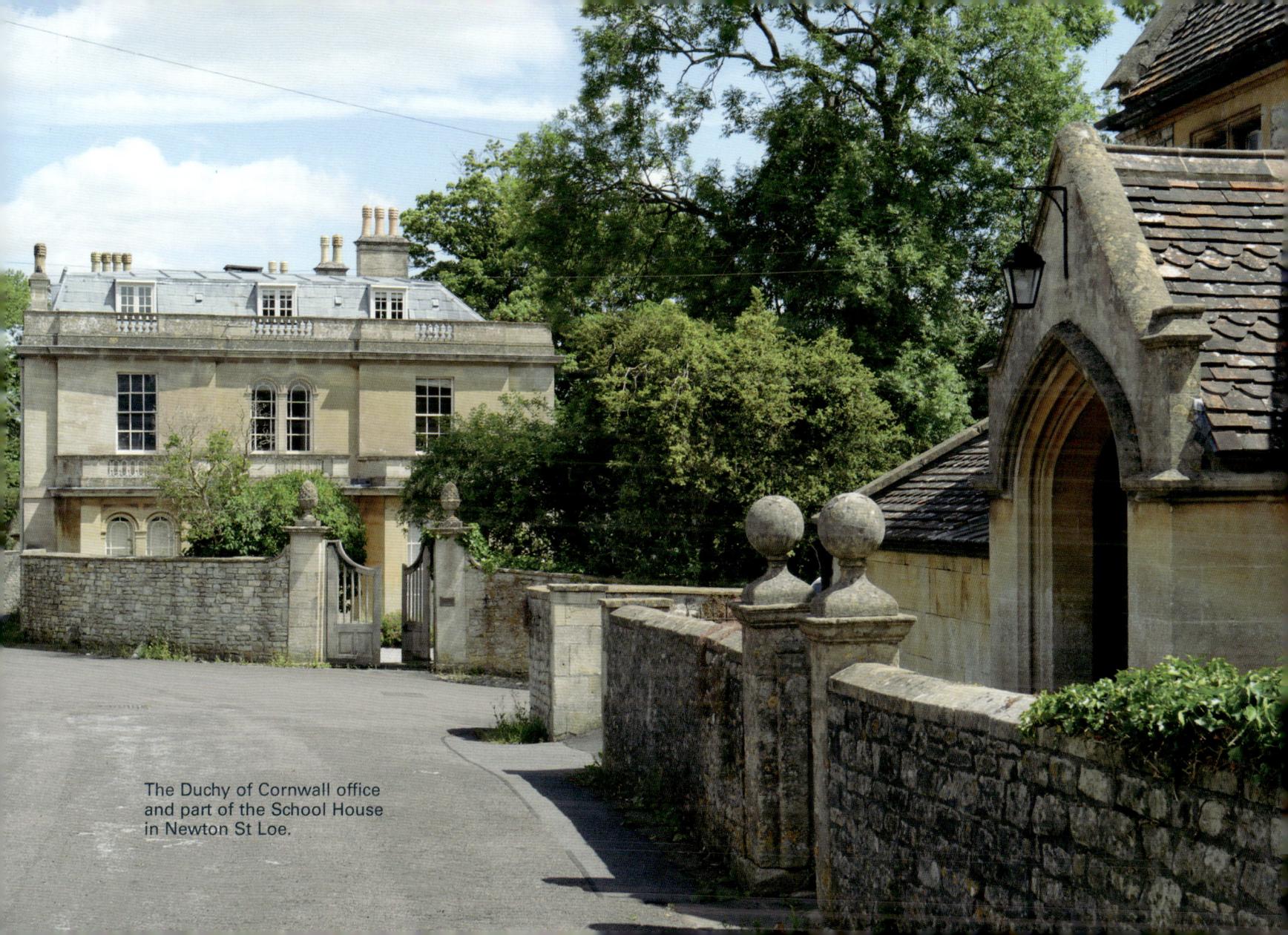

The Duchy of Cornwall office and part of the School House in Newton St Loe.

The house replaced a Tudor mansion in Kelston village nearly a mile to the north, with this site presumably chosen for its scenic views of the valley, as was newly fashionable. Around the same time, Hawkins commissioned the great landscape designer of the day, and possibly most famous of all time, Lancelot 'Capability' Brown to design the surrounding parkland.

Two miles further on from Newton St Loe is the village of Saltford, where the ancient parish church had to be rebuilt in the mid-seventeenth century after damage during the recent civil war. From here the river takes a particularly large loop off to the north-east, passing beneath the steep hill where the village of North Stoke and an Iron Age hillfort are located. Two of John Hore's locks – Saltford and Swineford – appear in quick succession.

Towards the end of the loop the river passes under a railway bridge. The line here was constructed in the 1860s by the Midland Railway and ran between Mangotsfield, on the railway's existing Birmingham to Bristol line, and Bath. It was never a massive success, not being helped by the Great Western Railway's own line running parallel on the other side of the river for much of its route!

Though the line closed as part of the Beeching cuts, a 3 mile stretch is still operated by enthusiasts. This runs from Bitton in South Gloucestershire to a new station constructed just south of the bridge to serve the nearby Avon Country Park. The line is also part of cycle and footpath networks.

Two miles down the road from Saltford, although at least twice that distance if you go by river, is the town of Keynsham, which has had quite a history.

Two Roman villas have been excavated here – one in 1921 when the chocolate factory, about which more later, was being built and another at the cemetery on the west side of the town in 1929. This has led to the local interpretation that a Roman settlement called Trajectus that is known from other evidence to have been in this area was at Keynsham, although a location back at Bitton has also been suggested. Either would fit the name, since *trajectus* or *traiectus* means 'crossing' in Latin, presumably a reference to a ford or bridge across the Bristol Avon or a tributary.

Keynsham itself dates from Saxon times, although there is a legend that it was named after a British princess of the fifth century, St Keyna. However, there is no good evidence that Keyna ever came here, and presumably someone once noted the similarity of names and drew their own conclusion.

A tributary, the River Chew, joins the Bristol Avon at Keynsham. Before doing so it flows through Keynsham Memorial Park, where the ruins of Keynsham Abbey are on display. This was founded around 1170 and belonged to the Augustinian order. After the Dissolution of the Monasteries, Keynsham House was built on the site, using some of the building material of the abbey. The house was itself demolished later, and some of the stonework ended

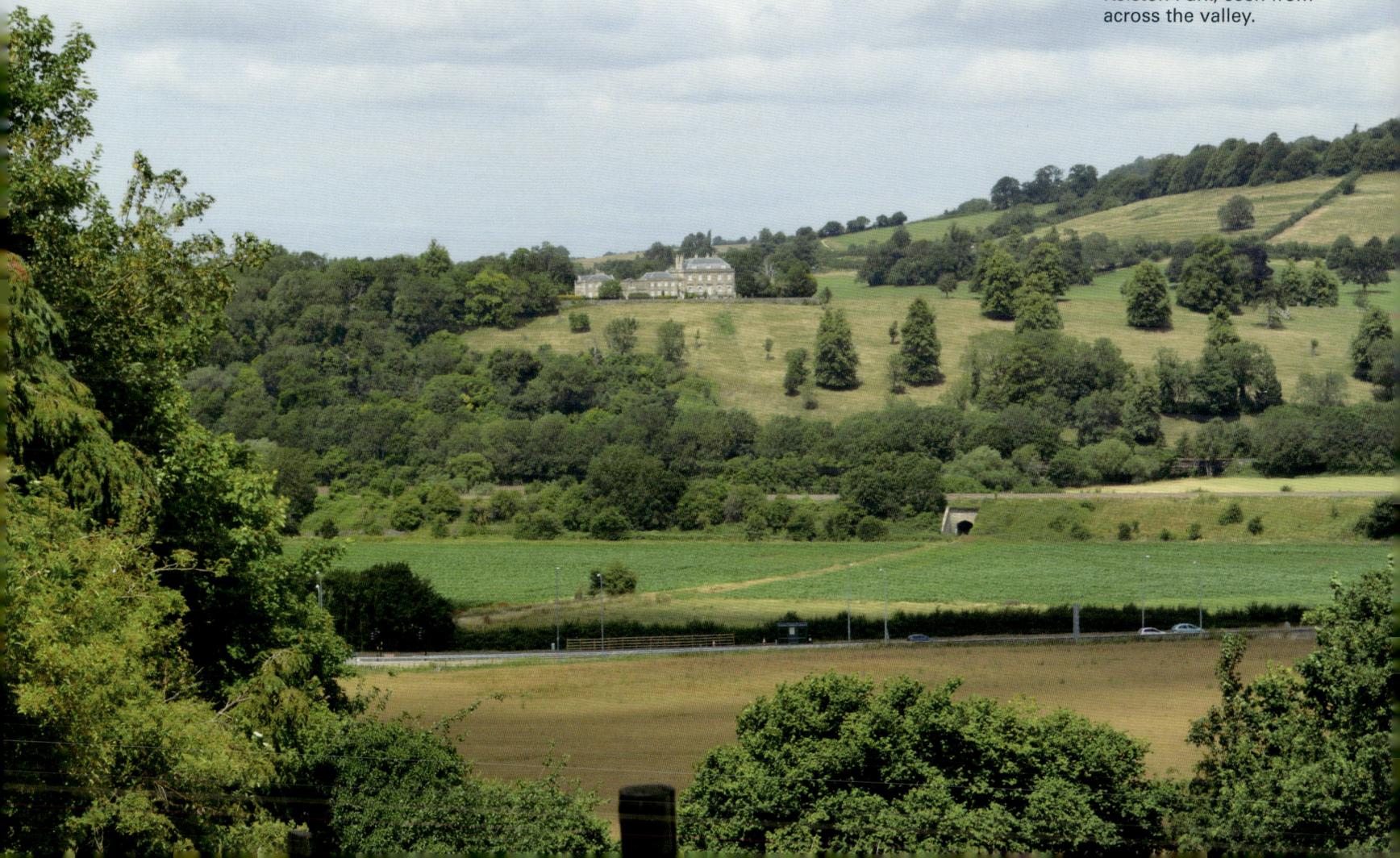

Kelston Park, seen from across the valley.

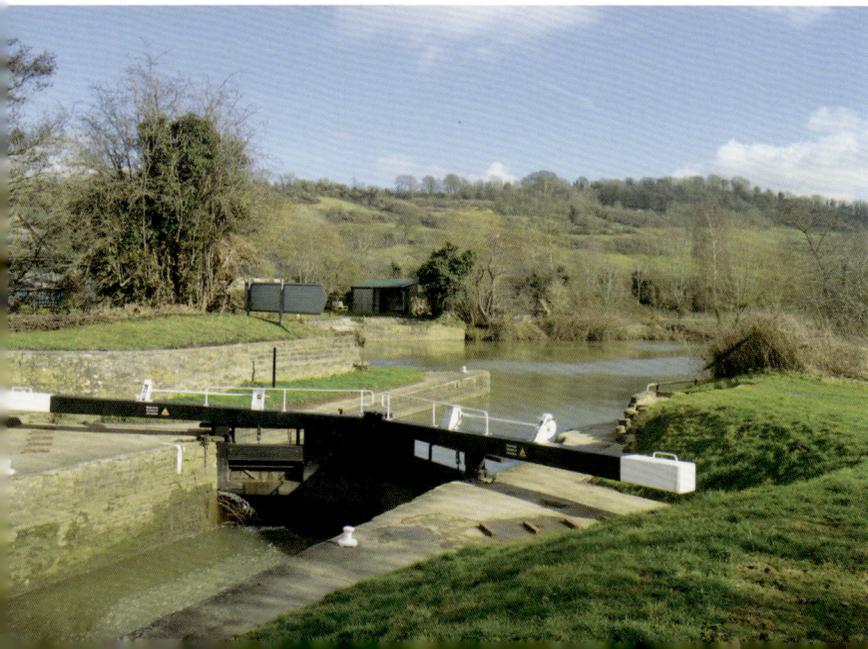

Above left: Saltford parish church, much of which dates from the twelfth century, while parts of the tower are thought to date from Saxon times.

Above right: The river at Saltford, looking towards Saltford Weir and the Iron Age hillfort at North Stoke.

Below: Swineford Lock.

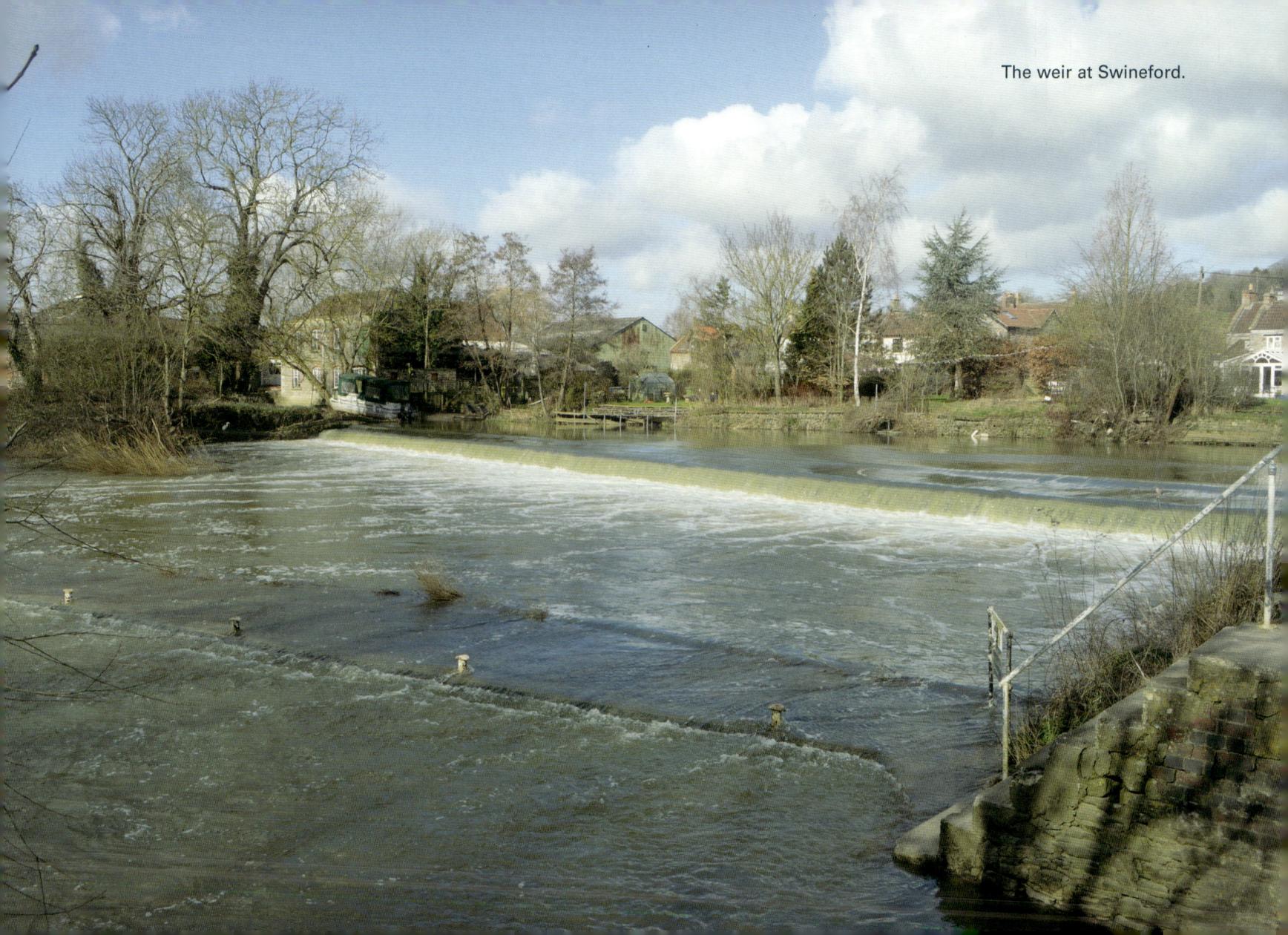

The weir at Swineford.

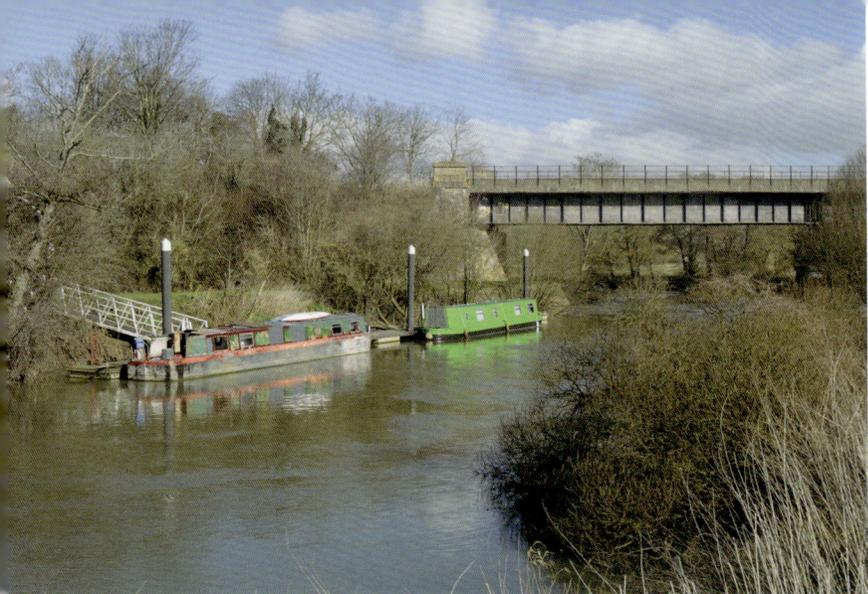

The Midland Railway's bridge over the Bristol Avon.

Avon Riverside station, which serves Avon Country Park.

up in an archway entrance in Station Road. Within this archway there is a mix of twelfth and thirteenth century stonework from the abbey itself, and some that was shaped in the seventeenth century when Keynsham House was built.

There was also a minor battle here that had a significant consequence. James, Duke of Monmouth, was an illegitimate son of Charles II. As a Protestant, he was preferred by many in the south-west as an alternative ruler to his uncle, James II. In 1685, Monmouth returned from exile, landing at Lyme Regis in Dorset, and a rather rag-tag army mustered to his cause. They were unable to capture the well-defended Bristol, and intending to head north on 25 June they crossed the bridge at Keynsham, which James II's men had damaged to make it difficult to cross. They then fought a skirmish with those forces on the north bank. A captured prisoner told Monmouth how many men were now ranged against him, persuading him to turn back south on a meandering route that took him to a final defeat at Sedgemoor in central Somerset. Monmouth was executed and an example was made of the defeated, with many people also being executed or transported; not just soldiers, but even those who had only sheltered the wounded.

A more recent piece of history concerns the riverside chocolate factory where the Roman villa was found. J. S. Fry's chocolate-making business began in Bristol in the 1750s. Then in 1919 the company merged with Cadbury's, and the Fry's side of the business moved out to this new site, which was named 'Somerdale Garden City' following a competition among the workforce. The new factory was finally completed in 1935 and had its own railway sidings. The Fry family were Quakers, and the new factory continued their tradition of providing social and recreational facilities for the workforce. Cadbury's stopped using the brand name 'Fry's' for the chocolate produced here in the early 1980s, and in 2011 the factory closed.

By the bridge that takes the northward road over the river, and so close to the scene of Monmouth's skirmish, there is another of John Hore's locks, which is bypassed to the south by the main river channel. There is a pub here, the Lock Keeper, which was built as a private house in the seventeenth century but had become a pub, then known as the White Hart, by the time the lock was built. Next to it there is a pretty little bridge over the lock and a causeway that took the road across boggy ground to the north, both of which are now bypassed by the modern road.

These features are in a separate county from Keynsham, for just before Keynsham and for several miles into the Bristol conurbation, the river forms the southern boundary of South Gloucestershire.

Another mile past Keynsham, the valley narrows into the second of the three gorges on its route, this one called after the nearby settlement of Hanham. This feature helps to maintain a rural feel for the river for several miles, even

The archway in Station Road, Keynsham.

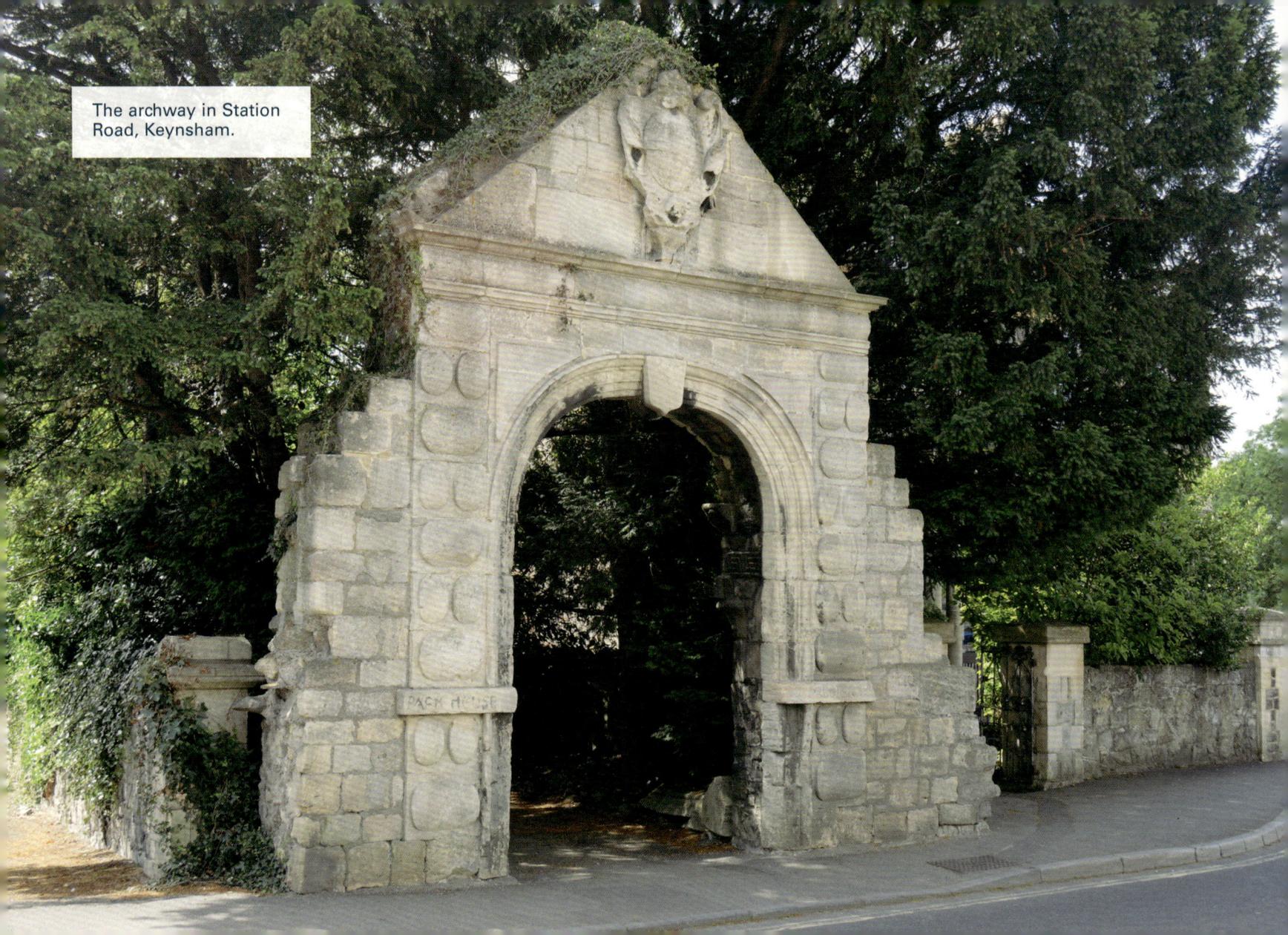

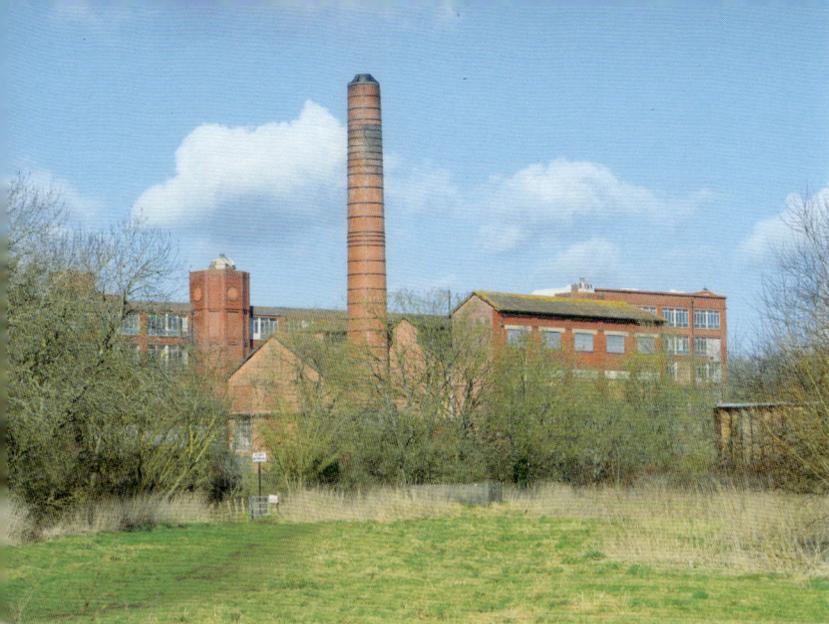

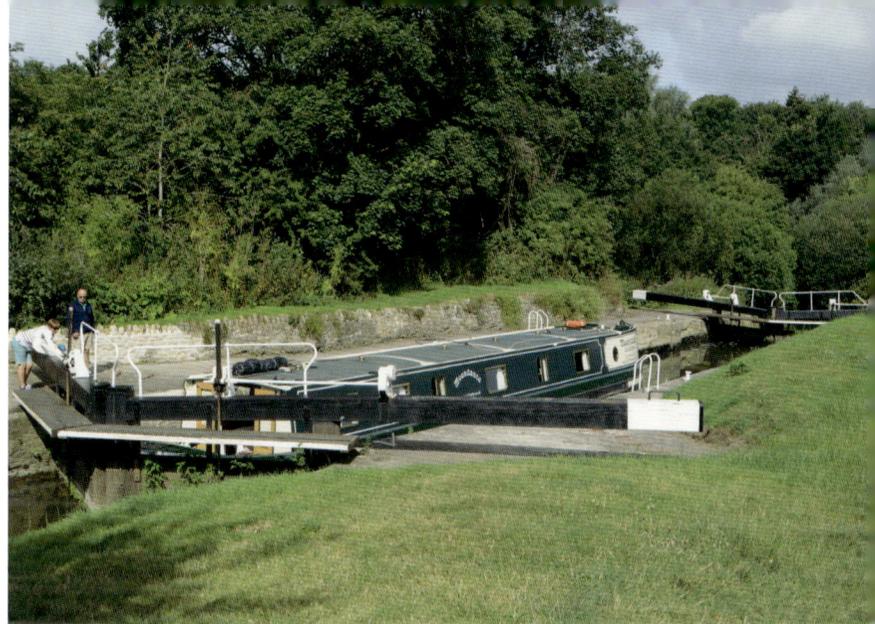

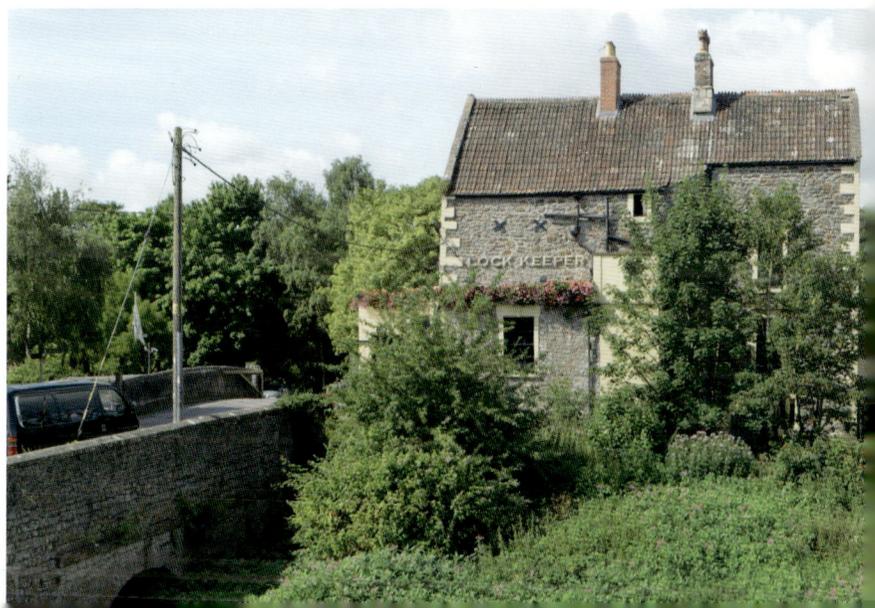

Above left: The former chocolate factory.

Above right: Keynsham Lock.

Below: The Lock Keeper pub and part of the causeway.

though around the spot where it enters the gorge it also comes into the Bristol conurbation – at river level you often cannot see the houses around you.

There is one very obvious exception to this. Not far past Hanham Lock, the A4174 uses a very noticeable bridge to cross the Bristol Avon. The alternative name of this road, the 'Bristol Ring Road', reflects the original intention of its designers, but only the half the job was done, on the northern and eastern sides of the city.

Two more miles into the city there is an excellent example of how rural the river can look, though it was not always so. Conham River Park sits within a loop of the river on the South Gloucestershire side. Today there are lots of trees and, again, houses can only be glimpsed occasionally. However, as the interpretation boards explain, there was a great deal of industry here in the nineteenth century such as quarrying, metalworking and candle making for nearby mines. Then in the twentieth century a sewage works was built and the rest of the site became a rubbish tip. All of this pays tribute to the amazing job of restoration that began here in the late 1970s.

Above left: Hanham Lock.

Above right: Cottages near Hanham Lock.

Below: The A4174 crosses the Bristol Avon.

Conham River Park.

6

THE FLOATING HARBOUR

The limited size of the existing harbour in Bristol and its tides in the river had begun to cause problems as trade and the size of ships both increased. In 1802 the civil engineer William Jessop, who had worked on canals and harbours across England, as well as a major canal in Ireland and a very early railway in Scotland, proposed the construction of the dam and lock at Hotwells to create a new harbour. Work started in 1804 and included construction of the Feeder Canal, the New Cut and Cumberland Basin, and the new harbour opened in 1809. The new construction is sometimes just called 'Bristol Harbour', although the 'Floating Harbour' is more common and refers to the water level being regulated to keep it at the same level.

We reach the start of the Floating Harbour complex at Netham Lock, a mile or two beyond Conham River Park. Here some of the river is diverted from its natural course into an artificial construction called the Feeder Canal, presumably so named because it 'feeds' water into the main body of the Floating Harbour.

The Feeder Canal runs almost straight for a mile to Totterdown Basin, just south of the main railway station, Bristol Temple Meads. Meanwhile, the river has reached a similar location on its natural, more looping course to the south. Some serious digging must have been done here just over 200 years ago, for now the two bodies of water 'swap' over. From Totterdown Basin the widening main body of the Floating Harbour continues from the Feeder Canal and follows the original course of the Avon through the city. The river itself enters an artificial channel called the New Cut, which runs along to the south of the harbour, roughly parallel to it. Unlike the Floating Harbour, the New Cut is tidal.

We will mainly follow the Floating Harbour rather than the New Cut through the city centre. Not only does it pass more of the historic features, but it was also the actual route of the Avon until just over 200 years ago.

This certainly does not mean that the New Cut is without interest. One feature of note is Langston Street Bridge, also

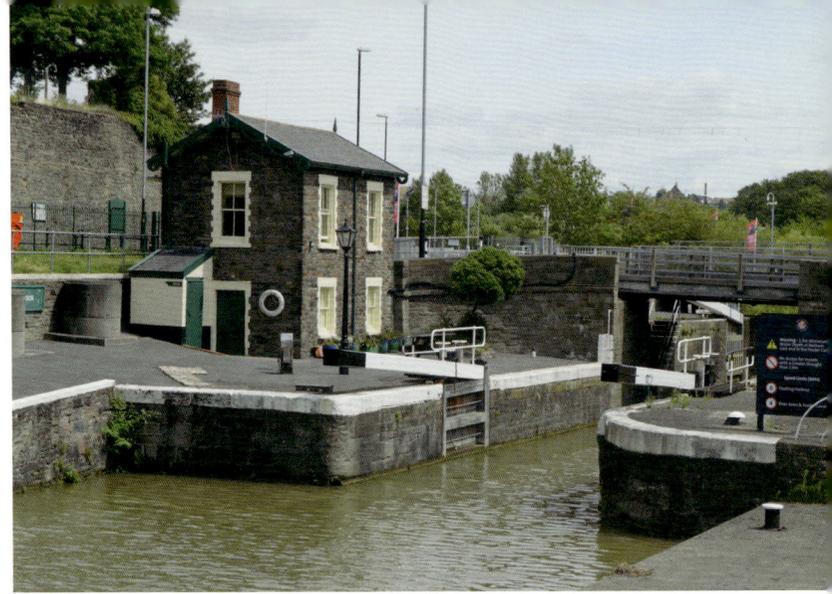

Above: Netham Lock.

Left: The Feeder Canal.

known as the Banana Bridge for reasons demonstrated by the photograph. In the 1880s it was erected temporarily in the location now occupied by the next one westward, Bedminster Bridge, before being moved to its present location. Then, in the Second World War, the area to the south was bombed particularly heavily, so the post-war redevelopment changed the whole street pattern and Langston Street, after which the bridge was named, disappeared entirely.

Meanwhile, the Floating Harbour runs around Bristol Temple Meads station. This was designed by Isambard Kingdom Brunel as the western terminus of his Great Western Railway, and opened in 1840. Those who were wealthy enough could alight here after their journey from London and transfer the short distance onto a ship to take them to North America or elsewhere in the world.

The station took on what was then the name of the area in which it was located, which simply meant 'the meadows near the Temple church'. The station was indeed built on what was then countryside on the edge of the city.

The Temple church in question is off Victoria Street, about halfway between the railway station and Bristol Bridge. It takes its name from an earlier church on this site that belonged to the Knights Templar, the order of crusading monks who also protected visitors to Jerusalem. In the early fourteenth century, when there were no crusades to go on and no Christian bases in the Holy Land for them to defend, they were suppressed as heretics by the monarchs of Western Europe. Cynics suggest that the rulers were less concerned about heresy and more concerned about getting their hands on the land and wealth of the Templars.

The present church was built not long after the demise of the Templars, perhaps because the old one had been circular like all Templar churches and this was now considered an unacceptable shape. This building was badly damaged by incendiary bombs in 1942. The tower leans out at a somewhat disconcerting angle, but this has nothing to do with bomb damage – apparently it began leaning as soon as it was erected.

Further along Victoria Street we cross Bristol Bridge, and beyond it we are in the oldest parts of Bristol, and we need a bit of background. The area had been settled since the earliest farmers – there was lots of good farming land, while fish and other resources were available from the river. There are a number of Iron Age hillforts in the locality such as that on Clifton Down, and Roman villas, some of which continued as estate centres after the breakdown of Roman administration, dot the wider Bristol conurbation.

On the north bank of the bridge and to the east, there is Castle Park. At first glance the park looks to have been here for centuries, an impression heightened by a ruined church on a rise, but it has only existed since the 1970s. The area was devastated by a massive air raid on Bristol on 24 November 1940, and it took decades for the area to recover. The now-roofless St Peter's church is one of the few remaining buildings of a once busy area.

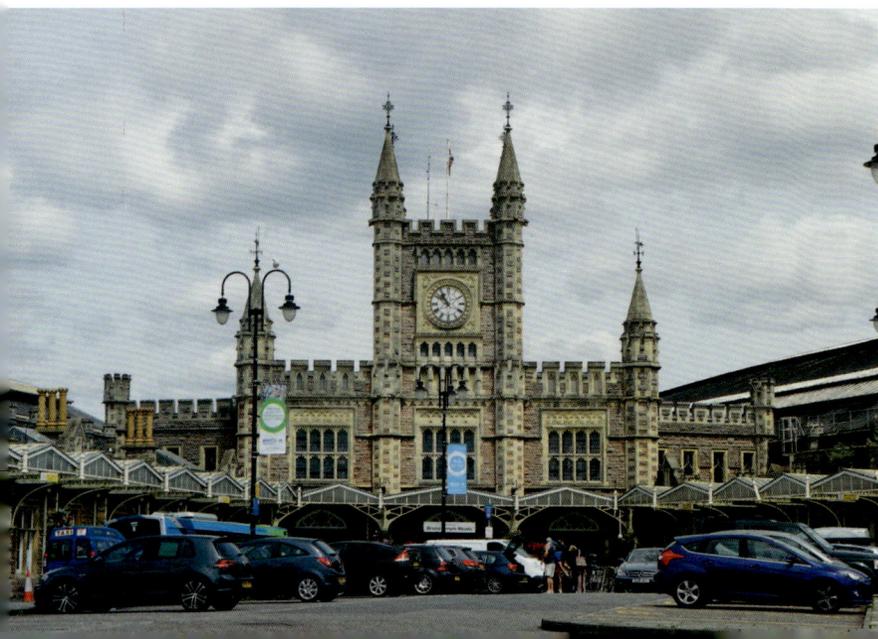

Above left: Banana Bridge.

Above right: Bristol Bridge.

Below: The Victorian Gothic frontage of Bristol Temple Meads railway station.

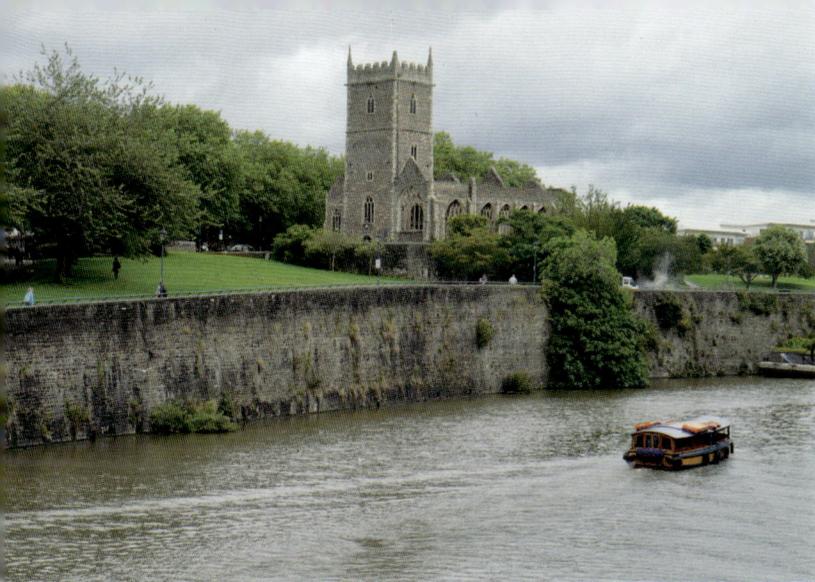

Above: Castle Park, seen from Bristol Bridge.

Right: The tower of the bomb-damaged Temple Church, seen from Victoria Street.

Within the park and further east than the church is the site of the original Bristol, at the confluence of the second tributary called the Frome and the Bristol Avon. This Frome rises about ten miles to the north-east of here near Yate, and flows in through the Bristolian suburbs. Today much of the final section of its course in the city centre runs underground.

The settlement here is first recorded around AD 1000, and its original name of Brycgstow ('the place by the bridge') tells us why it was here. This first bridge was made of timber, the first stone one being built in 1247, with its surviving replacement (which we have just crossed) dating from the 1760s.

Early Bristol was at a strategic location on a bend in the river, and soon after 1066 the invading Normans decided this was the best place for their local castle. The Bristolians were evicted, and a timber castle was built on the site of their homes. In the twelfth century the castle was rebuilt in stone, and some remains of this can still be seen in Castle Park. The displaced Bristolians built a new settlement a little to the west. Its walls do not survive, but much of their roughly circular course is followed by St Nicholas Street, Leonard Lane, Bell Lane and Tower Lane.

Bristol flourished in this new location, being granted city status in about 1150. Around this time the Normans of England were attempting to conquer Ireland, and Bristol would have been a good base from which to set off on raids. As an unfortunate precursor to an unpleasant part of the city's later history, at this time Bristol was trading in slaves captured in the Irish warfare. In 1373 Edward III gave Bristol the status of a county of its own. Before then, it had been in Gloucestershire, while its expanding suburbs south of the river were in Somerset.

Inland from the river, not far to the west of the circuit of the Norman defences, is a statue whose presence has caused controversy in the last couple of decades. The person depicted in Edward Colston (1636–1721), who for most of the time since his death was remembered with fondness as a philanthropist who gave much to Bristol. Today though, people tend more to recall that much of the money he was spending came from selling slaves and exploiting their labour. He has also become a symbol of Bristol's past involvement in the slave trade.

Colston was born in Bristol but his family moved away when he was a child, and he spent his adulthood living in London. He got involved in the overseas trading of goods, and became a member of the Royal African Company that had the British monopoly on trade with Africa. Much of Colston's trading, as with many others, involved sending ships on a triangular route. They took goods, especially textiles, from British ports (including Bristol) to Africa, exchanging them for slaves which they took to the West Indies and the colonies in North America and sold them there. Goods produced on slave plantations, notably sugar, were then bought and shipped back to Britain, completing what was usually a very lucrative voyage.

Above: A view within the original city of Bristol.

Right: The statue of Edward Colston, erected in 1895.

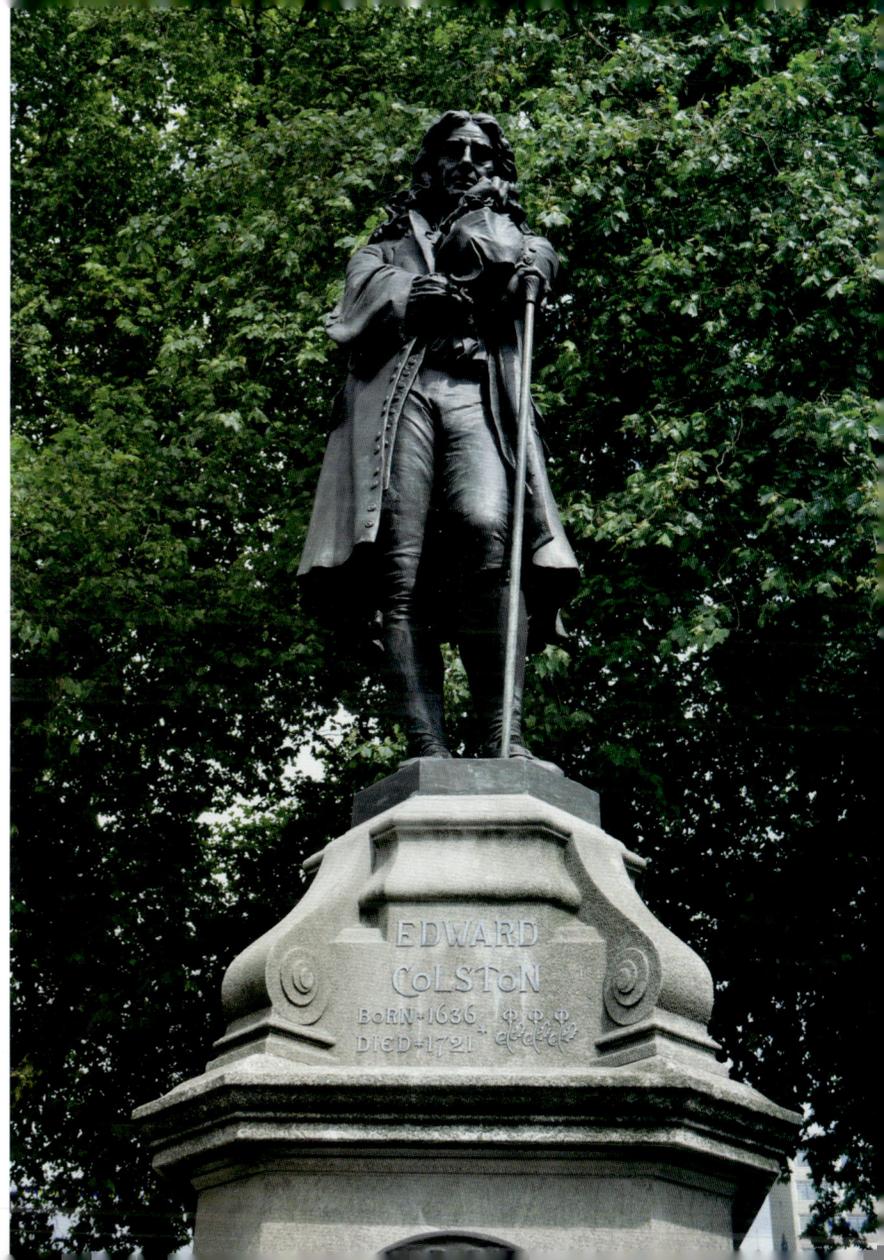

EDWARD
COLSTON
BORN·1636·
DIED·1721·

In the 1680s other members of his family returned to Bristol, and Edward invested in their businesses, including a sugar refinery that processed the material produced by slaves. In his later life Edward founded almshouses and a school in Bristol, and gave money to churches and the cathedral. Today places such as the concert venue of Colston Hall, the street in which his statue is situated and a tower next to it still bear his name.

Turning now southward and almost at the Floating Harbour, we arrive in Queen Square. It is difficult for anyone who didn't see the square until the twenty-first century to realise that a dual carriageway once ran across it!

Queen Square was planned in 1699 and completed in 1727, and named after Queen Anne, who reigned during part of this time. It was built on an area outside the city walls and close to the river called Town Marsh, so presumably drainage work was necessary. In the 1930s Bristol's Inner Circuit Road was laid out, and one section crossed the Square diagonally from north-west to south-east. During the 1960s, itself a time of much (and often insensitive) road-building, it was recognised that this road had problems, not least its impact on the fine buildings that surround the square. Concern grew to the extent that in 1992 the road was closed and by 2000 it had been removed. The park in the middle has been restored and events are held here regularly.

One of the houses on the south side of Queen Square bears a plaque saying that the first American consulate in Britain was established in a building on this site in 1792. While governments establish embassies in other countries so they can communicate with the governments of those countries, they establish consulates to look after their own citizens. The fact that Bristol was chosen in this instance indicates just how many Americans were in Bristol at the time – most of them involved in trade, including that in slaves.

Heading west from Queen Square, we go around a spur of the Floating Harbour and head a little way uphill to reach College Green, where one side is dominated by Bristol Cathedral. Initially it seems odd to find that the cathedral is outside the old city, but the reason is that it was first built for a different purpose. The building was founded in 1140 as an abbey church for monks of the Augustinian order. Some features such as the chapter house and parts of the cloister of this abbey survive and date from a few decades after the foundation, as does some of the stonework in the lower parts of the church walls. Construction continued in a seemingly piecemeal fashion until around the middle of the fourteenth century, when there was a long break in the work. New energies were put into the project around 1470, and for almost half a century work continued – the central tower, most of the transepts (the side-arms that make the building cross-shaped) and parts of the nave (the main body of the church) date from this period. Then in the 1530s the Dissolution of the Monasteries took the building out of the possession of the Augustinians, and in

Queen Square – the plaque recording the site of the American consulate is on the left.

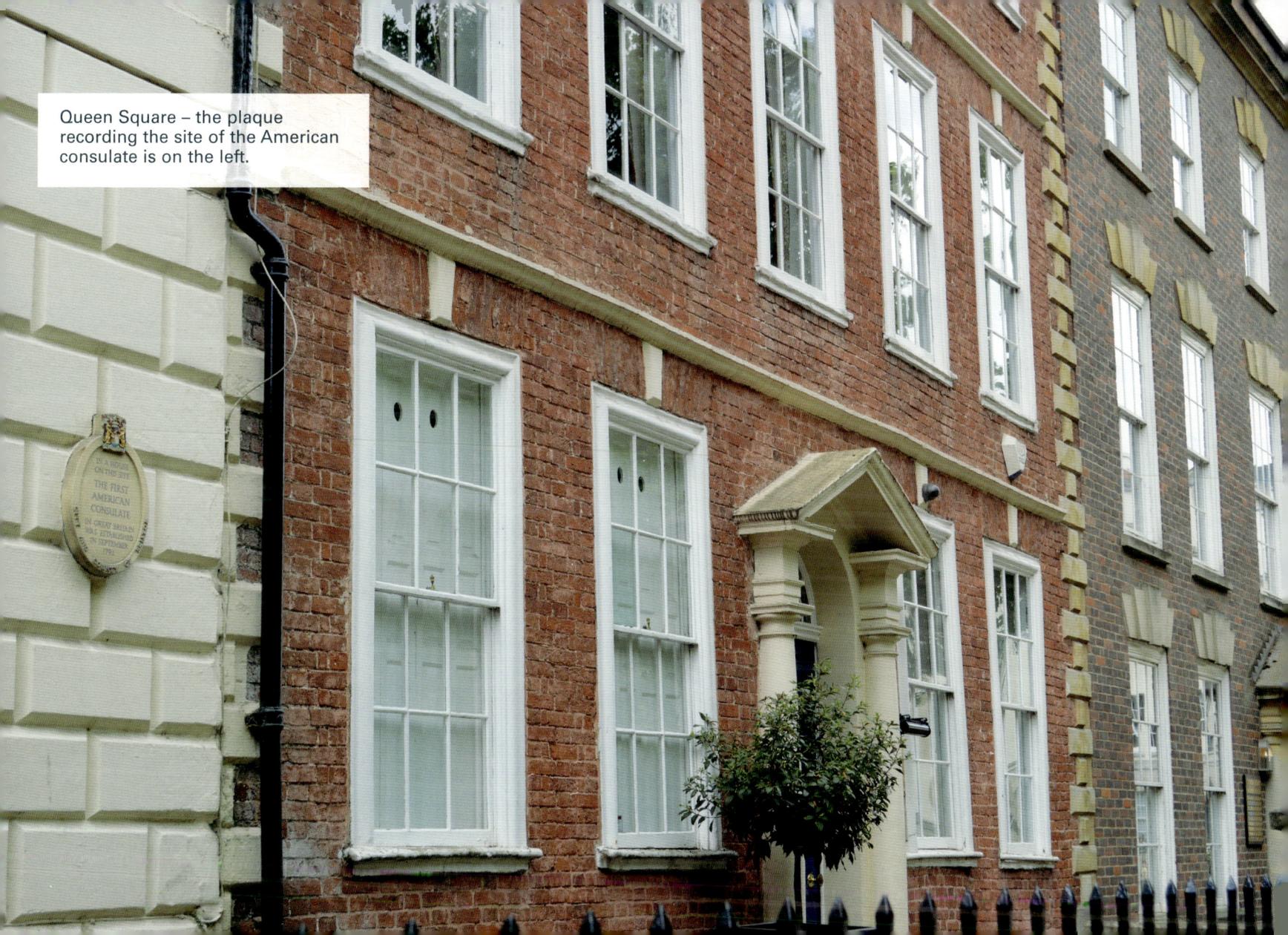

1542 Henry VIII made it the cathedral church of the city of Bristol.

It was not until the Victorian period that the church was completed, under the architect G. E. Street, with the upper parts of the nave and the two western towers being built. So you could argue that it took 700 years to build Bristol Cathedral!

Another side of College Green is occupied by Bristol City Hall, or the Council House as it used to be known. It was designed in the 1930s and a foundation stone was laid in 1938, then the Second World War caused a break in construction, and the building was not formally opened until 1956. In the centre of the curving frontage there is a statue that represents an Elizabethan seaman. It is the work of Charles Wheeler, who went on to be President of the Royal Academy.

There is another statue near the corner between the Cathedral and City Hall. This is of Rajah Rammohun Roy. He was born in 1772 in Kolkata in India and was an important social reformer, notably campaigning against the practice of suttee, whereby a widow was expected to fling herself on her husband's funeral pyre. He travelled to England in 1830 as an ambassador of the Moghul Empire, on a mission to ensure that Britain retained its ban on suttee in the parts of India under its control at the time, and died of meningitis in the then village (now Bristol suburb) of Stapleton in 1833.

Continuing westward and upward from College Green, we reach the park and nature reserve at Brandon Hill, the highest point in the city. The land here was given to the city by the Earl of Gloucester in 1174, and was used for grazing of livestock at first. There was also a hermitage on the hill that was dedicated to St Brendan, which is the origin of 'Brandon'. Later, in 1625, the livestock was taken away and it became the public open space that it remains today.

In 1897 the Cabot Tower was built on the summit, paid for by public subscription. It was constructed of local stone – sandstone for the main body and limestone, which can be carved, for the finer details. The reason was the commemoration of the 400th anniversary of John Cabot's voyage from Bristol to the New World.

If much of Samuel Colston's association with the port of Bristol is now seen in a negative light, I think John Cabot's is a much more positive story, with implications that can only be described as extraordinary.

John Cabot was born around 1450, probably in Genoa in Italy, but spent much of his adult life in Venice, from where he conducted trading voyages in the Mediterranean. He left Venice after getting into financial difficulties, and in 1494 was in Spain and Portugal trying to get royal support for a voyage across the Atlantic, as Christopher Columbus had done two years previously. Like Columbus he thought he would reach eastern Asia, but wanted to take a more northerly route to reach China.

This failed, so the following year he came to England, where Henry VII gave his backing. Cabot sailed from

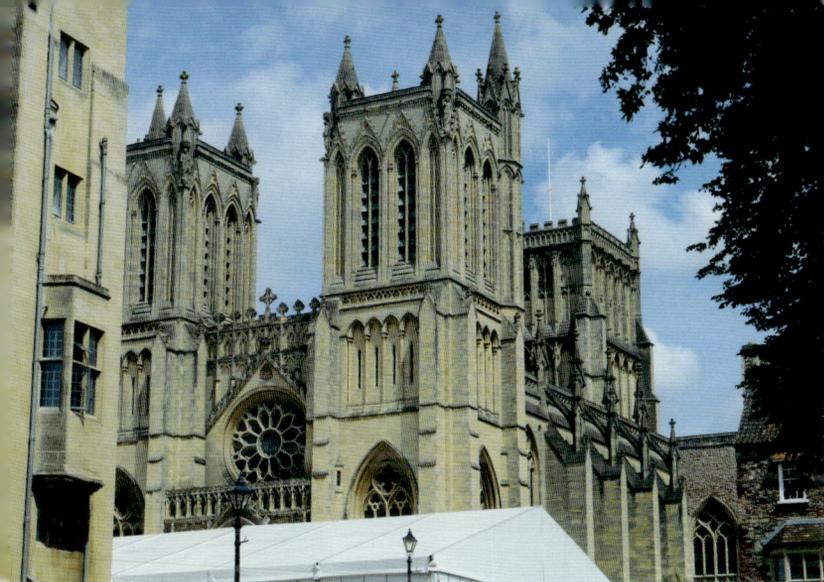

Above The west front of Bristol Cathedral.

Right: Charles Wheeler's statue of an Elizabethan seaman.

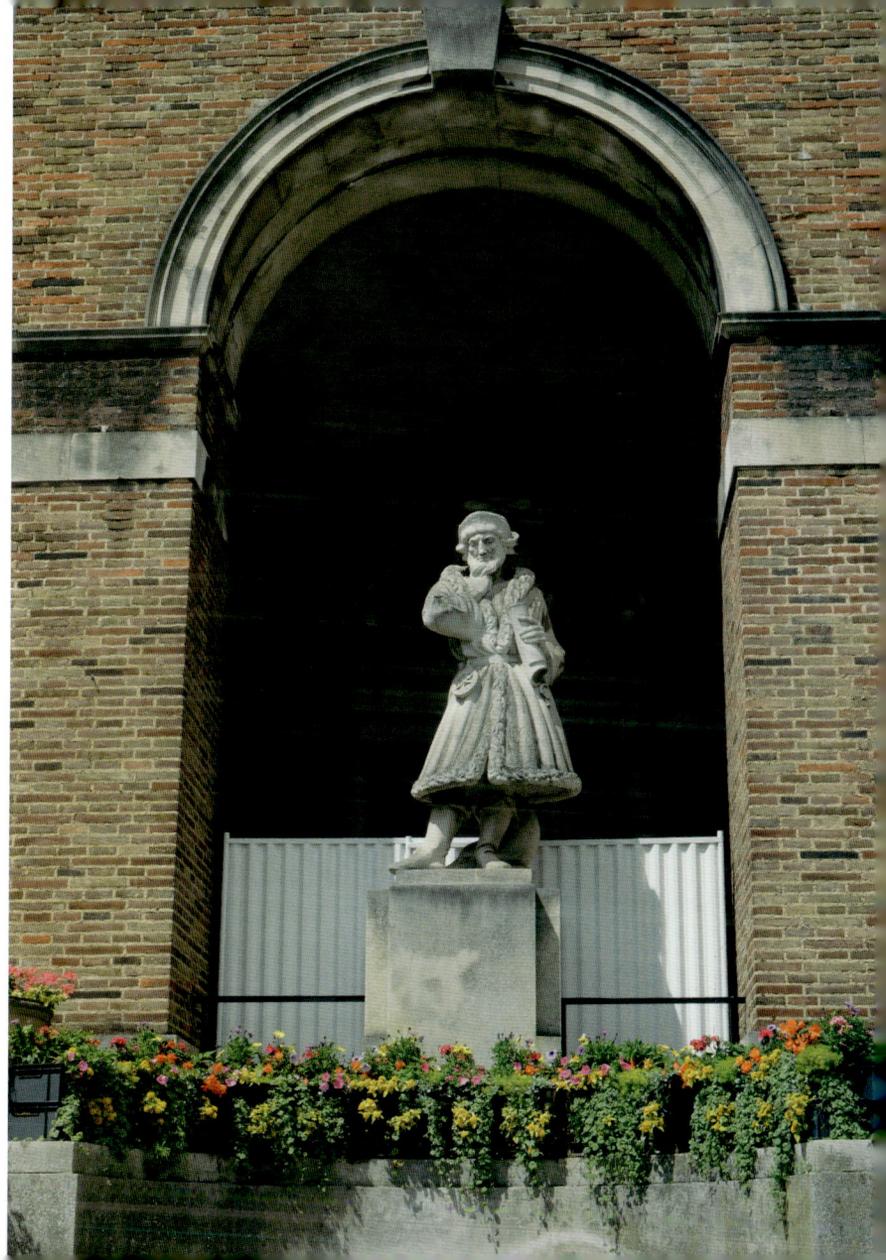

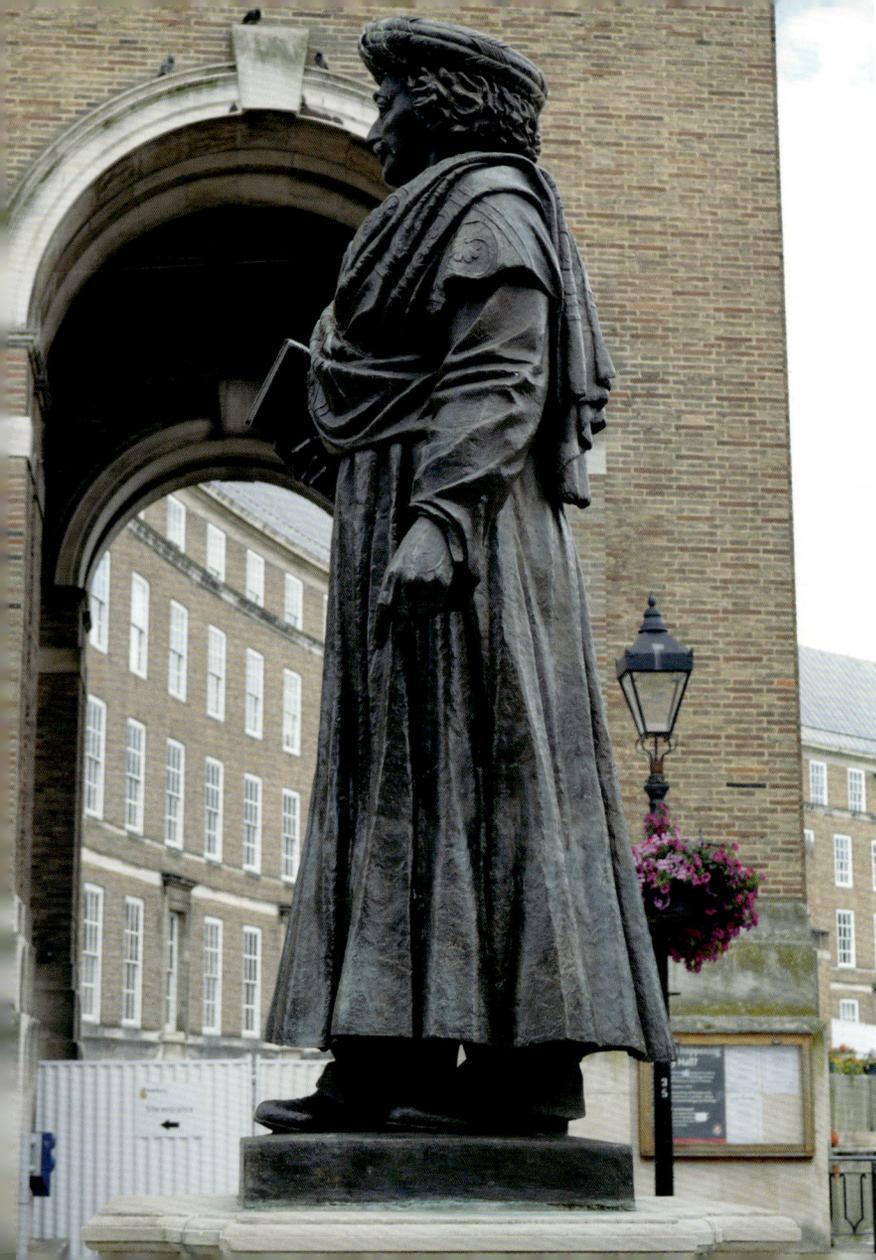

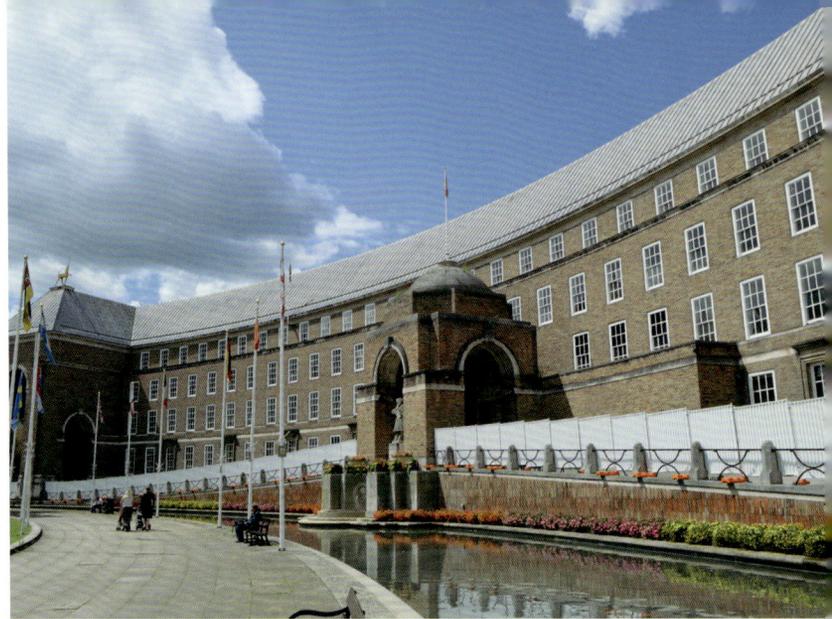

Above: Bristol City Hall.

Left: The statue of Rajah Rammohun Roy.

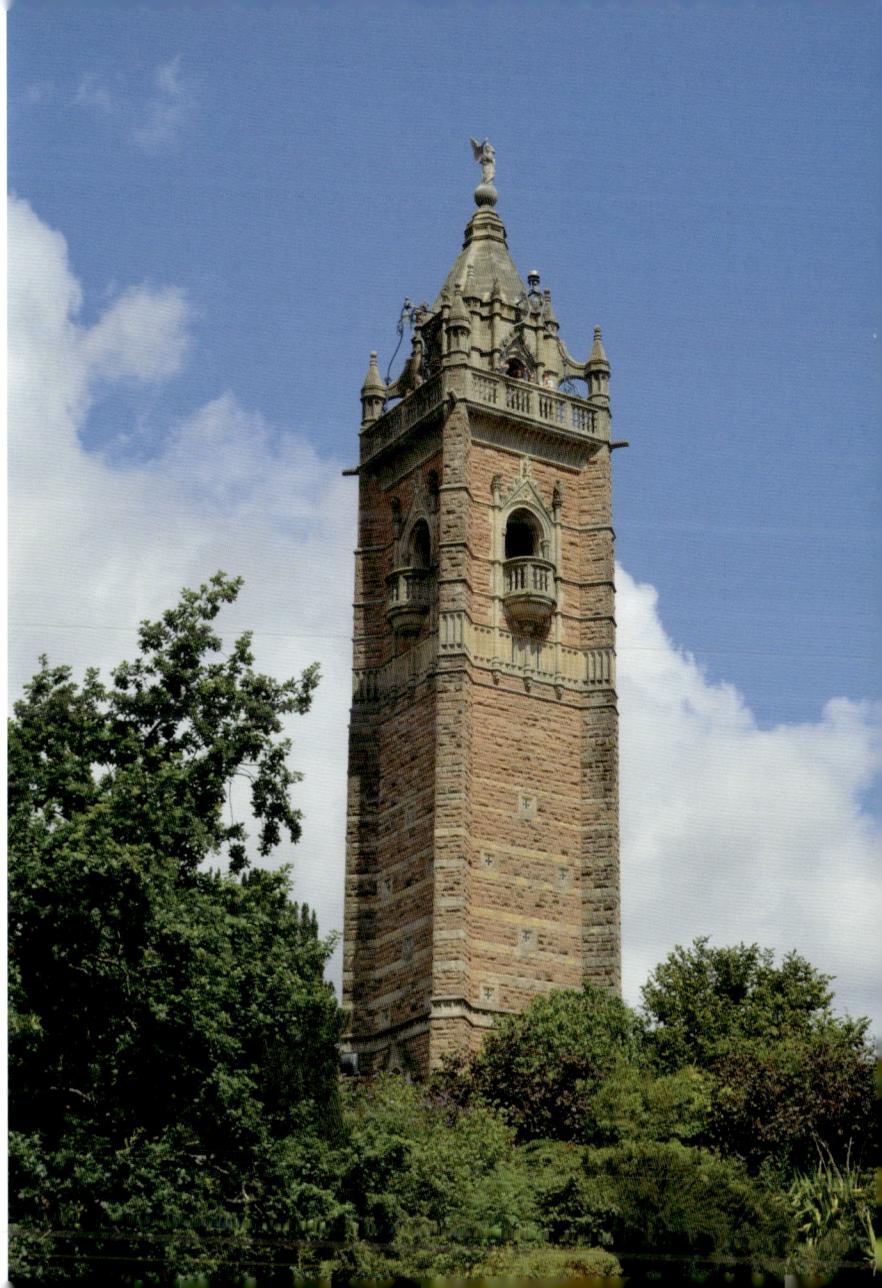

Cabot Tower.

Bristol in 1496 but had to turn back mid-Atlantic. In 1497 he tried again, sailing in the *Matthew*, and this time he was more successful, becoming the first European, possibly since the Vikings, to set foot on the North American mainland (Columbus had only landed on offshore islands). He did little more than this and after limited coastal exploration he came back to Bristol, yet nevertheless he was treated as a hero.

Cabot made a third voyage the following year, and though scholarly opinion formerly favoured the belief that the expedition was lost and Cabot killed, there is now a swing towards the view that his expedition undertook exploration on much of the North American coast and returned successfully in 1500. Whatever the truth may be, within a few years several other successful expeditions from Bristol had been undertaken, and Bristol's links with the New World had an excellent foundation.

The question of why Cabot and his successors sailed from Bristol has two answers, one obvious, the other rather fascinating. The first is that Bristol was England's second largest seaport at the time, and unlike the first, London, it faced west.

The second is that he may have engaged a Bristolian crew because they were experienced in sailing out into the Atlantic and maybe across it! There had been legends of unknown islands in the Atlantic for centuries, and around 1480 a couple of expeditions set off from Bristol to find one called Hy-Brasil. It was even said just after Cabot's 1497 voyage that all he had done was find the land that the Bristolians had found after they had located Hy-Brasil!

Linked to this are indications that Europeans had been fishing at The Grand Banks, an area off Newfoundland that was extremely rich in cod, for some time before Columbus, together with recent archaeological work in northern Canada that suggests the Viking settlers of Greenland (and perhaps Iceland) had extensive trading contacts with the native inhabitants of Canada for much of the Middle Ages.

The people who carried out such activities would have kept them secret to protect lucrative livelihoods, making it a difficult one to research. Nevertheless, the subject of the transatlantic voyages of Cabot and his Bristolian predecessors is currently being investigated by The Cabot Project, run by the University of Bristol.

And now to over to the south side of the Floating Harbour to a church associated with Cabot. The area called Redcliffe lies to the south-east of Queen Square, not that far from Temple Meads station. The land rises up here, but housing and other development has long since covered the sandstone cliffs that must have given the area its name. In 1574 Elizabeth I visited Bristol and is said to have described the parish church here, St Mary Redcliffe as 'The fairest, goodliest and most famous parish church in England', and many learned authorities have agreed ever since. Most of the stonework dates from the thirteenth to fifteenth centuries, and the best is of the

early fourteenth, including the two-storey north porch. The spire is the second tallest in England, although it is a nineteenth-century reconstruction of an original that collapsed four centuries earlier. A great deal of this decoration was paid for by rich merchants of Bristol, for many of the vessels that provided that wealth sailed from the nearby Redcliffe Wharf on the old river. John Cabot was one of those who attended this church.

We now head west and follow the south side of the Floating Harbour for some distance. First on Princes Wharf we find the M Shed, which is now a museum devoted to the history of Bristol. As its name suggests it is located in one of the 1950s storage sheds of the docks. Some exhibits that are a little too large to fit inside the museum are kept outside on Princes Wharf – these are four giant cranes that were also constructed in the 1950s. The harbour originally had ten times that number of cranes.

A replica of the ship used by John Cabot in his first transatlantic voyage is moored beside the cranes, and operates harbour trips from here. The *Matthew* was constructed between 1994 and 1996 at Redcliffe Wharf. It is not an exact replica because there are no records of Cabot's ship, but contemporary illustrations of ships and archaeological evidence were used to get as close as possible to the original.

One end of the Bristol Harbour Railway is also beside the M Shed. It dates from 1872 and was a joint venture by the Great Western Railway and the Bristol & Exeter Railway to link the Floating Harbour with the existing railway network at Temple Meads station. The route included a tunnel under St Mary Redcliffe church. In the following decades the railway was extended in several directions, then the original line closed in 1964. Part was demolished, but in 1978 a mile-and-a-half section was opened as a preserved railway and continues to operate at selected times today. It runs along the south side of the harbour from the M Shed (where its two locomotives are stored when not in use) west to the B Bond Warehouse beside Cumberland Basin, with a stop at the SS *Great Britain*.

The SS *Great Britain* definitely deserves some attention! It was intended as part two of your hi-tech journey from London to New York, courtesy of Isambard Kingdom Brunel. Having hopped off the train at Temple Meads, in theory you could hop onto the ship for the sea crossing.

It was the first vessel to combine two technological advancements – construction of iron and a screw propeller – and was designed by a team of engineers led by Brunel that had previously built the *Great Western*. Constructed here in Bristol, at its launch in 1843 the *Great Britain* was the largest ship in the world. However, several hitches such as getting stuck in the lock at the seaward end of the Floating Harbour meant it did not enter service until 1845.

It began on the Liverpool–New York run, but even now alterations were needed, which undoubtedly can be

Above: Bristol's skyline, seen from the south side of the Floating Harbour. The cathedral is right of centre, with the tower at the university behind it. Cabot Tower on Brandon Hill is on the left.

Left: St Mary Redcliffe.

Above: The *Matthew* on the open water of the Floating Harbour.

Right: One of the cranes outside the M Shed and the *Matthew*.

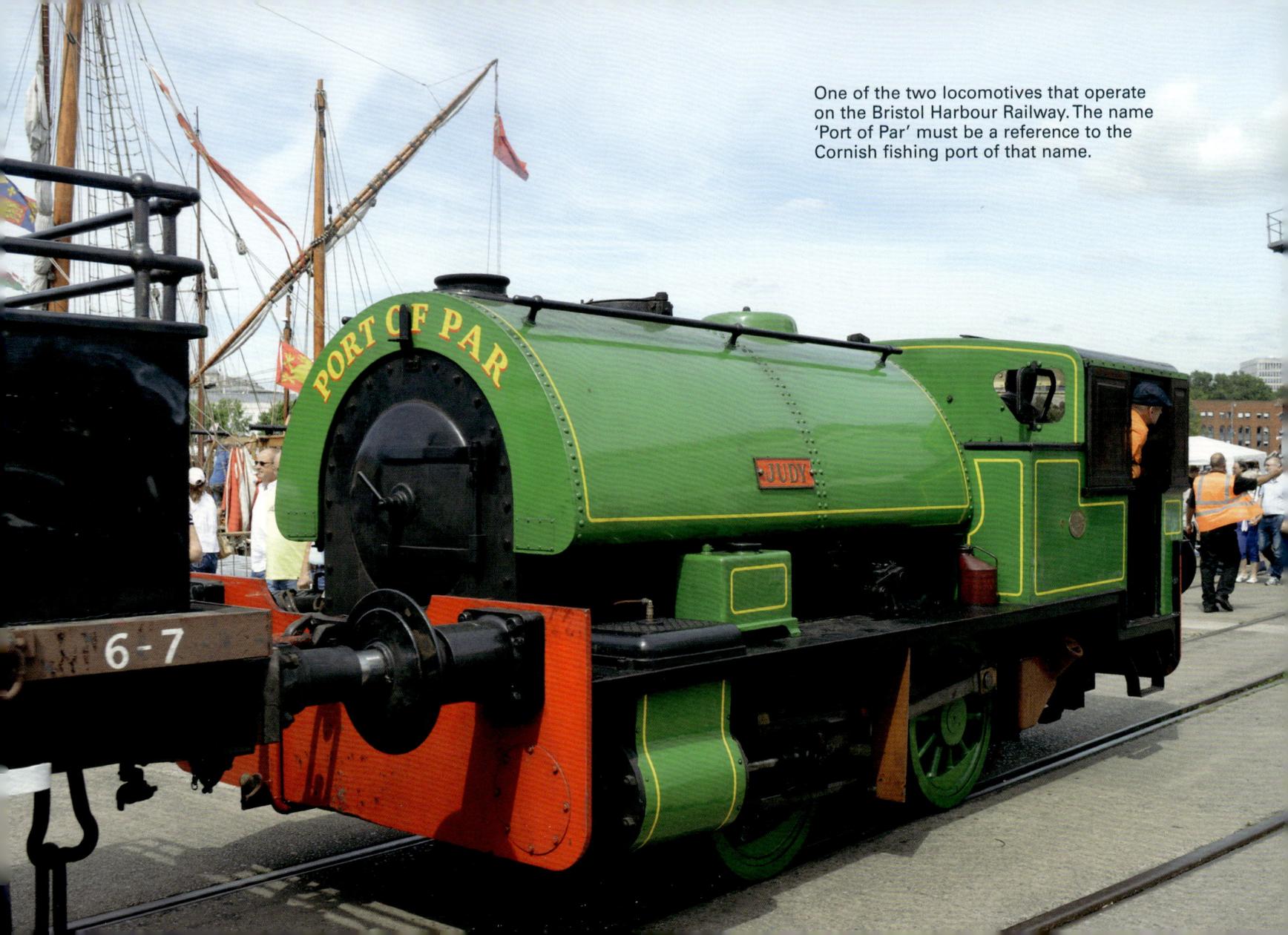

One of the two locomotives that operate on the Bristol Harbour Railway. The name 'Port of Par' must be a reference to the Cornish fishing port of that name.

excused on such a revolutionary new design. What might not be so excusable is that it was accidentally run aground off the Irish coast in 1846.

After being salvaged and then undergoing a change of ownership, in 1852 it began to be used on the Liverpool–Australia run, which continued until 1881. Rather ironically, it was then thought more cost-effective to take out the massive engine and make the *Great Britain* into a sailing ship, but then a few years later there was a fire on board and the ship limped into Port Stanley in the Falkland Islands. There, it was found that the cost of restoring it as a seagoing vessel was prohibitive, and the ship was used for storage and as a quarantine ship.

In 1970 a restoration project brought the *Great Britain* back to the city of its 'birth', where much work was initially necessary to conserve the ship and make it accessible to visitors. Further work has been required since then and the ship is now in a dry dock surrounded by a glass surface that looks surprisingly like water until you get very close.

Today, around 150,000 people a year visit what has become one of Bristol's iconic tourist attractions, and, after heading through a series of displays explaining the history of the vessel, they go on board to see restorations not only of original elements but also features such as the facilities for transporting horses when the *Great Britain* was used as a troopship during the Crimean War.

Continuing along the south side of the Floating Harbour, we get views of Clifton on a hill beyond the north bank.

The place had been a village since the Middle Ages, but was engulfed as a suburb of the expanding city in the eighteenth century. Many Bristolians built grand houses here to display the wealth they had made in the tobacco and slave trades in particular, and the lower-lying land between Clifton and the river was also developing as a spa on a lesser scale than Bath. The name of this land, Hotwells, explains why the spa was here.

Looking from the Floating Harbour, the skyline is dominated by Royal York Crescent, which must have been located with this purpose in mind, in a similar manner to the Royal Crescent in Bath. Royal York Crescent was built between 1791 and 1820, and was named after Prince Frederick, Duke of York, the second son of George III. This crescent is longer than the one in Bath, and the views between it and the watercourse below can be appreciated still.

A pump room was built at Hotwells in 1696 to exploit the hot springs that bubbled up in the area where the Clifton Gorge begins to open up. This was demolished in 1816 when Hotwells House was constructed, then the latter was itself knocked down in 1867 when the river was widened.

Just past Hotwells, we reach Cumberland Basin at the end of the Floating Harbour. For most vessels the river up to Bristol was only navigable at high tides, and William Jessop designed the basin as a holding area for ships either waiting to go out on the high tide or coming in at the same time. In the 1870s the basin was enlarged to carry more

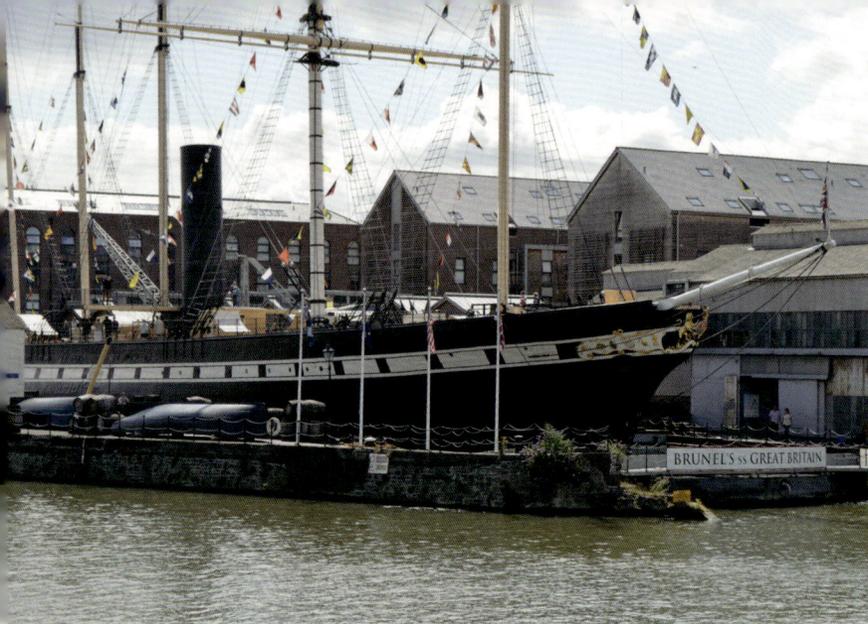

Above left: The SS *Great Britain*.

Above right: The marina to the west of the SS *Great Britain*, with the masts of that great vessel visible behind.

Below: The marina west of the SS *Great Britain* and the Victorian terraces of the area known as Cliftonwood on the hillside across the river. There is an admirable local tradition, as at several other prominent locations around the Floating Harbour, of painting these houses in bright colours, making them a distinctive local landmark.

vessels, and soon afterwards a hydraulic power system was installed to operate the locks at either end of the basin. This system was later improved and used for more purposes. The basin and its surrounds are a haven for industrial archaeologists, including the docks of the Underfall Yard and the three giant redbrick Bond Warehouses (named A, B and C) that were built in the first two decades of the twentieth century to store tobacco. This was a boom time for tobacco importation and the size of these buildings indicates just how pervasive smoking was at the time.

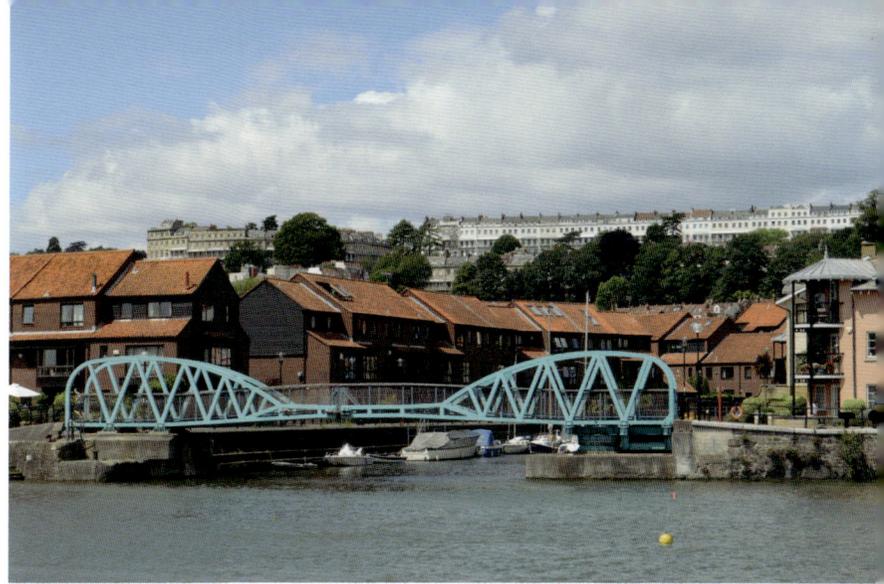

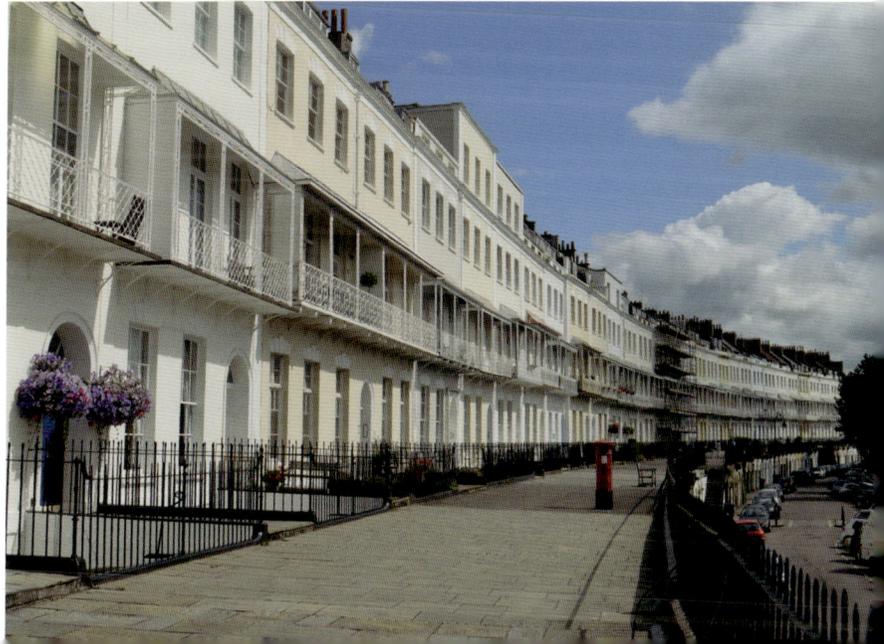

Above: The view from the Floating Harbour, with Royal York Crescent on the skyline.

Below: A closer view of Royal York Crescent.

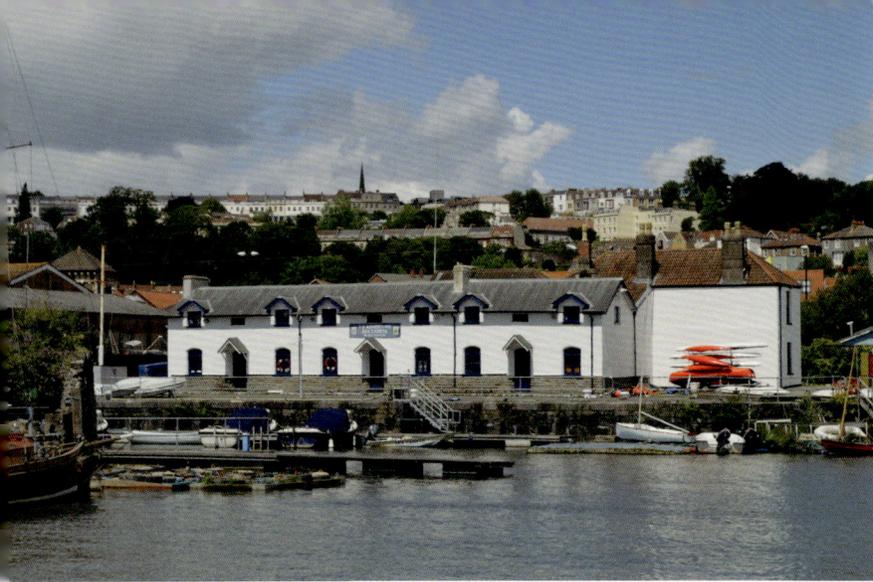

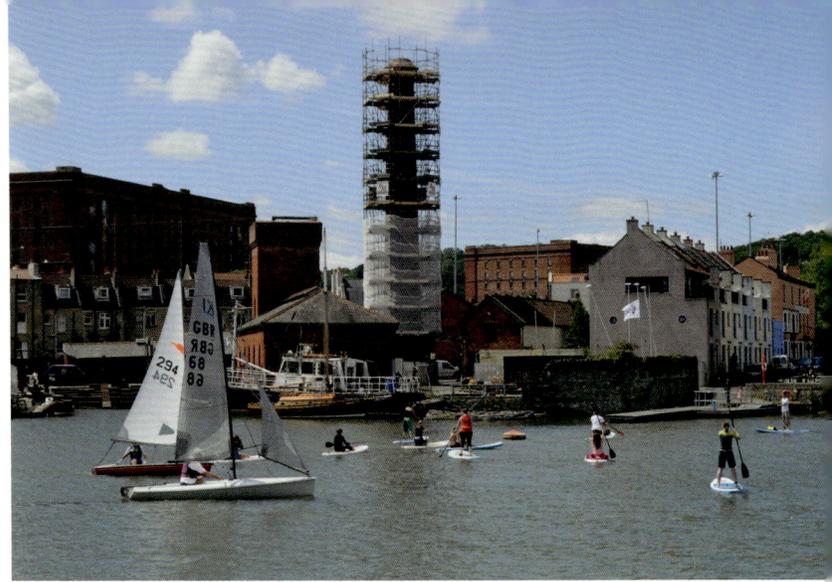

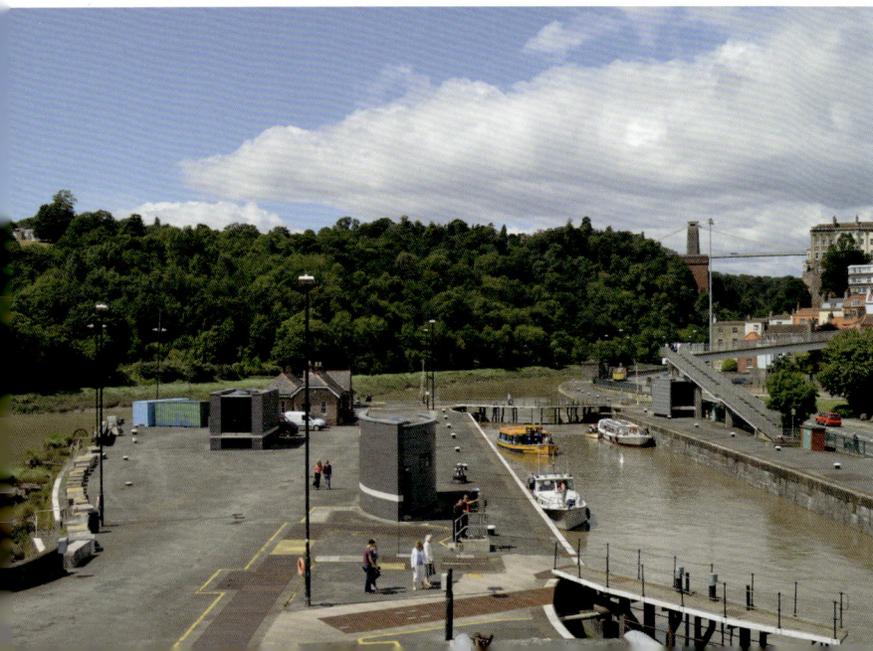

Above left: Looking across to Docks Cottages from near the Underfall Yard. These two-hundred-year-old buildings are now a base for the local sea cadets.

Above right: Leisure activities by the Underfall Yard. In the background are the original chimney of the hydraulic engine house and one of the red-brick tobacco warehouses.

Below: The lock at the seaward end of the Floating Harbour.

THE FINAL STRETCH

The Floating Harbour and the New Cut having joined back together, the river now enters the Clifton Gorge. First, it is worth reflecting that this is a spectacular natural feature which, at its closest, is not much more than a mile from the centre of Bristol, and that very few English cities have anything so extraordinary within their boundaries.

The river is cutting through a 10-mile-long ridge composed mainly of limestone, which initially seems odd since instead of bending northward to pass through the gorge, it could head across flatter land to the west. The most likely explanation is that during the last Ice Age, ice blocked the river's more natural course, forcing it to divert through the gorge. The limestone and the local sandstone called Pennant stone were quarried here – much of the material for the city's expansion in the eighteenth and nineteenth centuries came from these quarries, which can still be made out on the sides of the gorge.

The unusual conditions of the gorge have made it a very special ecosystem, with a variety of plants that are rare elsewhere or even unique to the gorge. There are some good information boards on this topic by the Clifton Tower of the Suspension Bridge, and even some examples growing next to them. For instance, this is the only location in Britain where the Bristol onion and Bristol rock cress grow, and the Bristol whitebeam is found nowhere else on the planet!

I should also mention that from now on the west side of the river lies in the modern administrative county of North Somerset, while the east remains in Bristol.

The Portishead railway runs through the bottom of the gorge on the western side. It was opened in 1867, and though initially closed entirely in the Beeching cuts of the 1960s, it now carries freight as far as the Royal Portbury Dock.

On the east side the old Bristol Port Railway from Hotwells to Avonmouth was constructed earlier in the 1860s. The Portway road was built here, starting just after the First World War and completed in 1926). This effectively barged out the section of the railway between

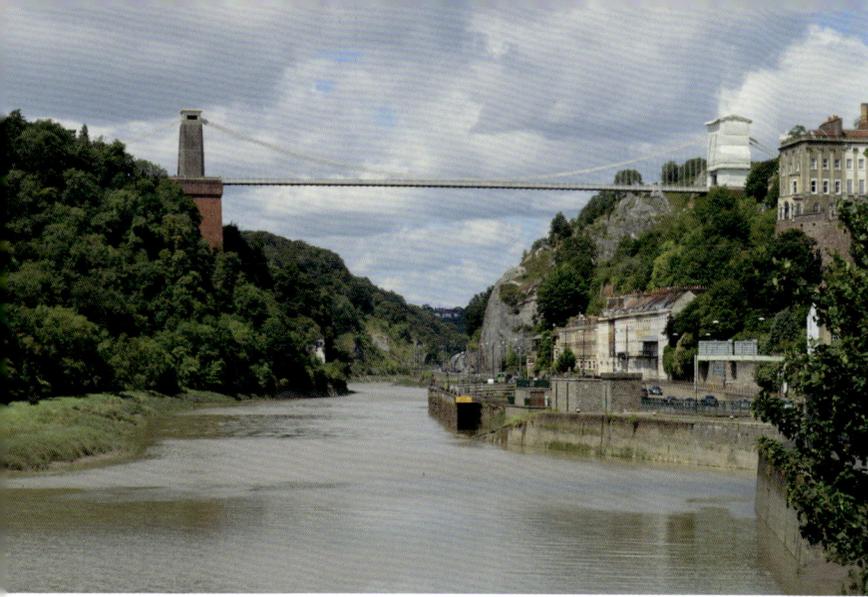

Hotwells and Sneyd Park Junction. The further part of the line is still in use, going through a tunnel under Clifton Down to get into Bristol.

Following the Portway along the east side of the gorge, we first past terraces of houses, some dating from the 1780s. Then there is an odd-looking façade built into the side of the gorge. This was the frontage of the lower station of the Clifton Rocks Railway, which opened in 1893. This station connected with trams coming from Bristol, and there was a second station in Sion Hill, just south of the Clifton Tower of the Suspension Bridge. The funicular system used here had two pairs of cars – each pair arranged so that as one car descended, its weight plus water ballast pulled the other one up. The water used was then pumped back up separately.

There were two reasons why this system, which required some very expensive tunnelling through the rock of the side of the gorge, was chosen. The first was the opinion that an open-air railway would spoil views of the gorge. The second was a wish to protect what was seen as the exclusivity of Clifton from the rundown port area below – the railway could not carry many people and the fares would not have been cheap.

Above: Looking down Clifton Gorge to the Suspension Bridge, showing how wooded the west side of the gorge is, even here.

Below: The tunnel of the former Portishead Railway beneath the Suspension Bridge's Leigh Woods Tower.

Above: A Georgian terrace on the gorge's east side.

Right: Disused wharves on the east side of the gorge, near Hotwells.

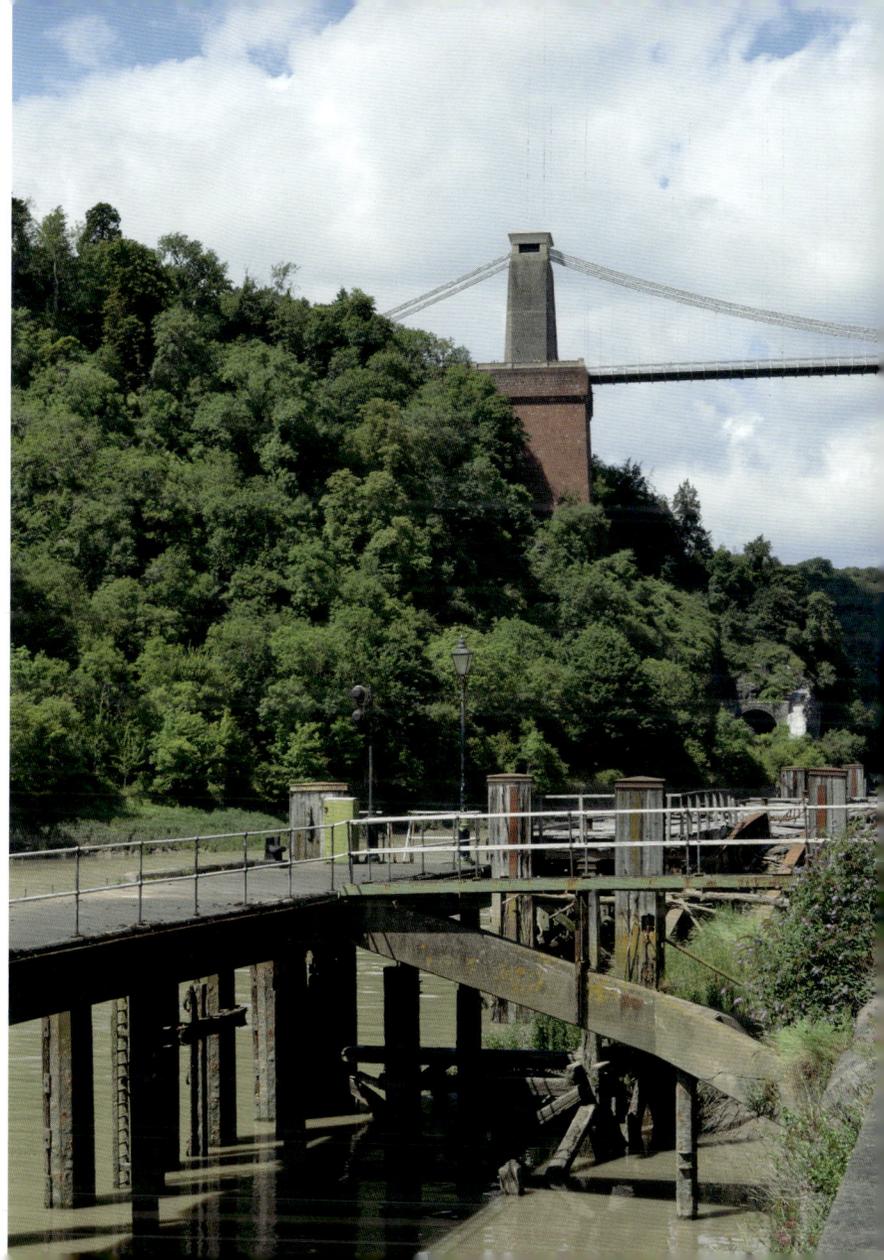

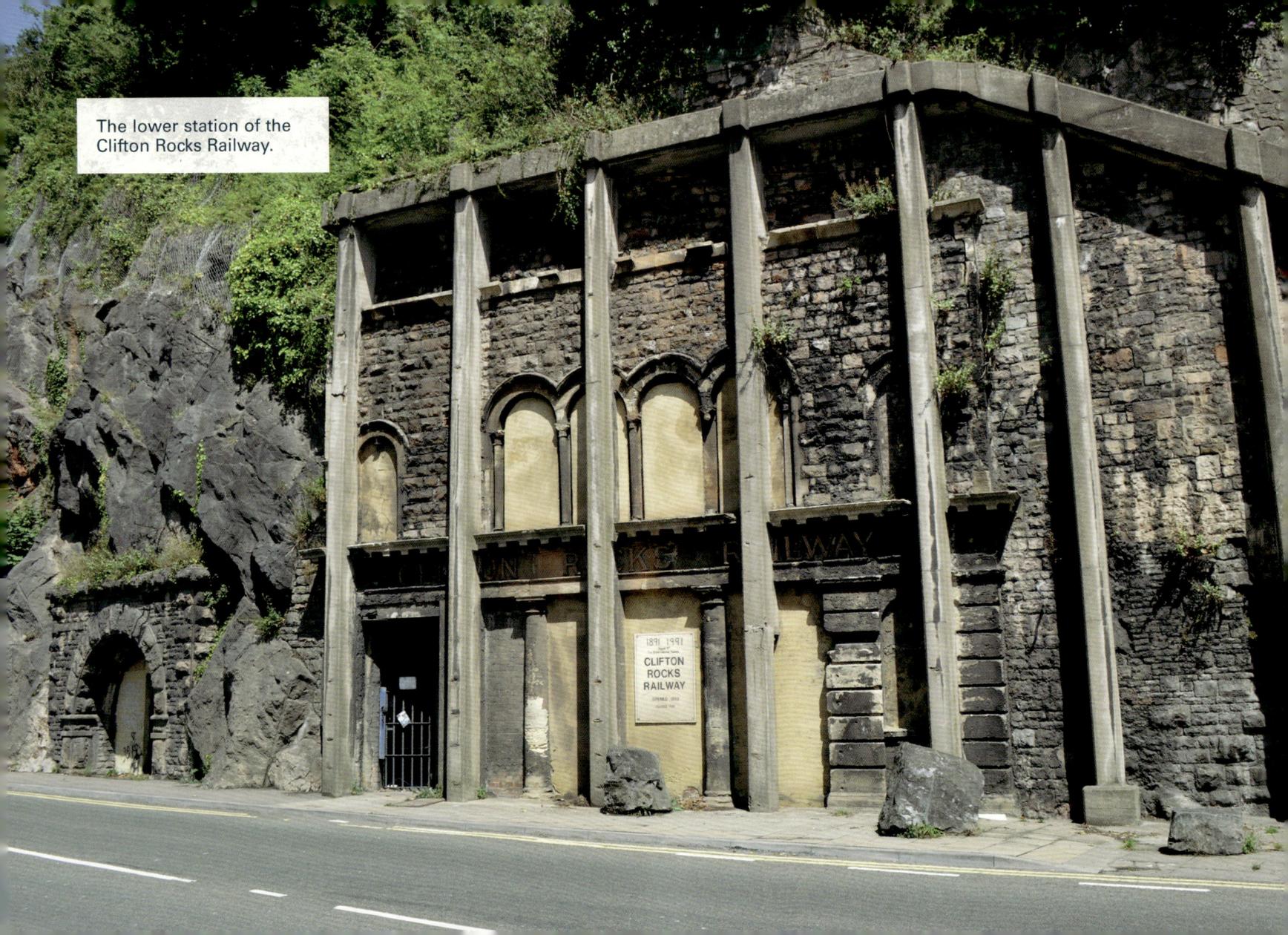

The lower station of the Clifton Rocks Railway.

Construction of the Clifton Rocks Railway was funded by Sir George Newnes, a publisher who had also paid many of the costs of the Lynton & Lynmouth Railway, another funicular which opened in 1890 to link these two settlements on the north Devon coast. The latter is still in operation and is open-air, allowing the principle to be seen.

The construction of the Portway made use of the lower station more inconvenient, and, after making a loss for some time, the railway closed in 1934. Then during the Second World War, the BBC had some rather grandiose plans for its use as an emergency studio and at the lower end a series of four chambers were formed. No concerts were broadcast from here, but it did good service as a transmitter station. Today, the Clifton Rocks Railway Trust is aiming to restore the railway for passenger use.

The Clifton Suspension Bridge is a spectacular site today, especially when seen from below at river level. How much more so must it have appeared to the Victorian Bristolians who saw it when first built, and who would not have seen anything remotely like it in size and engineering complexity before?

Though a triumph when built and still an iconic symbol of Bristol today, its construction took decades and had major setbacks. In the 1750s, a local wine merchant called William Vick left money in his will from the building of a bridge across the Clifton Gorge to link Clifton with Leigh Woods and North Somerset. He left £1,000 with the idea that it be invested until the sum reached £10,000. By the 1820s the required total still hadn't been reached, and it was clear that the cost would be much more than Vick had envisaged anyway. Also the continuing expansion of Bristol was increasing the need for such a bridge. So after the granting of an Act of Parliament (then the equivalent of planning permission), a company was set up that could obtain subscriptions for the construction, and which would then levy tolls on bridge-users to repay the subscribers with interest and fund the bridge's maintenance.

After further toing-and-froing, the young Isambard Kingdom Brunel's design was chosen and he was appointed as the engineer in charge of the work. On 21 June 1831 a ceremony was held to mark the start of construction, but soon after the Bristol riots occurred, investor confidence was dented and subscriptions ceased, leading to a break in the work.

Work did not start again until 1836, but then money ran out in 1843. Brunel died in 1859, and by the time that circumstances were right for work to restart, much of the material of the partially completed structure had been sold off, leaving little more than the two piers, or towers, on either side. Brunel's original design was first revised considerably by William Henry Barlow and Sir John Hawkshaw, and then construction began anew in 1862.

To make the span, ropes were hauled from one side of the bridge, down the gorge, ferried across the river, then

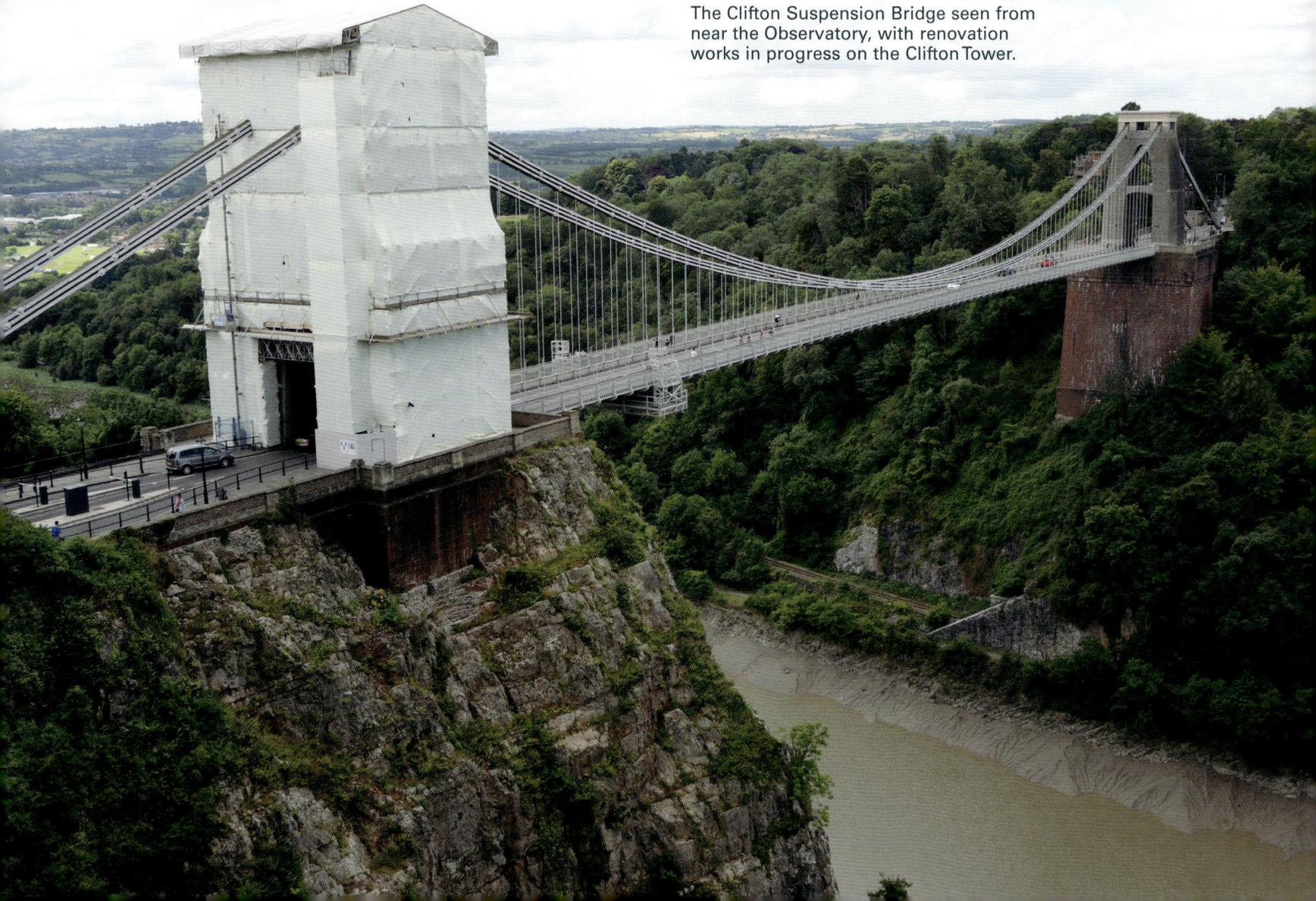

The Clifton Suspension Bridge seen from near the Observatory, with renovation works in progress on the Clifton Tower.

taken up the other side to be attached to the other pier. These ropes were then used to haul wire cables across the span, from which a planked footway was suspended. Chains could then be added across the bridge link by link, from which girders were hung to support the decking.

Work was completed in 1864 and the bridge was opened officially on 8 December that year. Apparently two men were killed during the construction – nowadays we would see that as two too many, but for its time, and considering the nature of the work, this is perhaps a surprisingly low number.

Today, the bridge is operated by the Clifton Suspension Bridge Trust and there is a visitor centre at the Leigh Woods end.

In a little park above the Suspension Bridge on the Clifton side, we find the Observatory. The park occupies Clifton Camp, an Iron Age hillfort. The hillfort's defences are generally obscured by trees and other vegetation, although you can see the top of the bank as a rise at the edge of the open part of the hilltop in places.

The Observatory was built as a windmill in the eighteenth century, and badly damaged by a fire in 1777. A local artist called William West (1801–61) leased the building in 1828 for conversion to an observatory. The following year he replaced the observatory with a camera obscura (in which the view of the surrounding landscape is projected onto a white surface), and in 1835 adapted the tower to hold a new observatory and dug a tunnel to a Ghyston's Cave in the side of the gorge below the observatory.

Today it is still possible to visit the observatory and the camera obscura, one of only two in the country that can still be seen, as well as to descend through the tunnel to see the view from the cave. While doing so, it is tempting to wonder exactly what West felt about the gigantic bridge being built, right in the field of view of his camera obscura!

The views from the Clifton Suspension Bridge are spectacular. You see the southern part of the city in one direction, and in the other the view down the gorge seems wild and remote except for the road in the bottom. But there is another viewpoint that you should not miss when visiting the area. This is the parkland at Clifton Down, which starts just over half a mile downriver on the northern side, and is noticeably higher than the bridge. From here, you get views back to the bridge in one direction, and in the other you see the remainder of the course of the Avon, much of it still within the gorge, then beyond the river's mouth on a clear day you see across the Severn Estuary to the mountains of South Wales.

Meanwhile the western side of the gorge has been passing the National Trust's parkland and nature reserve of Leigh Woods, and that side remains mostly rural until the village of Pill. The eastern side is urban, with the suburbs of Bristol running into Avonmouth at the river's end. One of these suburbs, Shirehampton, is a good example of the separate villages that have been swallowed up within the expanding Bristol conurbation. It was once part of the manor of Kingsweston, and Kings

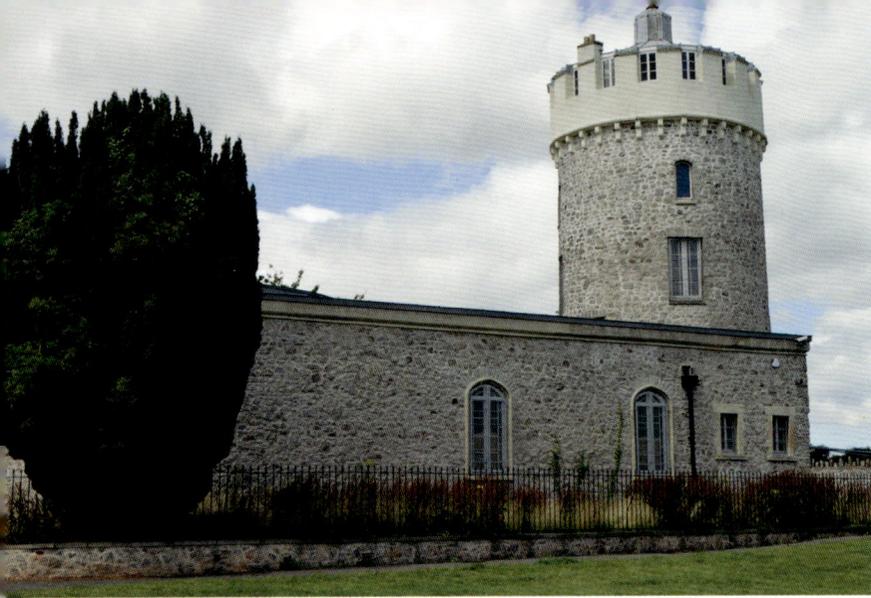

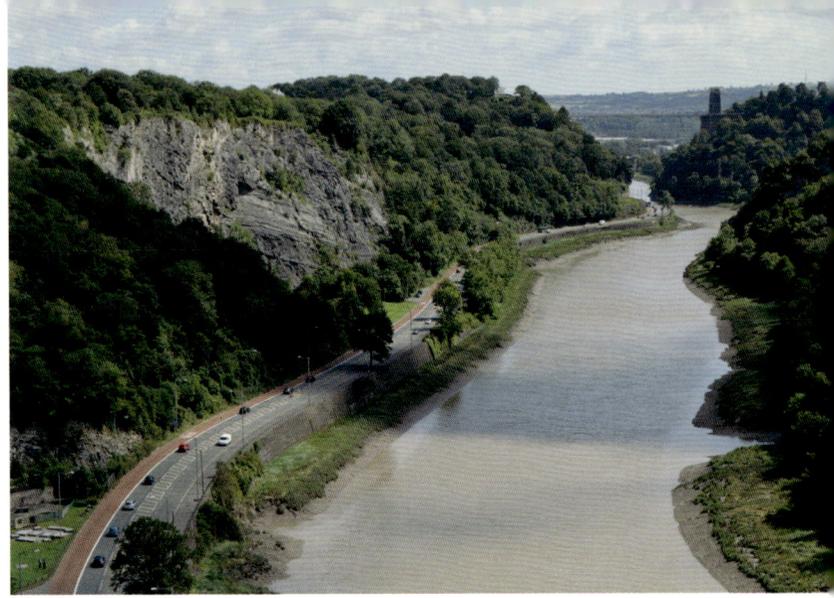

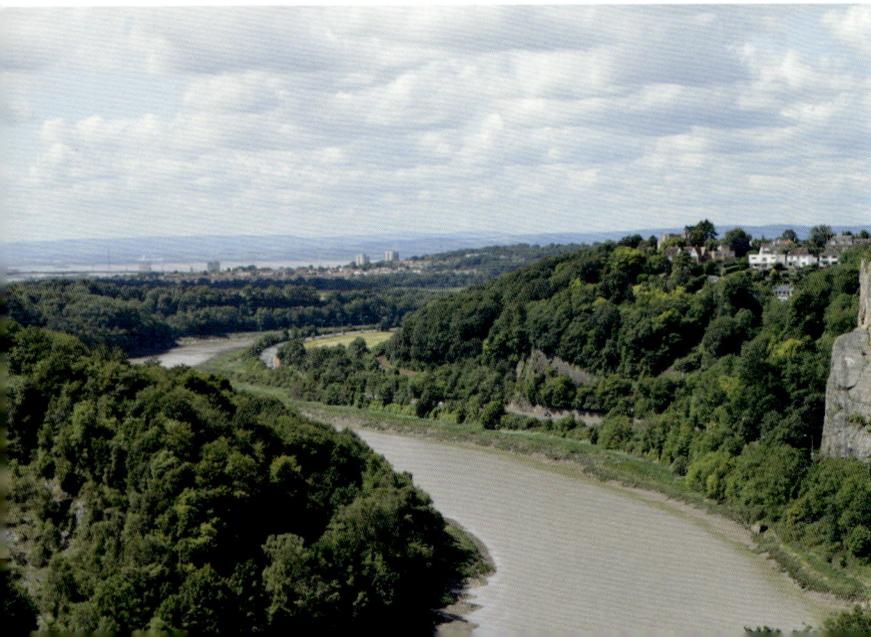

Above left: The Observatory.

Above right: The view upriver from Clifton Down, back to the Clifton Suspension Bridge.

Below: And the view towards the river mouth.

Weston House survives. 93 acres of its original grounds of 220 acres are still open land, some of it occupied by the local golf club. In the eighteenth century Shirehampton became popular for day trips, often by people who were holidaying in Bristol or Bath.

The village of Pill lies opposite and just a little downstream from Shirehampton – a rowing boat that left the latter near the Lamplighters pub used to act as a ferry between the two villages. The section of river just before Pill is called the Hung Road, which has a steep bank on the south side, while on the Shirehampton bank there is a reedbed – a rare survival on the Bristol Avon. Historically, the Hung Road was where many large sailing vessels transferred their loads to small ones for transport up to Bristol. Many of these were pulled by rope from the riverside, some by horses, others by men known as hobblers.

Pill's name was originally 'Crockerne Pill', which meant 'crockery wharf' – in the Middle Ages pottery manufactured in the immediate hinterland was transported from here. Later, it became the base for pilots who guided vessels in and out of the river – these men used a characteristic boat called a Pill Pilot Cutter.

Today, Pill is the endpoint of the River Avon Trail, which started back at Pulteney Bridge in Bath. The riverside area is divided from the village centre by the viaduct that carries the freight line to Royal Portbury Dock, and at the head of a little creek there is the American Monument. This commemorates Methodist preachers who sailed from here to America in the late eighteenth century. It was erected in 1984 on the bicentennial of the Methodist Episcopal Church USA and of one of the preachers setting off on the journey.

Pill Foreshore is an area of grazing marsh immediately downriver from the village. It is important for migratory and other birdlife, as well as reptiles and various species of plant. The view across the marsh from Pill towards the river mouth is enhanced, or spoilt, depending on personal interpretation, by the Avonmouth Bridge on the M5 motorway.

Most of the M5 was constructed between 1967 and 1977, and the building of the Avonmouth Bridge was within this phase, beginning in 1969. The bridge is 4554 feet long and the central span is 538 feet. To deal with increased traffic, the motorway on the bridge was widened to four lanes between 2002 and 2004.

Beyond are the docks that are a continuation of the story of Bristol as a port. Though the Floating Harbour was intended to solve the problem of the increasing size and number of ships coming into Bristol, it was really only a temporary solution. Attempts around the 1860s to improve the channel through the Clifton Gorge were not a complete success and it was realised that new docks at the mouth of the Avon were the solution. Avonmouth Docks on the north-east side of the river mouth were opened in 1877, with a large dock constructed here in the first decade of the twentieth century. On the opposite side of the river

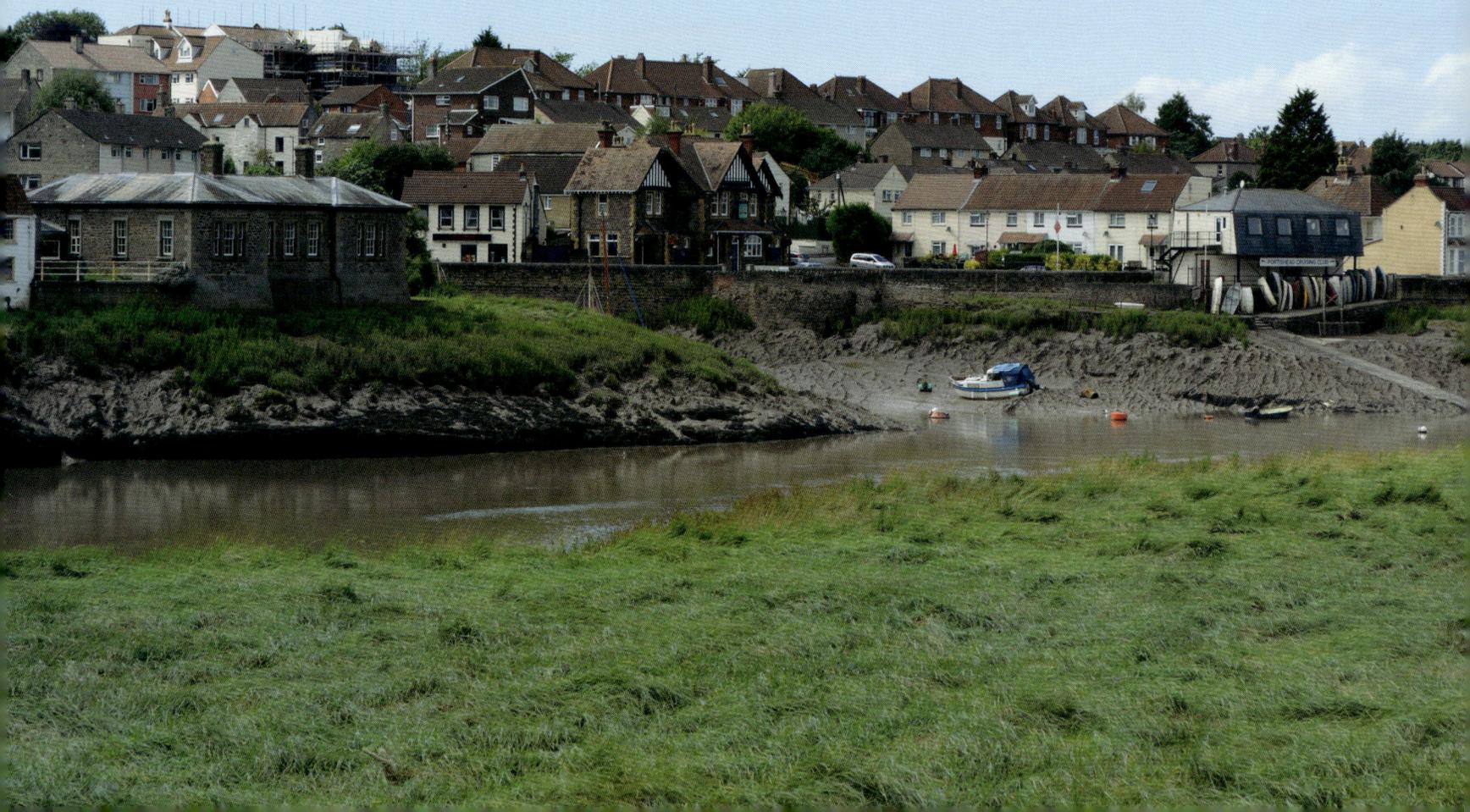

Pill, viewed from the
Shirehampton side of the river.

Above left: The viaduct carrying the freight line to Royal Portbury Dock over Pill.

Above right: The American Monument.

Below: Boats in the creek at Pill.

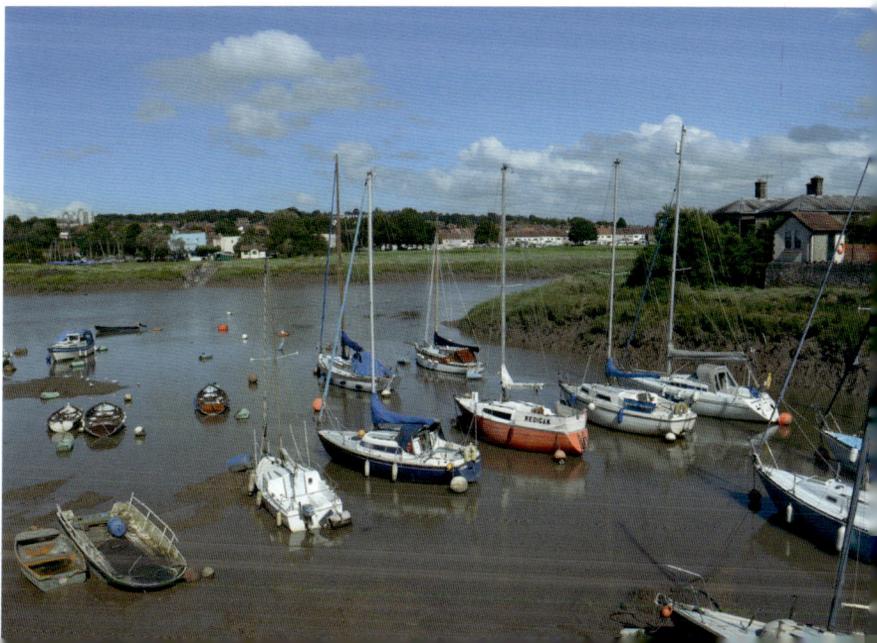

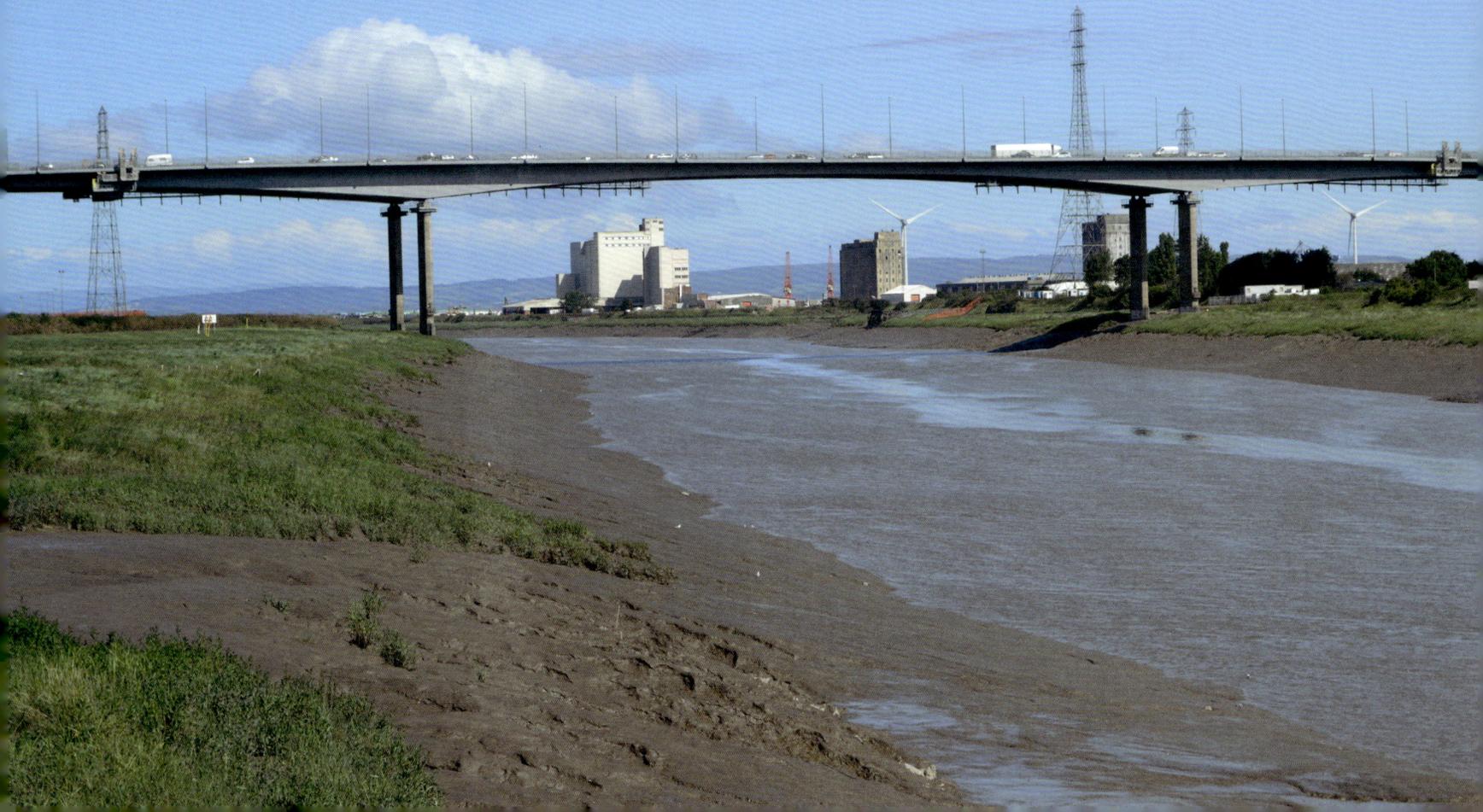

The Avonmouth Bridge with docks beyond.

mouth is Royal Portbury Dock, whose deep-water dock was built in the 1970s. Today, the main imports of these docks are chilled food and motor vehicles respectively.

Unlike many other major British rivers, you cannot reach the river mouth. There is a footpath shown on Ordnance Survey maps that runs from Pill under the Avonmouth Bridge and then a half a mile or so further, but ends at the dock complex. And if you are a passenger in a vehicle crossing the Avonmouth Bridge northbound, you can get a glimpse of the river mouth as you speed by. I went to a different location to get this book's final illustration, heading to the resort town of Portishead which lies on the Bristol Channel a couple of miles west of the river mouth.

To finish off, we need to consider whether we have now reached the sea. There is some disagreement about where the Severn Estuary becomes the Bristol Channel – it is difficult to define the boundary because there is nothing obvious, just a gradual widening from river through estuary to sea, and because the body of water is tidal well up to what is clearly the river). The favoured view seems to be that the Bristol Avon flows into the Severn Estuary, although since two other large rivers, the Wye and the Usk, flow in around here on the Welsh side, this stretch is sometimes seen as a joint estuary. If the river mouth is not at the sea, then the Bristol Avon is a tributary of the Severn, just like its Warwickshire namesake!

The view towards the mouth of the Bristol Avon from Portishead. There is a long low pier running across the middle of the view. It is protecting the entrance to Royal Portbury Dock, and the mouth of the River Avon lies just beyond it, out of sight.

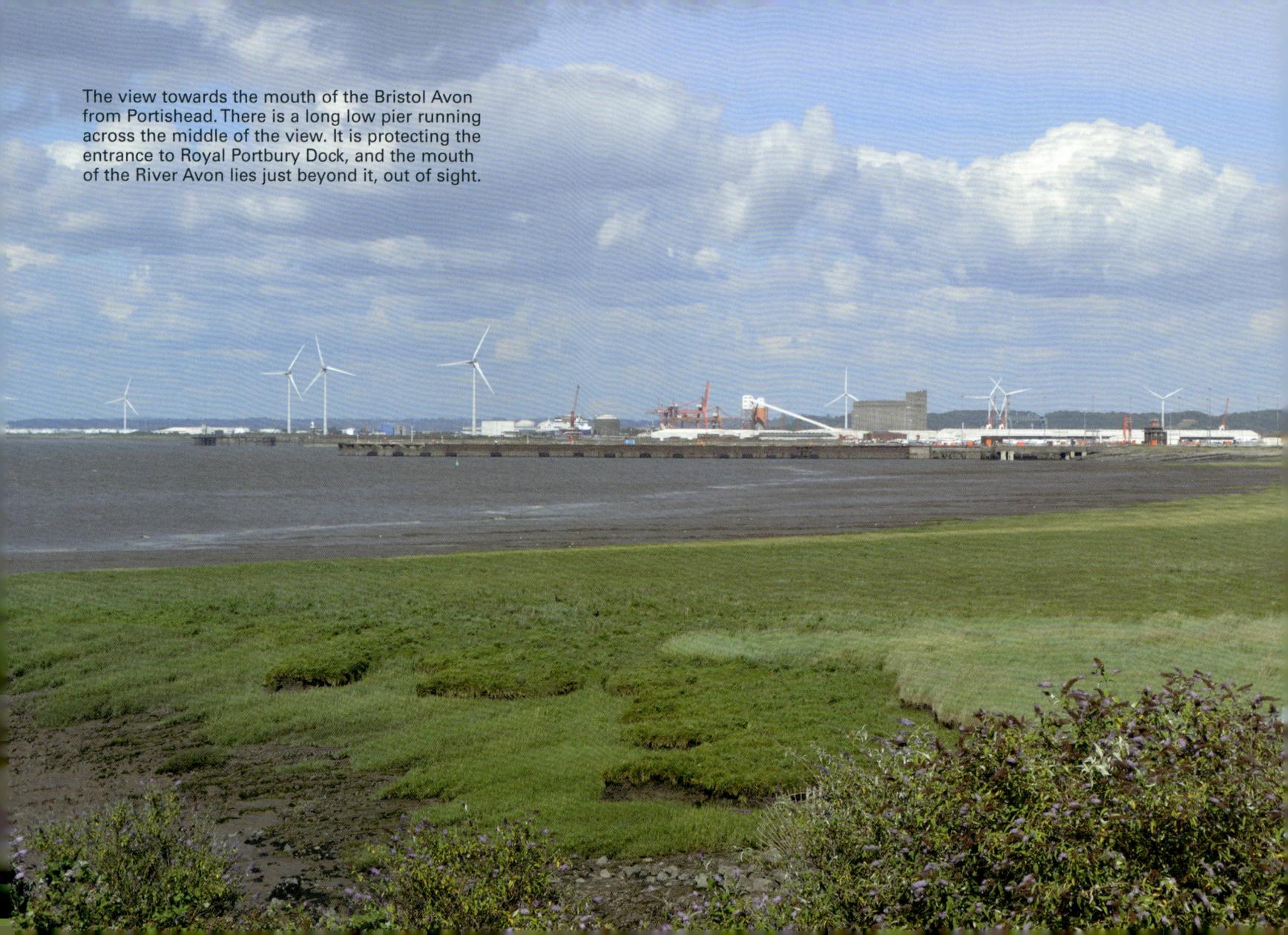

CONCLUSION

The Bristol Avon has had a massive influence on many people's lives in this country and abroad. It flows through a fascinating variety of countryside and settlements large and small, imprinted with lots of evidence of past inhabitants. The river and its valley are great places to explore, made more accessible by the proximity of all parts of the river to one another, so that the visitor can experience seemingly remote countryside (some of it flat and some almost rugged), pretty villages, and historic towns and cities without having to travel any great distance between them. If you live near the Bristol Avon and have a car, all the fascinating places along it are within easy range of afternoon trips.

I know that there is a great deal concerning the Avon and its valley that I have missed out from this book, so again I urge you to explore the area for yourself and find out more.

Finally I ought to admit that the Bristol Avon does not quite match the description 'from source to sea' that is used in the titles of this series. There is no clear agreement on which is the source, and it is probably best to admit that there are several of them, and equally it is arguable whether the Bristol Avon flows into the sea or an estuary!

BIBLIOGRAPHY

In writing this book I have used a number of internet sites as sources of information (too many to list here, as the saying goes) but I must single out the value of the British Listed Buildings website for details of particular buildings. I also used the following books, all of which were a pleasure to read or just browse through.

Cheetham, J. H. and Piper J., *Wiltshire: A Shell Guide* (3rd ed., London: Faber & Faber, 1968)
Dickens, C., *Our Mutual Friend* (Wordsworth: Ware, 1997)
Dunning, R., *A History of Somerset* (Chichester: Phillimore & Co., 1983)
Geddes, I., *Hidden Depths* (Bradford on Avon: Ex Libris Press, 2000)
Jenkins, S., *England's Thousand Best Churches* (London: Penguin, 1999)
Jenkins, S., *England's Thousand Best Houses* (London: Penguin, 2003)
Mee, A., *The King's England: Somerset* (2nd ed., London: Hodder and Stoughton, 1968)
Moriarty, M., *Buildings of the Cotswolds* (London: Victor Gollancz, 1989)
Pevsner, N., *The Buildings of England: North Somerset and Bristol* (London: Penguin, 1958)
Pevsner, N., *The Buildings of England: Wiltshire* (2nd ed., London: Penguin ,1975)
Verey, D., *Gloucestershire: A Shell Guide* (2nd ed., London: Faber & Faber, 1970)